CINEMAPS

MAPS

AN ATLAS OF GREAT MOVIES

MAPS BY
ANDREW DeGRAFF

QUIRK BOOKS
PHILADELPHIA

ESSAYS BY
A. D. JAMESON

Contents

Back to the Future (1985) ——————————— 82

Labyrinth (1986) ————————————————— 89

Predator (1987) —————————————————— 92

The Princess Bride (1987) ——————————— 97

Indiana Jones and the Last Crusade (1989) ———— 100

Edward Scissorhands (1990) ——————— 105

Terminator 2: Judgment Day (1991) —————————— 108

The Silence of the Lambs (1991) ————————— 113

Jurassic Park (1993) ——————————————— 116

Pulp Fiction (1994) ——————————— 121

Clueless (1995) ————————————————— 124

Fargo (1996) ——————————————— 129

Rushmore (1998) ————————— 132

The Lord of the Rings Trilogy (2001–2003) ————————— 137

Shaun of the Dead (2004) ——————— 143

Star Trek (2009) ———————————— 146

Guardians of the Galaxy (2014) ————————————— 151

Mad Max: Fury Road (2015) ——————————— 154

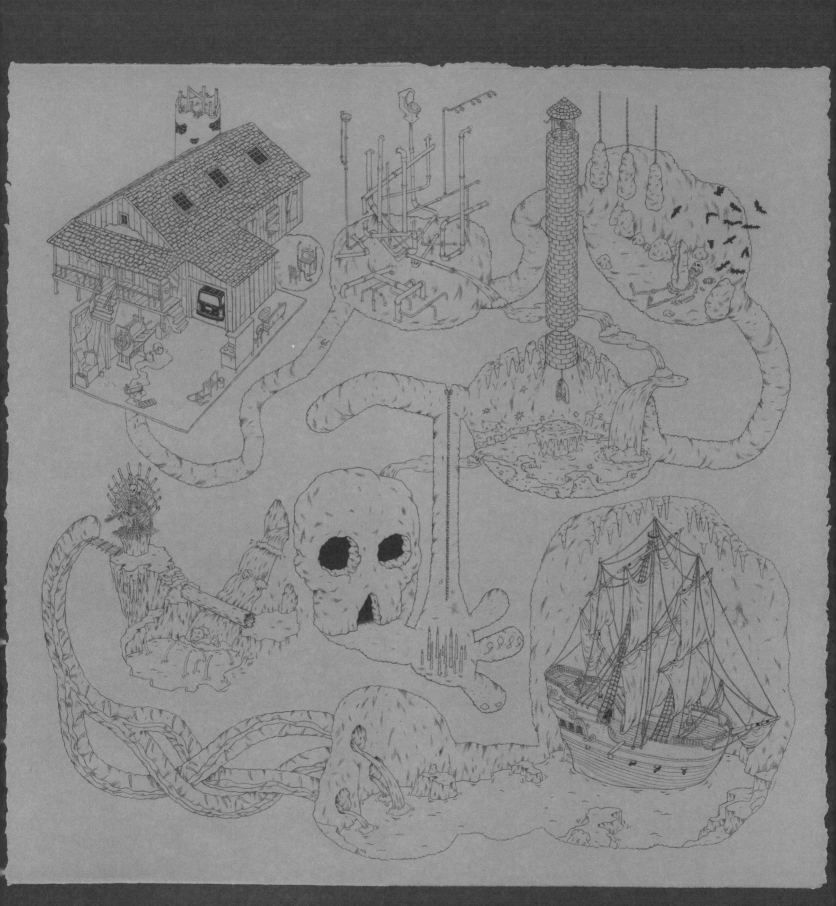

In Pursuit of Willy (2010), 22 x 22 in (56 x 56 cm). Gouache on paper.

INTRODUCTION

I love movies. Studio movies, indie movies, black-and-white movies, animated movies, subtitled movies—I love them all. And growing up with the first generation of VCRs and video rental stores, I could revisit my favorites again and again. Nowadays, this is something we all take for granted, but back in the mid-1980s "movies on demand" was a new and utterly amazing experience. For the first time in motion-picture history, viewers could watch movies in their own homes, on their own schedules, and on their own terms.

As teenagers, we studied our favorite films with manic intensity, pausing the tapes to parse lines of dialogue, study the architecture of a starship, or note a weird directorial signature. We rewound *A New Hope* to watch that one clumsy stormtrooper bumping his head on the ceiling. We read the credits in search of familiar names. We laughed over the perverted Easter eggs hidden in animated Disney films.

If you grew up watching movies in the late 1970s or early 1980s, you probably did many of these things, too. It was the advent of the summer blockbuster. All the tools of the great cinematic masters—Kurosawa, Hitchcock, Lang, Bergman—were being applied to something new, fresh, and fun, to movies tailor-made for the children of baby boomers. We were an audience of millions, with hungry imaginations, time on our hands, and allowance money burning holes in our pockets. We were raised on *Star Wars* and *Indiana Jones* and we wanted more—more aliens, more monsters, more strange worlds to explore. But if we couldn't have more movies, we'd settle for the same movie again and again. We'd line up on opening weekends for the sequels to *Back to the Future*, *Ghostbusters*, and *Star Trek*.

These films were marvels of craftsmanship created by extraordinary talents. Our monsters were created by H. R. Giger and Jim Henson. Our locations and sets were designed by Syd Mead, Ron Cobb, and Ralph McQuarrie. Our comedy, by directors like John Hughes and Rob Reiner, was deftly insightful and, later, beautifully manicured by the likes of Edgar Wright and Wes Anderson. Our adventures were designed and dressed by Jim Steranko. Our posters were painted by Drew Struzan and John Alvin. As a child, I didn't realize how lucky I was. Now I do, and I suppose this book is the evidence. The illustrators, designers, painters, and creators mentioned above were some of my earliest influences, even if I didn't yet know their names. This book and its paintings are in many ways an homage to all the talented people working behind the scenes of my favorite films. Before I knew what I wanted to be, I knew I wanted to be them.

So as I gleefully kneel at the altar of popular cinema, you might be wondering why I've left such strange offerings.

In other words, why did I paint all of these maps?

The answer probably lies somewhere in my childhood. As a kid, I covered my bedroom walls with full-color maps pulled from the pages of my father's *National Geographic* collection. I had a comforter listing all the states and their capitals; you could say I was effectively swaddled in maps every night. I was fascinated by the way maps blend information with graphic design. I'd trace my finger over rivers and roads, imagining the people who lived in these strange and far-flung places.

Jump cut to twenty years later: I was working as a freelance illustrator when a travel magazine asked me to create some maps. It was an irresistible opportunity, but I quickly learned that *creating* a map is a lot harder than *reading* one. To make a good map, I had to really know my subject, wrangling a laundry list of different things into some sort of order. If you've ever handpainted a sign and found yourself running out of room for the last word, then you have an inkling of the mapmaker's dilemma. Planning ahead is essential. Geography and spacing are generally going to hinder, not help, you. But I enjoyed the challenge, and more map assignments started coming my way.

Camp Firewood (2011), 22 x 22 in (56 x 56 cm). Gouache on paper.

Then one day it occurred to me that I might marry my two childhood interests—maps and movies—on the same page. My first effort was drawing the underground caverns of Richard Donner's *The Goonies*; I followed up with the summer camp setting of David Wain's *Wet Hot American Summer* (opposite). Neither was as detailed as the maps in this book; there were no character arrows and the approach was pretty stark, just one color of gouache and zero people. But they were sprinkled with little Easter eggs from the films, like Troy's bucket (from *The Goonies*) and the bale of hay roadblock (from *Wet Hot American Summer*). To my delight, people really responded to these paintings. They recognized the settings and mentally filled in the rest—the story and the quotes and the characters they knew so well. Soon they began requesting more.

After those maps came *North by Northwest*, with its Saul Bass–inspired use of arrows for one character, and then *Star Wars* and *Indiana Jones*, with arrows following all the major players. Then *Shaun of the Dead*, *Star Trek*, *Back to the Future*, *The Shining*, *The Lord of the Rings*, and others. I think of these paintings as scale models of summer blockbusters, diagramming a limited amount of time—usually about 120 minutes—between the opening and closing credits. As viewers and fans, we've traveled every inch of these journeys before. We've trekked through the forest and the jungles, we've soared past the planets and the space stations. Yet we keep returning to these worlds again and again. With these maps, we can view our favorite films from a fresh perspective. We can travel the familiar journeys in new and unfamiliar ways.

The mapmaking process is long and laborious. Each one takes several weeks, even months, to complete; my map for the *Lord of the Rings* trilogy was the most complex of all, requiring more than 1,000 hours. When I'm working on a new map, I'll watch the corresponding film at least twenty times, occasionally as many as fifty times. For weeks, the film I'm mapping will be a constant backdrop to my life. The soundtrack will invade my dreams. I'll spend a lot of time researching locations through set photography, production notes, and some of the insanely detailed LEGO models posted by fans online (I can't believe these exist, but they do).

Sometimes I'll even research locations that are never completely shown in the film. Whenever possible, I like to reveal the full extent of a place, like the Soldiers and Sailor memorial in Pittsburgh, which houses significant scenes in *The Silence of the Lambs* but whose lovely exterior is shown only in a passing glance in the black of night. Or the old LaSalle Street Station in Chicago, where Cary Grant performed his little bathroom shaving gag in *North by Northwest*. Hitchcock doesn't show the exterior, but it's a part of the map and quite lovely, too.

To my surprise and great delight, these maps have found an eager and enthusiastic audience on the internet. I am forever grateful to the early adopters who bought paintings and prints and posted them online. From big-name directors like J. J. Abrams (who bought my map of his first *Star Trek* film) and well-known producers to fellow mapmakers, designers, writers, and film enthusiasts, my work has found an audience in a wide cross-section of people. The tribe of pop culture and popular cinema is nothing if not a big tent, and it's growing all the time.

I always hoped to compile my maps into a single volume, and as their number increased, I began to think more seriously about what form such a volume might take. I didn't want to make a conventional art book or a conventional film book. My hope was that this collection could be a bit of both. Enter Quirk Books and publisher Jason Rekulak: master of the intersection where art, academia, and pop culture meet and to whom I am ever thankful. At the same time, I knew I needed a writer to give context and impart a deeper understanding of why we love these films so much and the reasons they resonate. This film bard would have to be able not only to start the conversation, but also to inform the reader why they should watch the film again (or for the first time). Beyond those herculean requirements, this person would have to shed new light and insight on some of the most discussed, parsed, lampooned, and dissected films of all time. Enter the talented A. D. Jameson, to whom I am also forever thankful.

Now I had a great publisher, and a great writer, and a large number of maps and movies to consider for the book. Because I had begun by working with the 1970s and '80s blockbusters of my childhood, it made sense to concentrate mostly on that era. But of course I also wanted to include such classics as *King Kong* and *Metropolis* as well as more contemporary masterpieces like *Mad Max: Fury Road*. All told, we whittled down well over 200 different movies to wind up with this collection of 35 maps, and I think they serve as a snapshot of popular cinema, from proto-blockbuster to blockbuster to postmodern blockbuster. Why stop at 35? Well, if my upbringing as a popular-movie fan has taught me anything, it's that you always leave room for a sequel, and then cross your fingers for the franchise.

Perhaps by now you've decided that I'm a rather nostalgic person, and I won't disagree. Perhaps this whole endeavor is a selfish expression of my desire to relive parts of my childhood and the great experiences I've had with films. But I like to think of it as an invitation. One might even say, without too much of a belabored metaphor, that it's a ticket to a viewing of our collected childhoods, whatever age we may be. These are maps to the places we've all visited together; they populate our tribe's family album. So take a seat and remember. Remember not only the worlds created for you in movies, but also the world in which you first saw them: the sticky theater floors, the worn-carpet living rooms, or the old recliner covered with an army blanket. The day after Christmas. The night at the drive-in. The hours spent choosing at the video store. Remember the people who were watching at your side. Maybe it was Mom or Dad. Grandparents or siblings. Girlfriends or boyfriends. Husbands or wives. Maybe it was your own children.

In many ways, the nostalgia of film is the nostalgia for the reality in which we viewed those films, and the people we shared them with. I hope these maps and essays are pathways back to those moments. Perhaps even a deepening of those feelings, and a better understanding of them that bring these movies home.

ANDREW DeGRAFF

DIRECTED BY **Fritz Lang**

RELEASED IN **1927**

- FREDER
- JOH FREDERSEN
- MARIA
- C. A. ROTWANG (THE INVENTOR)
- GROT
- JOSAPHAT
- THE THIN MAN
- THE MACHINE MAN
- 11811 (GEORGY)

Paths of the Metropolis (2017)
Gouache and charcoal on paper
16 x 22 in (41 x 56 cm)

Did Fritz Lang invent Metropolis? Or did he discover it? Upon arriving in Manhattan in 1924, or "Neuyork" as he called it, he was inspired to make the city's art deco skyscrapers— strong and streamlined and symmetrical—the stars of a motion picture. He told this idea to his wife, Thea von Harbou, who wrote a novel that they then adapted together. Between the skyscrapers, Lang inserted a new Tower of Babel; to their side was Yoshiwara, Tokyo's red light district. In between he ran highways and elevated trains and made room for airplanes, models suspended by wires that made long slow graceful arcs. In the city's shadows he placed, like a cuckoo's egg, the inventor Rotwang's house, a simple cottage that bears witness to both the future and the past. Inside, behind a heavy curtain, lies a shrine to a dead woman, Hel, Rotwang's unrequited love. In another room sits the *Maschinenmensch*, a robot, in a chair beneath a pentagram, a fusion of science and magic, waiting patiently for the word that will cause it to stand up, open its eyes—and thereby bring Hel back to life.

Metropolis is melodramatic, feverish, operatic—wrought with neuroses and anxieties, which it lays bare for all to see. A nightmarish vision of humans reduced to mere bodies while robots are given flesh, it is anything but subtle. An early sequence sees a social worker named Maria lead a gaggle of orphans and urchins straight out of Dickens into the wealthy upper city to witness how the other half lives. There, in gardens that bloom eternal, the children of

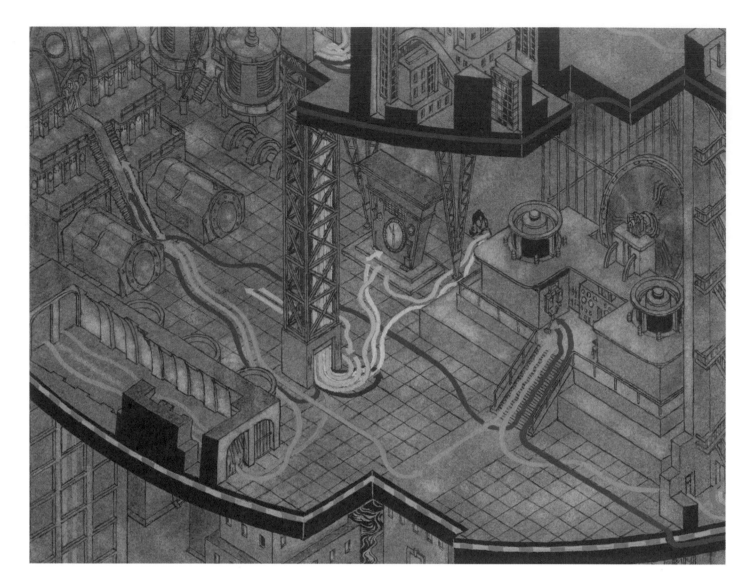

privilege idle away their days, chasing each other around fountains in fancy costumes while peacocks preen. Freder, son of Joh Fredersen (the Master of Metropolis), sees Maria and is immediately smitten; we know this because he stops dead in his tracks with his hand on his heart. That's par for the course in *Metropolis*, whose actors gesticulate wildly, posing and being posed by Lang (by all accounts a tyrant on set). It's acting as dancing, choreography for camera, everyone wide-eyed, plastered with makeup, every hairdo a work of sculpture. Some have called it over-wrought, but there's a method to the

commotion, a logic written through the picture. Underground, the city's workers live out their lives to the beat of the clock, shuffling along in subdued regiments, obediently filing into lifts that smoothly descend. If they look unnatural, it is because the city is unnatural, grand and immense. They are its products.

We see one worker all but crucified on a clock whose hands spin unpredictably. Time in Metropolis is neither fluid nor sane but violent, unbearable, out of joint. That man collapses as Freder approaches, though he remains devoted to his task: "Someone *has* to stay at the machine!" Who's working what? And in the steaming depths that extend below the city, Freder learns how anonymous masses spend their lives enslaved to his father's infernal con-traptions, watching with horror as one—the Heart Machine, of all things (the city is a body)—goes kablooey and explodes, scalding men and sending them tumbling and screaming. In Freder's eyes, the machine becomes Moloch, a

monstrous visage whose helmeted priests herd cowering men up the stairs to be fed into an insatiable metal maw.

Decades later, Fritz Lang confessed to Peter Bogdanovich that the film was "silly and stupid," a "fairy tale." He'd been lis-tening to his critics, who dismissed it upon release as simpleminded and naive, even soulless. But Lang and von Harbou were in a fairy-tale mood at the time, having just completed their magnificent two-part *Die Nibelungen*, an adaptation of the epic medieval poem. *Metropolis* is that film's futurological counterpart—like Rotwang, the couple was pinned between two com-peting fantasies, future and past.

Fredersen orders Rotwang to give his *Maschinenmensch* Maria's likeness, then sends it out amid the workers to sow dis-sent. Dancing lasciviously, her limbs jerking every which way (like the crazy clock), she rouses a mob that destroys the Heart Machine, unwittingly flooding the city. The people realize they've been betrayed and burn the impostor at the

A PLEASURE GARDEN (above)

ADAM: Metropolis's topmost peak, the home of the idle rich, is a place of universities, athletic stadiums, gardens, and cathedrals. Hidden below, out of sight, is the city's industrial base, the vast network of machinery that powers and enables that luxurious life of leisure.

stake, revealing the robot underneath. Freder chases Rotwang, driving him to the top of the cathedral, where they battle to the mad inventor's death. Then, reunited with Maria, Freder negotiates a truce between his father and the workers, serving with Maria as Metropolis's true heart. Okay, admittedly, it's cheesy. But *Metropolis*'s achievement lies in its bluntness and in the boldness of its imagery, its every shot and scene as strong and straightforward as skyscrapers.

After *Metropolis*, Lang and von Harbou made another sci-fi film, *Woman in the Moon*, followed by *M*, the sound film classic with Peter Lorre. That came out in 1931. Two years later, Adolph Hitler became Reich chancellor, and Joseph Goebbels asked Lang how he felt about working for him. In response, the director fled Germany for Paris, then made his way west to Hollywood, where he made nearly thirty more films, many of them noirs— *The Woman in the Window*, *Scarlet Street*, *The Big Heat*, *While the City Sleeps*. Thea von Harbou stayed in Germany and joined the Nazi Party. And *Metropolis*—savaged by critics, butchered by censors—largely vanished. I first saw it on VHS, only eighty minutes long (just over half the original film), color tinted, and with a soundtrack produced by Giorgio Moroder, featuring Bonnie Tyler, Pat Benatar, Freddie Mercury, and Adam Ant. Which is *terrific*—but far from what Fritz Lang had in mind. Not until 2010 could anyone see a version like the theatrical release.

But even as the film (cut down) disappeared from sight, the city spread. New neighborhoods sprang up, districts like Coruscant (in George Lucas's *Star Wars* prequels), Gotham City (in Tim Burton's *Batman* films), and the urban mishmash of George Miller's *Babe: Pig in the City*. Other inhabitants filtered in, attracted to the bustle and nightlife: Clark Kent, Darth Vader, C-3PO, Dr. Strangelove, the *Blade Runner* replicants, Sam Lowry from *Brazil*, and countless others. As cinema grew, *Metropolis* took in its patrons, enveloping us, making room in its skyscrapers and back alleys. We're living there still. Look at all the pretty lights. Don't dwell on the sacrifices that fuel them. ◦

KING KONG

DIRECTED BY **Merian C. Cooper and Ernest B. Schoedsack**

RELEASED IN **1933**

● **KING KONG**

○ **ANN DARROW**

● **JACK DRISCOLL**

● **CARL DENHAM**

● **MILITARY PLANES**

● **PTERODACTYL**

"Is this the moving picture ship?" a man asks a watchman on a dock in New York City. "Yeah," answers the watchman. "It's the *Venture*!" Which has been chartered by Carl Denham, a "crazy fellow" who "ain't scared of nothing." Denham is a movie director, see, famous for going around the world and making thrilling documentaries about rhinos, tigers, lions. Now he's hunting bigger game.

The men go onboard and talk with Denham, and for a while *King Kong* is a lot of talk, indeed. It opens not with any action, but with exposition about the voyage, and explosives, and nerve-gas bombs, and the monsoon, which is the tropical rainy season. Denham has everything he needs for his expedition except one thing: a beautiful gal. He's been listening to his critics, who all agree that if his movies only had romance, they'd gross double. (In real life, Merian C. Cooper had heard the same thing.)

Thus Denham sets out in search of a heroine. He finds one in Ann (Fay Wray), fainting with hunger beside a fruit stand. Like Eve, she tries to steal an apple. Denham—the serpent?—steals her instead. He buys her a dress and shoots a screen test, filming her using a hand-cranked camera, directing her to look up and act frightened, as though she sees something that terrifies her. In another twenty minutes she'll be doing it for real.

The metatextual angle is obvious. Denham wants to make and exhibit the most sensational motion picture ever made. Cooper

Paths of Kong (2016)
Gouache on paper
19 x 21 in (48 x 53 cm)

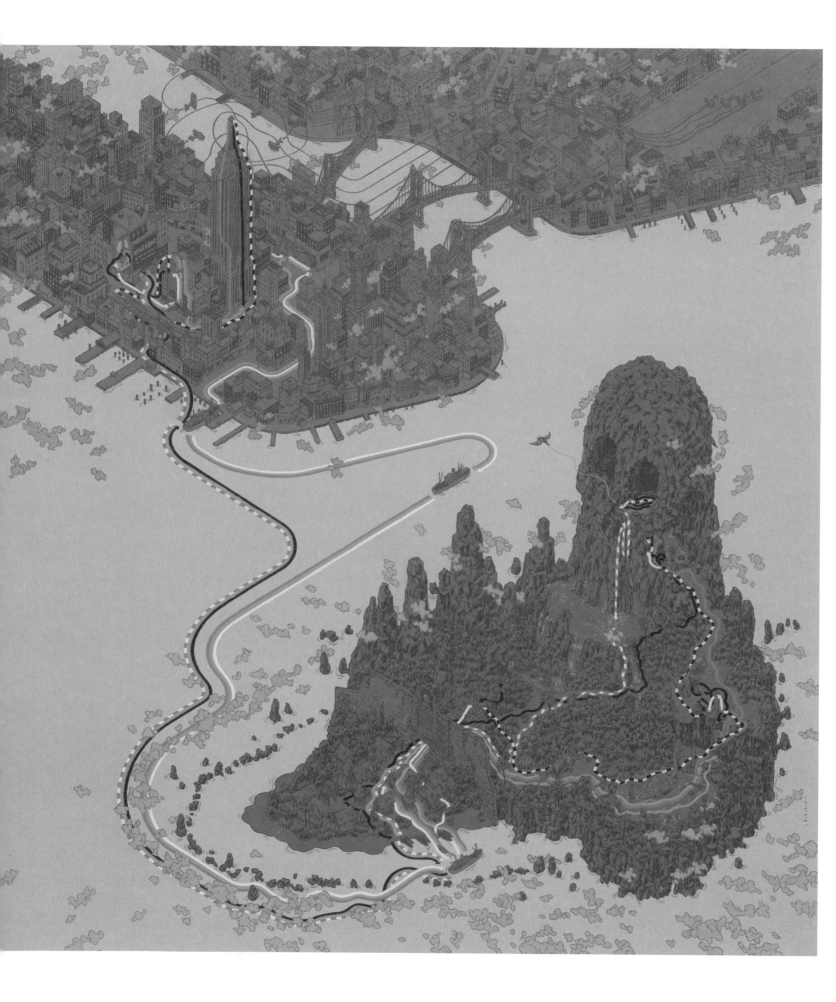

THE TOP OF THE WORLD (above)

ADAM: The Empire State Building was still brand new in 1933, having been completed two years prior. Kong presumably seeks it out because it resembles his mountainous jungle abode—he is trying to take Ann Darrow home. But the modern world, with its airplanes and skyscrapers, eradicates Kong, cutting off all routes of escape.

and Schoedsack want the same thing: to amaze and astonish a Depression-era public with gorillas, natives, dinosaurs—anything but home. It's funny, though: Denham wants something that no one has ever seen before, but the movie we're watching couldn't be more formulaic. And Kong's appearance is heavily foreshadowed, from the Chinese cook's pet monkey to the recurring talk of beauty and the beast. When asked what they might find on their voyage, Denham describes a mighty monster laid low by love, as though he knows what's going to happen.

King Kong never claimed to be novel. *Tarzan* had already proved to be a hit, as had several *Lost World* flicks. Indeed, RKO financed *Kong* because it figured that a gorilla plus a screaming beautiful woman was a surefire thing. What made *Kong* stand out from the pack was that it did it *better*. Cooper and Schoedsack knew their stuff; they'd actually traveled around the world, making melodramas like *Chang*, set in northeastern Thailand, where Schoedsack was nearly trampled by elephants. Now they, like Denham, wanted bigger. To realize their vision, they turned to special effects, hiring Willis O'Brien (Ray Harryhausen's mentor) to

whip up the film's innovative stop-motion creatures and composite editing techniques. They worked to make King Kong seem not like a special effect, but like a real ape, "the Eighth Wonder of the World."

They also knew how to structure a movie. The opening third might be a tad slow, but it builds up a lot of suspense. Before we get to see the beast, Denham takes us to an island not on any chart, a place wrapped in fog and the sound of drums. We go ashore to find that the natives are all elsewhere, anointing a maiden with flowers while others dance, pretending they're apes. They live outside a massive wall, behind which is something they fear, "something no white man has ever seen."

The natives are stupefied by Ann and try to buy her, speaking what sounds to my ears like Huttese—the made-up language that Jabba speaks in *Return of the Jedi*. But *King Kong* is like that; it inspired so many movies that it now seems like a collage of popular culture. Skull Island is an obvious predecessor to Jurassic Park and Marvel's Savage Land. And since *King Kong*, how many other Others have laid waste to New York City? Godzilla, Gremlins, the mucousy aliens from *Independence Day*, the monster in *Cloverfield*—to name just a few.

Around the forty-two-minute mark, King Kong pokes his head in. Preceded by his roar and the sound of toppling trees, he struts from the forest to stare at Ann, his eyes open wide—possibly even wider than hers. She's never seen anything like him, but he's not seen anything like *her*: a pale white woman, blond as a banana. She screams and thrashes within her restraints. He picks her up and carries her off. Like so many movie monsters, he's looking for a bride.

In hot pursuit are Denham and Driscoll and the others, soon up to their necks in nonstop dinosaur attacks. A great deal of running and shouting ensues, as well as screaming and men getting killed. Kong fends off all comers, roaring and pounding his chest, his soft fur gently rippling. He may be a monster, but he's more like us than the dinos—able to love Ann, while the lizards just want lunch.

In its time *Kong* was state of the art, and presumably filmgoers found it scary.

Today it looks very, very fake—shot in Hollywood, not on an island west of Sumatra. I find the monsters more adorable than abominable. My favorite is the lizard thing that scrambles up a rope toward Driscoll; second favorite is the *T. rex*, due to its cute little raspy chirps. It always saddens me when Kong kills him, snapping his jaws apart to let the blood drool out.

The artifice doesn't diminish the charm, though; I don't believe that anyone ever thought it was real. No matter how realistic art gets, we still know it's fake. Therein lies its pleasure: there are no monsters but what we make. We project ourselves into the world, animating it, making it bigger than it is. Kong grows larger throughout the picture—as he needs to, because the tragedy demands it. A captive god, he coos at Ann, then touches the bullet holes left by the planes, which have pierced his heart. He stares at his own blood before plummeting to the street, laid low by beauty just as Denham had promised. We choke back a tear. We find the giant brute sympathetic, though of course we would. He's our creation.

King Kong is many things, but at bottom it's a lament for the end of the Age of Exploration. The westerns couldn't be made until the closing of the West. And *King Kong* couldn't be made until technology had domesticated nature. We scour the globe but find only ourselves, and like Alexander the Great, we despair. There are no new lands for us to conquer. The movie knows this. The first thing we see is the RKO logo, a radio tower surmounting the globe, broadcasting in Morse code. Here's what it's saying: "We've driven the monsters of myth from the earth, and revealed that there are in fact no places like Skull Island, no lost worlds. But don't despair; hope isn't lost—because there is cinema! This moving picture ship you're about to board is the greatest adventure!" •

SKULL ISLAND (below)

ADAM: King Kong lives in the penthouse of Skull Island, setting up shop in its eye sockets—he's the Sauron of the natural world, top of the food chain, able to see all. Not even dinosaurs can dethrone him. His Achilles heel proves to be a woman from New York City.

DREW: *King Kong* is a grotesquely pessimistic film, and I wanted the color to reflect that. Both New York City and Skull Island are sick, the former due to the Depression, the latter due to misplaced faith. Wherever Kong goes, he finds people motivated by base, desperate needs. No wonder he takes to Ann Darrow, a kindred exception!

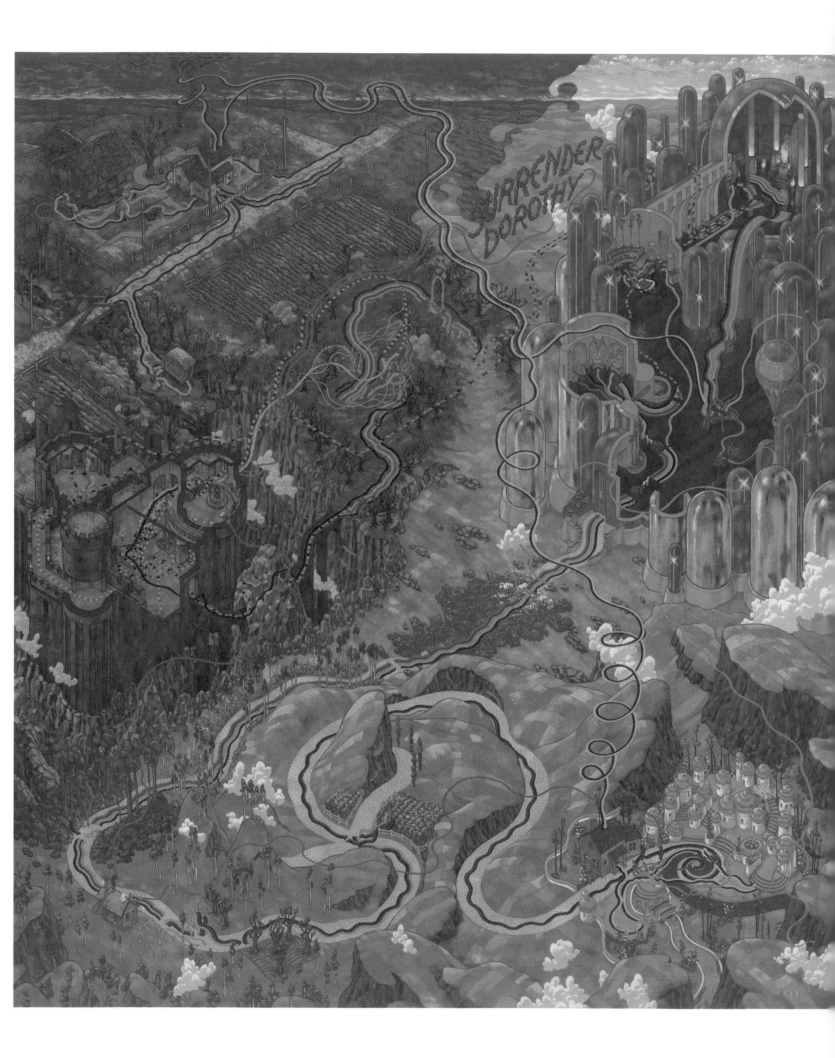

THE WIZARD OF OZ

DIRECTED BY Victor Fleming et al.

RELEASED IN 1939

- ● DOROTHY
- ● DOROTHY WITH RUBY SLIPPERS
- ● TOTO
- ● THE SCARECROW
- ● THE TIN MAN
- ● THE COWARDLY LION
- ● THE WIZARD
- ● GLINDA
- ● THE WICKED WITCH OF THE WEST
- ● AUNTIE EM
- ● UNCLE HENRY

Paths of Dorothy (2016)
Gouache on paper
18½ x 22 in (47 x 56 cm)

When we think of it, which is often, we think of the movie version first. Oz's true legacy has been up on the screen, its slippers ruby instead of silver, its heroine brunette instead of blond. There's even a history of responses and follow-ups, from the opening of Martin Scorsese's *Alice Doesn't Live Here Anymore* to the entirety of John Boorman's trippy *Zardoz* to Walter Murch's nightmarish sequel *Return to Oz*—and on and on and on. May it be forever so.

It's the kind of movie you can go home to, which is appropriate. "There's no place like home," proclaims Dorothy Gale. Oh, but there is, Dorothy—there's Oz. That's why, when she wakes up in her bed at the end of the film, she sees so many familiar faces. Not just people she already knew, but the new friends she met in that fanciful place: the Scarecrow, the Tin Man, the Cowardly Lion, as well as none other than the great and powerful Oz, Professor Marvel. "You were there," she exclaims as they crowd around her bed, "and you, and you, and you! But you couldn't have been, could you?" Her Auntie Em dismisses it as a dream, but Dorothy protests. Just like her predecessor, Alice, she's convinced the colorful wonderland she just visited was a real place, a truly live place.

And maybe it is. We shouldn't be too hard on her aunt, whose name implies that she'll never get to Oz. As the story goes, L. Frank Baum took the country's name from a filing cabinet labeled "O–Z." Auntie Em was in another drawer. The origin story

SURRENDER DOROTHY

helps explain why Oz is a haven for bureaucrats, replete with groups like the Lullaby League and the Lollipop Guild, and elaborate customs, as when the coroner goes back and forth with the mayor about whether the Wicked Witch of the East, lying under the house, is truly dead—not only *merely* dead, but really most *sincerely* dead. And the Wizard of Oz himself, mighty and powerful, turns out to be neither wizard nor god but a fraud, a humbug of a man behind a curtain, frantically working levers and buttons of a newfangled contraption. He's a Kansan, too, with purplish prose and a hot-air balloon that, he confesses, he hasn't the faintest idea how to work.

It's a proper metaphor for the movie, which from all accounts was messy to make: different directors coming and going, and actors taking ill from makeup and getting scorched. Even Toto got trod on. But you wouldn't know any of that from the final film, which is perfect. Its every frame is iconic, from Margaret Hamilton cackling with glee to her dead sister's stocking feet curling up—which you know struck a chord with a young Tim Burton.

What's it about, then? Commiserating with Toto in Kansas, Dorothy dreams of life somewhere else, in an imaginary place she heard of once in a lullaby, where the skies are blue and dreams come true and troubles melt like lemon drops. It's her version of Big Rock Candy Mountain or Cockaigne, where the bluebirds sing, too, and the sun shines every day, fair and bright, on the lemonade springs. With Toto in tow, Dorothy sets out to find her

Utopia, running away, or walking away, looking as glum as Charlie Brown. Instead of paradise, the two stumble across Professor Marvel, a fortune teller and sometimes juggler and sleight-of-hand artist, not to mention balloon exhibitionist. After feeding Toto a hot dog he offers to tell Dorothy her fortune, peering into a crystal ball he claims was once used by the priests of Isis and Osiris, and many others. Really, he's peering into her basket while she obediently keeps her eyes closed. Dorothy falls for his flimflam ways, and the professor tricks the gullible girl into going home with the lie that her Auntie Em is sick.

He sends her out into a storm that's still terrifying—but I don't need to tell you the plot, which we all know by heart. It's one of those films we watch repeatedly as kids. I find it beguiling but also frightening—fitting for a movie obsessed with duality. It's cinematic yet also theatrical, treating fantasy like vaudeville, with lots of wordplay and moments of direct address to the camera. Much of the mugging comes from Bert Lahr, the Cowardly Lion, who's constantly bawling and wringing his tail, unable to act like the king of the forest because he doesn't have any courage. "Ain't it the truth! Ain't it the truth!" There's no Oz version of Dorothy because she's already double, both happy and sad, about to cry in joy or in grief. She's delighted to find herself in Oz, but she has to get home because she believes the professor's lie. In the Emerald City, where everyone laughs the day away, her genuine sorrow for Auntie Em leads her to break down on the stairs, compelling the comically crabby doorman to let them in.

In *Star Wars: A New Hope*, Dorothy's mopey grandson, Luke, dreams of leaving Tatooine, a dull dusty place in the middle of nowhere. But once Luke escapes, he never looks back, never mentions his aunt or uncle again. Dorothy, braver, does return, swearing allegiance to drab and dreary Kansas, saying how if she's ever tempted again by desire, she'll look no farther than her backyard—the place with the chickens. The Great Plains were caught in the Dust Bowl then, and many of Dorothy's neighbors were dreaming of someplace where skies were bright and blue. Dorothy, still only a girl and unable to leave, takes refuge from the twisters and the dust storms in the one thing she has: her imagination. Oz was her, and she was Oz. She carried it with her, transforming chickens into Munchkins (we see them waking up inside eggs). And she made Auntie Em the Emerald City, which is why the Wizard, though fraudulent, still knew what Dorothy wanted.

Oz is what Dorothy wishes Kansas really were: a place with the people she knows and all the comforts of home—but also exciting and lush, with flowers and lollipops. It's her secret desire, and she fears it. I fear it, too. Oz follows me everywhere I go; it's haunting me, and it haunts you, too. Home is wherever you hang your hat, but Oz will always be inside us. •

THE DUST BOWL (opposite top)
ADAM: Miss Gulch, we're told by Auntie Em, owns half the county. But she doesn't own nature, which is why the tornado is able to whisk Dorothy away, flinging her over the rainbow to a place where Gulch's counterpart, the Wicked Witch of the West, owns only half as much (though still poses a major threat).

THE EMERALD CITY (opposite bottom)
ADAM: The Wizard of Oz pretends to be a face amidst flames, an elemental force—the God of the biblical Old Testament speaking from the heart of the burning bush. Professor Marvel must have gotten the idea from the fire that powers his hot-air balloon. But it's all a fake; he's nothing more than a movie projection.

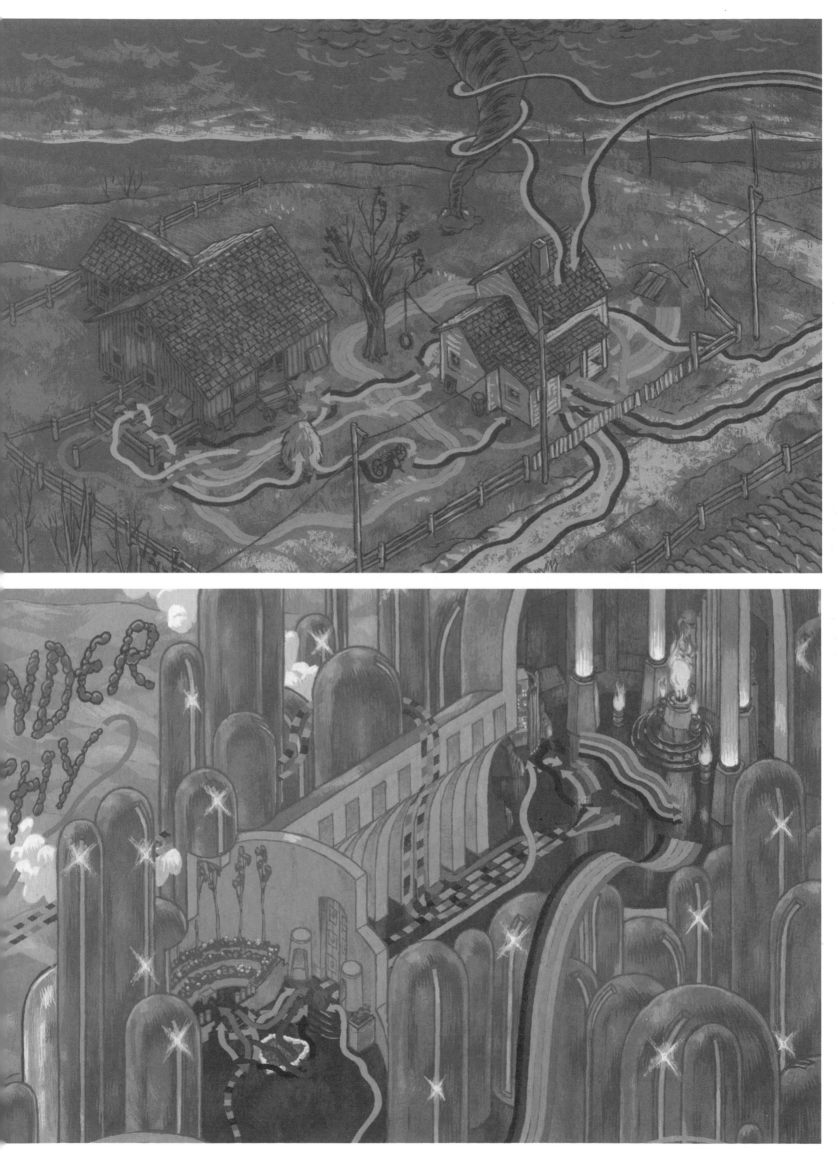

MAPPING THE LAND OF OZ

DREW: *The Wizard of Oz* is half amusement park, half fairy tale, half acid trip—it doesn't always add up. The wider shots that we get of Oz, which are mostly matte paintings, don't really match the way space is laid out in the scenes. Painting the map, I had to resolve those contradictions, which was trippy, like painting a house with rooms that are bigger than the house.

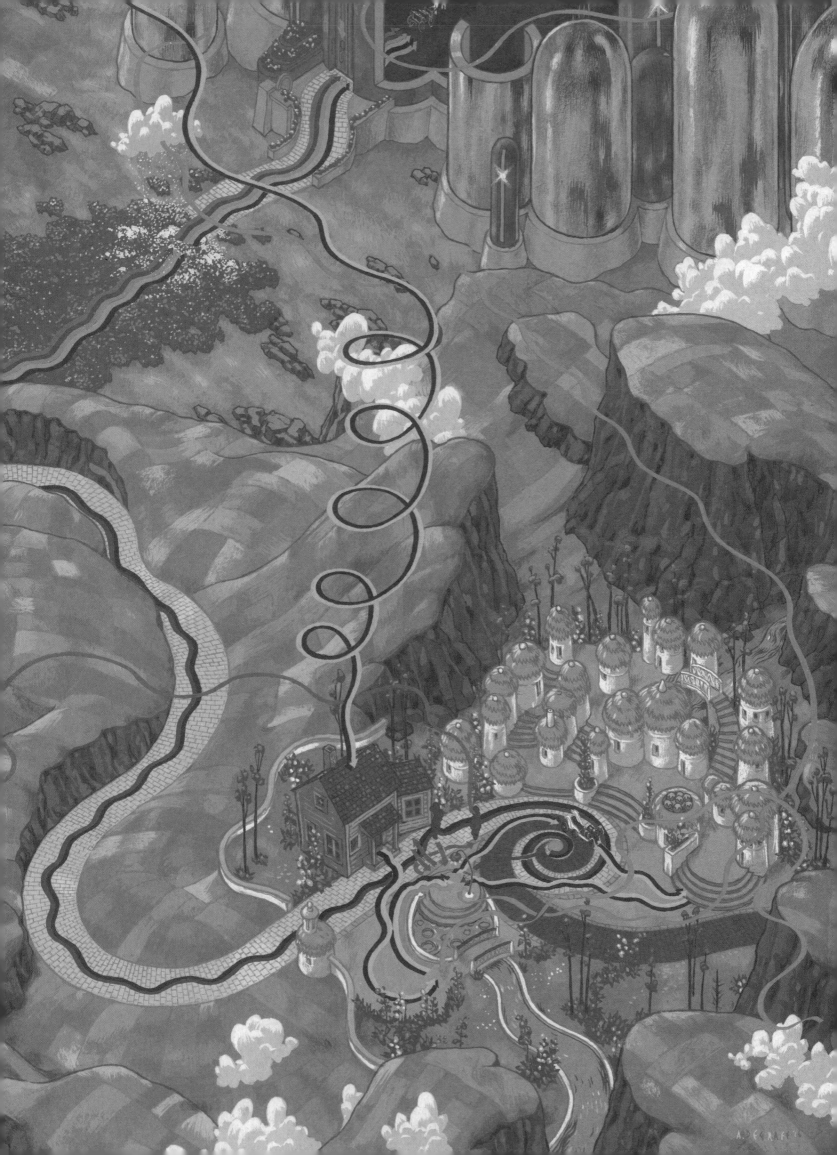

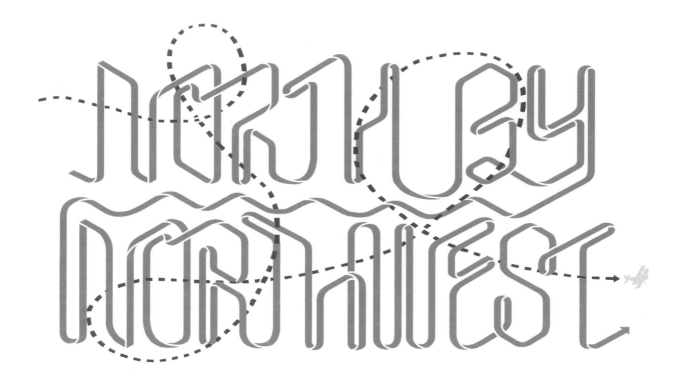

The basis for the modern action thriller, *North by Northwest* is a film about energy and movement—in fact, its studio nearly named it *Breathless*. It opens with gusto: Bernard Herrmann's bombastic score strikes up as Saul Bass slides the names of the film and its stars across the screen, white words snapping into place on a grid of blue lines against green. Already everything is slanted. Then a skyscraper fades in, providing its own grid, reflecting a busy New York City street whose cars distort as they cross the window panes. We cut to shots of bustling subways and stairs and avenues, where Hitchcock himself arrives too late to catch a bus. Amid the commotion appears our hero, Roger O. Thornhill, striding forward, dictating to his exhausted secretary in a hectic walk-and-talk. He's a Manhattan advertising executive, a workaholic, possible alcoholic, twice divorced, a mover and shaker in a world in which "there is no such thing as lying."

He's about to enter a world where that's all there is. Sitting down for two martinis with colleagues, he's mistaken for someone else—a Mr. Kaplan—and abducted. Taken at gunpoint by two goons to a manor outside town, he's interrogated by a genteel villain involved in (as it turns out) Cold War spy chicanery. Then comes the first of several assassination attempts: Thornhill is forced to drink an entire bottle of bourbon and then set down a winding seaside road in a stolen Mercedes—the victim of what he tells the police was "assault with a gun and a bourbon and a sports car."

DIRECTED BY **Alfred Hitchcock**

RELEASED IN **1959**

● **ROGER THORNHILL**

North by Northwest Passage (2012)
Gouache on paper
22 x 22 in (56 x 56 cm)

A THOUSAND TINY WINDOWS (above)
DREW: The great Saul Bass designed this movie's titles, a rush of slanted text and arrows imposed over the windows of a skyscraper. I borrowed that angular approach, and it was my pleasure to pay Bass tribute, even if it meant painting a thousand tiny windows.

That scene ends in a pileup, after which misrecognitions pile up on misrecognitions. Thornhill, sober and clear of the cops, tries tracking down Kaplan, only to be mistaken once again for the mystery man. He next goes after the manor's owner, Mr. Townsend, who's addressing the UN General Assembly. He finds a totally different man who, seconds later, is toppling forward, a switchblade embedded in his back. Now wanted for murder, Thornhill skedaddles, stowing aboard the Twentieth Century Limited, where he runs smack dab into cool Eve Kendall, a twenty-six-year-old industrial designer who wastes no time telling her brand-new friend that she's never been married and that he has a very nice face. But Eve, of course, is the villain's mistress, and she betrays Thornhill to the man. Except she's also *not* really his mistress—in *North by Northwest*, no one is who they claim to be. Thornhill spends the first two-thirds of the film squarely on the back foot, caught off-balance just like the viewer, being led here and there by the nose, constantly learning and relearning that no one is honest.

In a shell game, you keep your hands moving to keep the audience distracted.

North by northwest is the route of the action, but the direction is less important than the fact that Thornhill keeps running, chasing others and being chased. The locations are constantly changing, each one distinctive from the last. The movie takes us from Manhattan to Long Island, then back to Manhattan, then to Chicago via train, then to a cornfield, then to an auction house, then to a Frank Lloyd Wright–style home, and at last to Mount Rushmore, with many more places in between. It pauses only for absurdities, as when Thornhill has to shave with a miniature razor, or when a crop-dusting plane changes course and swoops in, trying to kill him. The movie retraces its steps only once, so Hitchcock can show us another deception. When Thornhill drags the police and his mother to Townsend's

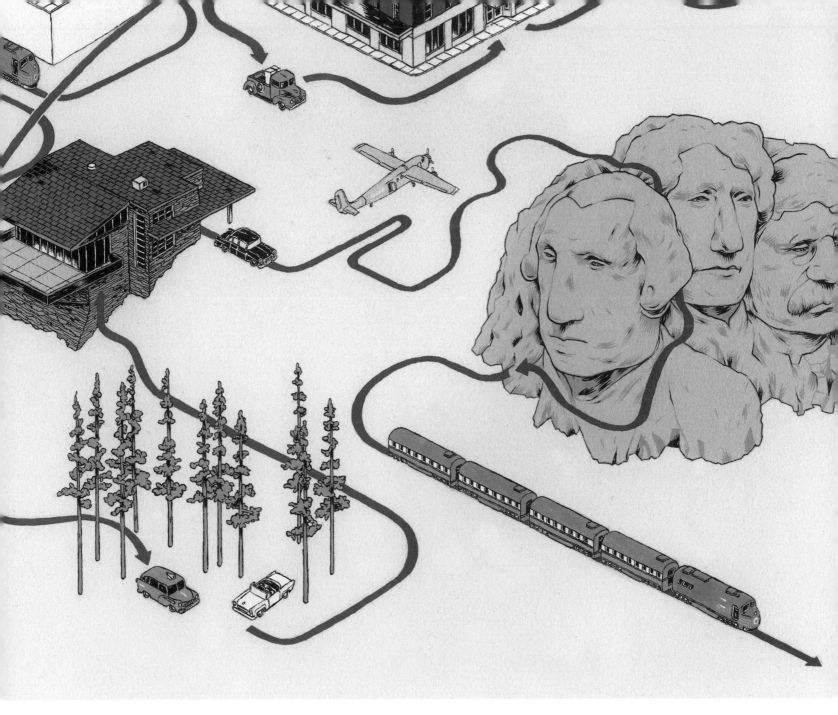

ADAM: According to Hollywood legend, Alfred Hitchcock toyed with calling the film *The Man in Lincoln's Nose*, and planned a scene in which Roger Thornhill, hiding in or under the sixteenth president's nose, gave away his hiding place by sneezing.

manor, he finds the place transformed: there's no bourbon stain on the sofa cushion, and the liquor cabinet holds books.

North by Northwest is a game of lies, with plot twists and turns and murders (both real and fake) performed in broad daylight. It's been copied a thousand times. As noted, it formed the basis for the modern action thriller, including the fifty-year-old James Bond movie franchise. Albert R. Broccoli and Harry Saltzman

supposedly cast Sean Connery as Bond because he resembled Cary Grant. In *From Russia with Love*, they created their own crop-dusting scene. This time, a dive-bombing and grenade-dropping helicopter attacks first a flower truck, then Bond as he scrambles across the Turkish landscape (in reality, Scotland).

Yet there is a crucial difference that, fittingly enough, has gone unobserved. Roger Thornhill was never a spy—he's an advertising executive who gets caught up in the adventure when he's mistaken for a spy who doesn't exist. The real secret agent is Eve Kendall, who isn't introduced until forty-five minutes into the film, and who isn't revealed as a government agent until the 100-minute mark. Just like Bond, she seduces Thornhill half out of desire, half because it furthers her mission. That leads

him to complain about how she treats him: that she uses sex "the same way some people use a flyswatter." Her boss retorts that she did what she had to—she was protecting herself from "exposure, assassination." She's only pretending to be the movie's femme fatale, just as she's only pretending to be the villain's mistress. That villain, Vandamm, gets distracted by the adman who's busily dodging planes and climbing in and out of windows. He chooses the wrong shell. The first James Bond to appear in the movies was a woman. •

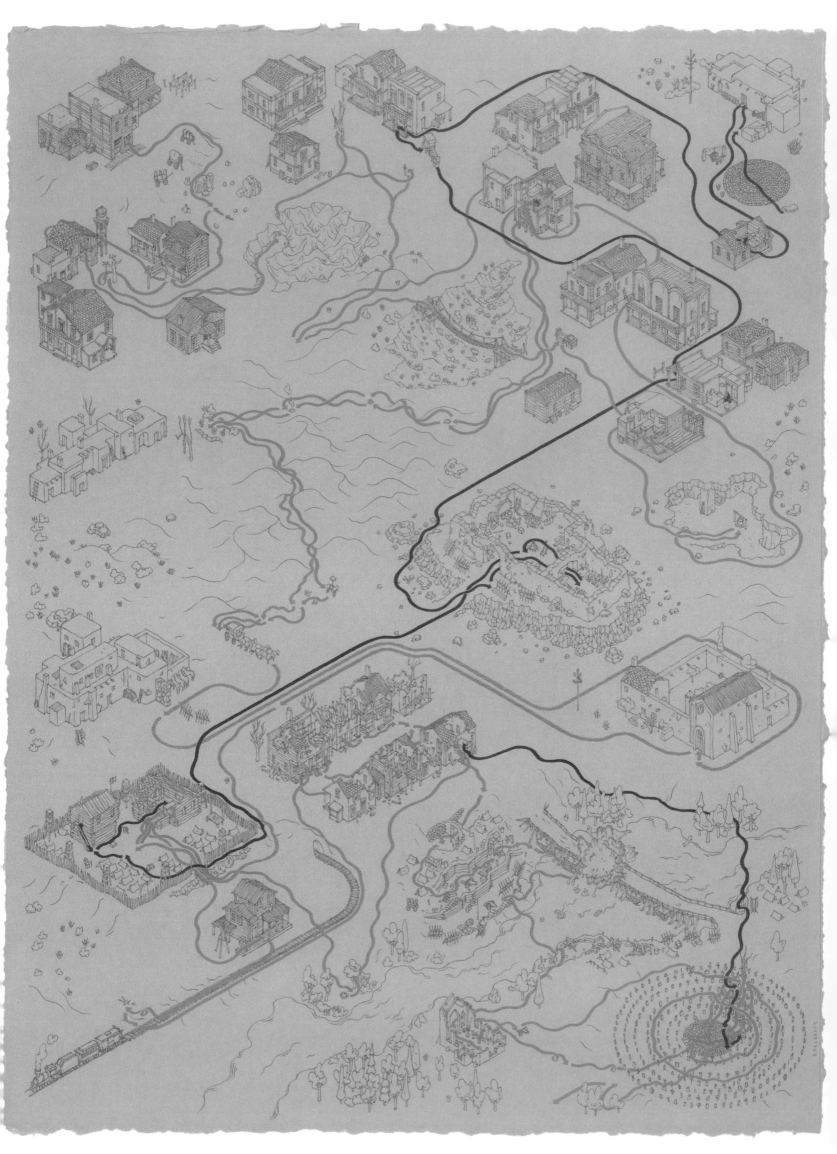

DIRECTED BY **Sergio Leone**

RELEASED IN **1966**

- ● **BLONDIE**
- ● **ANGEL EYES**
- ● **TUCO**

Paths of Blondie, Angel Eyes, and Tuco (2017)
Gouache and ink on paper
16½ x 22½ in (42 x 57 cm)

The greatest spaghetti western, arguably even the greatest western, *The Good, the Bad and the Ugly* sprawls across the cinema screen, opening with an onslaught, a title sequence made up of high-contrast photographs in duotone, a flurry of red and orange and green, as white silhouettes of men on horseback gallop past, getting blasted to smithereens. The title theme, meanwhile, features a whistle, a crying trumpet ("wah, wah, wah"), electric guitar, and a male chorus chanting. It's intense.

It is the story of three men (named in the title) desperately searching for buried treasure in the American Southwest. The Ugly, Tuco, is a bandit, wild-eyed, always crossing himself, a little mad. The Bad is Angel Eyes (Lee Van Cleef), a ruthless man with sunken cheeks who will do anything to survive and who, when paid, always sees the job through. The Good is Blondie (Clint Eastwood), the Man with No Name, still and taciturn, cool and minimal in his actions and his words, unfazed by anything. He regards the world and war warily, via a squint, his perpetual grimace exaggerated by the cigarillo protruding from the corner of his mouth.

Their tale is structured around raising stakes—fitting for the follow-up to *A Fistful of Dollars* and *For a Few Dollars More*. Angel Eyes shoots a man worth five hundred dollars, then one who's worth two times as much. Blondie saves Tuco, who's worth two thousand, and whose price increases to three thousand. After

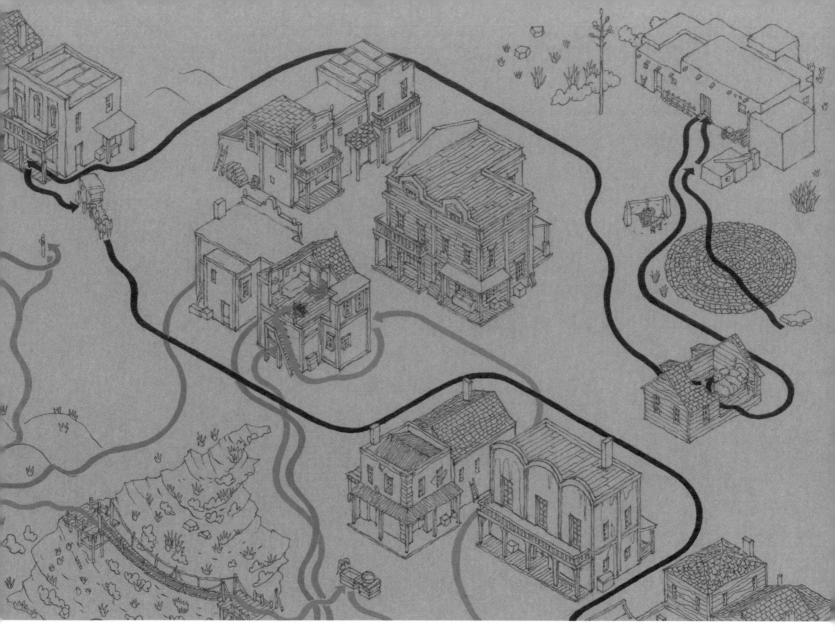

A WESTERN ON MARS (above)

DREW: Part of what makes this movie so transfixing is the "close but no cigar" landscape and architecture. Sure, there were a lot of Spanish-inspired buildings in the Southwest, but the ones in the film never feel quite right—which in a way is perfect. The movie feels like a western on Mars.

Blondie abandons him, Tuco enlists the help of three men for revenge, promising four thousand split four ways. Angel Eyes next appears with five others, in pursuit of the ultimate sum: two hundred thousand dollars in gold, a cashbox stolen by a one-eyed Confederate soldier named Bill Carson.

As it happens, Tuco and Blondie find Carson first, bleeding to death in a runaway carriage in the middle of the desert. The dying soldier tells each man one half of his secret, forcing them to work together. Just as in *Mad Max*, there are no true friendships, only temporary uneasy alliances wherein a man is worth whatever he can bring you, and the only constant is deception. The plot twists and turns through reversals of fortune and double-crosses: Tuco and Blondie pretend to be Rebels, only to wind up in a prisoner-of-war camp, where Angel Eyes is wearing a Union officer's uniform. Tuco, fidgety, sweaty, proves to be the trio's worst cheat, much too obvious in his lies, his inner nature bursting through. But he knows that artifice is just a means to an end, and that in this world there are two kinds of people: those with power and those without. The trick is always to come out on top. After killing a one-armed bounty hunter, he berates the dead man: "When you have to shoot, shoot! Don't talk!" Words are just a waste of breath.

The biggest deception is the landscape, one place pretending to be another, the American Southwest portrayed by Italy and Spain. Back in Hollywood, the westerns were in decline, giving way to cops and gangsters—in five years' time, Clint Eastwood would cash in the Man with No Name for Dirty Harry. But for now, Leone commanded the cinemascope screen, crafting his masterpiece, a parody of the genre and a satire on war. The result is episodic and existential, a precursor of *Apocalypse Now*. Leone lingers on the slaughter's grim realities: soldiers reduced to boiling corn cobs, and a shivering dying young man whom Blondie stops to lend him his coat. Tall and lean, a future pale rider, Blondie delivers a bitter judgment: "I've never seen so many men wasted so badly." Yet at the same time an air of unreality hangs over the proceedings: the locations look slightly off, European mountains looming in the backgrounds of shots. The uncanny spirit is amplified by the movie's dubbing, which is horrendous, producing an uneasy mixture of familiar and estranged.

THE TRIO (above)

DREW: The final showdown in the circular cemetery, between Tuco, Angel Eyes, and Blondie, is iconic, a gladiatorial arena attended by an audience of the dead.

The stakes keep rising, escalating. So does the war. It's 1862 and the Union Army is driving the Confederates before it, after the failed New Mexico Campaign. Matters come to a head at a bridge where both sides are stuck in a stalemate. Blondie and Tuco blow up the bridge as cannons fire all around them. When the explosions finally stop, they find they're the only survivors, the last two living in a landscape of the dead. The movie buries the corpses, shifting the action to a graveyard. Tuco is the first one to arrive, running pell-mell while Ennio Morricone's finest composition, "The Ecstasy of Gold," begins and swells, the camera deliriously spinning, the whole film spinning, all caught up in

Tuco's excitement, whirling with him until he finds the grave of Arch Stanton, where he thinks Carson buried the money. Inside that earthen plot lies the movie in miniature: men are money, money men. But this is just another deception, another one of Blondie's tricks—instead of money, there's a skeleton. The gold is really in the next tomb, marked UNKNOWN.

Rather than share it, the three men square off, a showdown inside a Roman circus (more of Italy peeking through). Leone builds the intensity to a fever pitch, to a whisker shy of absurdity. At last Blondie fires at Angel Eyes, knocking him into an open grave, then sending his hat tumbling after for good measure. He and Tuco divide the gold, one hundred thousand dollars apiece. But like the coyote whose cry is heard repeatedly on the soundtrack, Blondie reveals another trick, betraying Tuco, leaving the ugly man stuck in a noose, balanced precariously atop a wooden cross. This proves yet

another deception: Blondie rides off, then circles back, shooting Tuco free to land on his half of the loot.

The film's final mystery, however, belongs to Leone. Whose grave is the one with the gold, marked UNKNOWN? The director could pass off southern Europe for America, and his massive cast of extras for the Yanks and Johnny Reb. But there was one crucial aspect of 1862 that only absence could represent. His sign tells the truth: the grave belongs to all those poor folk unknown in the film, unseen and unmentioned, those whom Confederate dollars purchased. Men are money, money men. The empty grave at the end of *The Good, the Bad and the Ugly* isn't empty. It's full of slaves. •

MONTY PYTHON AND THE HOLY GRAIL

S cholars doubt King Arthur really lived, but if he did, it was in the fifth century or the sixth, and most definitely not in 932 A.D., as the Pythons take pains to tell us right up front. Of course that title card is a joke, a wry bit of fun that comes at the end of opening credits which include (among other things) a bunch of subtitles in mock Swedish ("Wi nøt trei a høliday in Sweden this yër?"), and many credits involving moose—or "møøse"—naming (for instance) who had the task of training one "to mix concrete and sign complicated insurance forms."

Yet what's most surprising about *Monty Python and the Holy Grail* is how much it gets *right*—how historically accurate it seems, in spirit if not in fact. Consider the witch-burning scene, in which a village mob decks out a poor girl in an obviously false nose, determined to "burn her, burn the witch!" The sham trial proceeds via inane logic: "There are ways of telling if she is a witch. . . . If she weighs the same as a duck, she's made of wood." This is an England of casual cruelty, where people strike streams with sticks and beat shrieking cats against wooden posts. Steam and smoke shroud a mucky landscape. A man pulls a cart full of corpses as peasants wallow: "There's some lovely filth down here!" King Arthur rides past, resplendent, prompting the observation: "He must be a king. . . . He hasn't got shit all over him." But soon even Arthur is being pelted with chickens and cabbages and cows, as well as unidentifiable liquids best left unidentified.

DIRECTED BY **Terry Jones and Terry Gilliam**

RELEASED IN **1975**

○ **KING ARTHUR**

● **SIR BEDEVERE**

● **SIR ROBIN**

● **SIR GALAHAD**

● **SIR LANCELOT**

● **TIM THE ENCHANTER**

● **THE OLD MAN FROM SCENE 24**

● **THE POLICE**

Paths of the Grail (2017)
Gouache and ink on paper
9 x 12 in (23 x 30 cm)

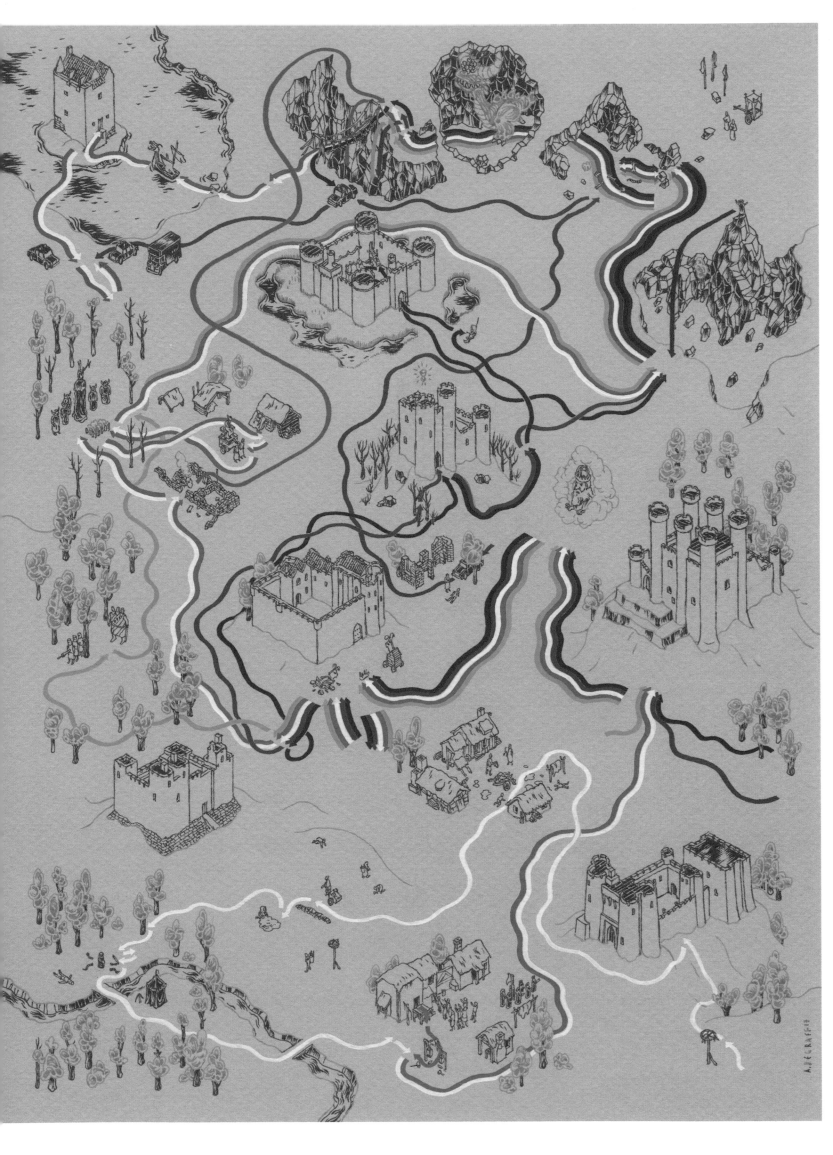

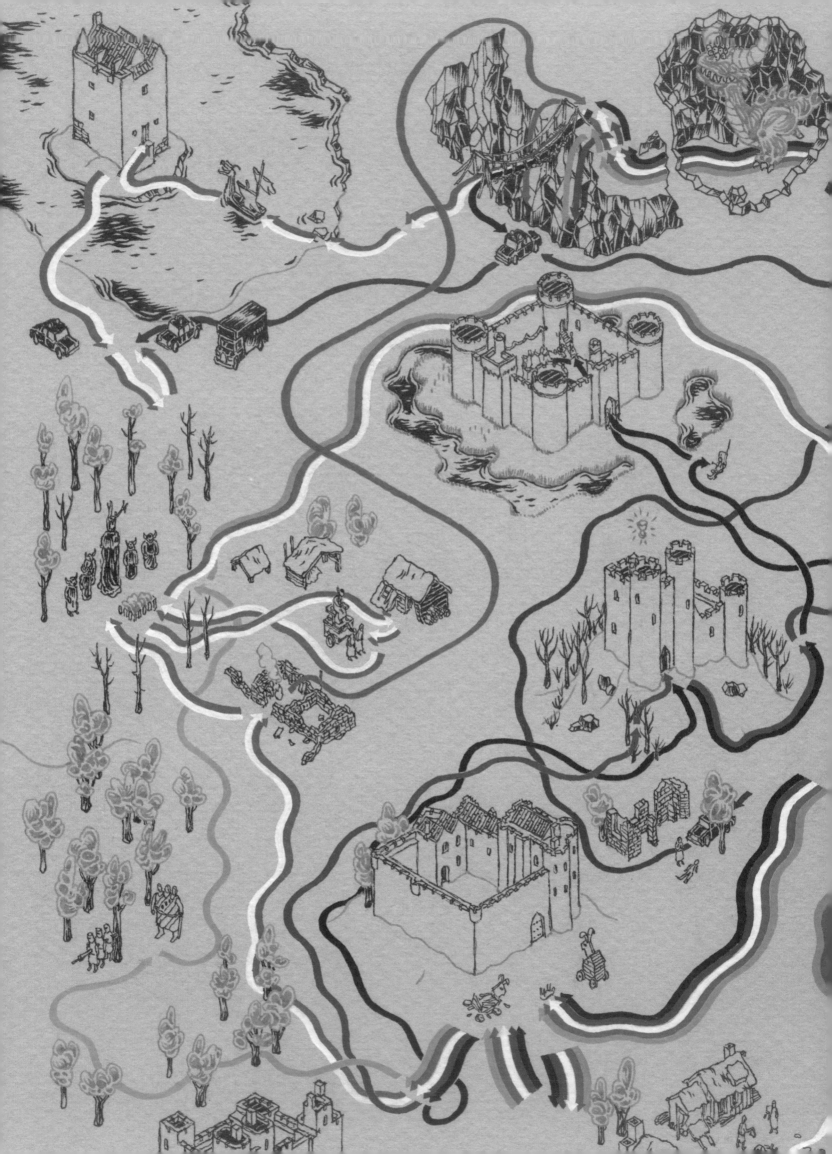

Here and there, the movie suggests that it is nonfiction. At times it's a history book, whose illuminated pages form the basis for several animated scenes. At other times it becomes a documentary film. Half an hour in, we're introduced to a "famous historian" who eagerly explains how, after his taunting by the French, Arthur ordered his knights on their separate ways. But before the bow-tied elder can fill us in on the details, he gets struck down by a passing knight. This isn't so much a historian's murder as it is the murder of history. But what version of Arthur did that guy intend to tell on the program *History for Schools*? The one with Merlin, and Morgan le Fay, and Excalibur, and the Lady of the Lake? Because none of that's true; it's all sheer fantasy passed down through the ages—"strange women lying in ponds, distributing swords"—and no more or less ridiculous than what the Pythons have up their grimy sleeves. It's also "no basis," as the commoner Dennis puts it, "for a system of government." But just try telling that to Arthur, who clearly believes every word of it and therefore tells everyone he meets he's King of the Britons, even if they don't have a clue what Britons are. Still, Arthur believes many crazy things, such as that he's riding about on horseback, while his trusty servant (fittingly named Patsy) scuttles behind him, banging together two coconut halves.

History is whatever gets written down. Brave Sir Robin was "unafraid to die / to be killed in nasty ways"—gruesome deaths that get spelled out in increasingly graphic detail. When he scampers away from a three-headed knight, the lyrics change: "When danger reared its ugly head / he bravely turned his tail and fled." (The offending minstrels, too honest, later get eaten.) After Lancelot storms a castle only to murder a wedding party, the father of the groom, sensing financial opportunity, brushes the matter under the rug: "Let's not bicker and argue about who killed who." With the historian dead, with history dead, the Pythons are free to play, striking down time-honored tales to invent new ones, told in a range of funny voices. Weirdness abounds: wicked knights say "Ni!" and the most feared creature in the realm is a killer rabbit with "big, pointy teeth." Others deny reality, like the Black Knight who cries, "It's just a flesh wound!" after losing his left arm. Above all else, *Holy Grail* is irreverent iconoclasm, "the Matter of Britain" turned on its head: bravery transformed into cowardice; science, superstition; logic and good sense, nonsense.

Still, some reason shines through the filth. The movie's ending sees Arthur reencounter Fytghtrench knights who claim possession of the Grail, which is only fitting, since a Frenchman, Chrétien de Troyes, introduced that sacred cup to the Arthur legend late in the 1200s, along with Lancelot and Guinevere (a lady conspicuous by her absence). As Arthur prepares to lead a charge in fulfillment of his destiny, the film transforms yet again, becoming a cinéma vérité documentary. The police show up and shut down the absurd goings-on, not unlike the colonel character Graham Chapman played on the Pythons' TV program, who interrupted whenever sketches got "too silly." One cop cuffs Arthur while another covers up the camera lens, recalling nothing so much as police arresting political demonstrators.

We might have forgotten this today, but the Pythons emerged from the counterculture, and they probably knew people who got beat up on camera. They also debuted in the midst of a long revival of interest in King Arthur. T. H. White's 1958 novel *The Once and Future King* inspired a quarter century's worth of works: the musical *Camelot* (1960), Disney's animated film *The Sword in the Stone* (1963), the live-action film adaptation *Camelot* (1967), Robert Bresson's *Lancelot du lac* (1974), Éric Rohmer's *Perceval le Gallois* (1978), and John Boorman's *Excalibur* (1981). So it's no coincidence that John F. Kennedy's 1,000 days in the White House were called "Camelot." But by 1974, JFK had been dead for over a decade, and the president in the White House when the Pythons started filming, on April 30, was Richard Nixon, whose name appears alongside the møøse in the opening credits. He promises viewers that the movie is only a fiction, with no intentional similarities to any actual persons or history. The same day the Pythons started filming, the White House released edited transcripts of the Nixon tapes to the House Judiciary Committee. Nine days later saw the start of impeachment hearings, in which the committee insisted on listening to the tapes. The Pythons wrapped their production on June 12, three days before the publication of Woodward and Bernstein's *All the President's Men*. On August 8, Nixon resigned. Monty Python, working in its own weird way, documented that historical fall from grace. Nixon is Arthur, and Arthur is Nixon—he's any authority figure, once and future, in need of bringing down. *Monty Python and the Holy Grail* is a movie made of lies, but it tells the truth. •

CASTLE AARGH

ADAM: Castle Aargh is really Castle Stalker, a well-preserved fortress in western Scotland. *Highlander*, *Braveheart*, and *Harry Potter* all followed the Pythons' lead and filmed scenes nearby.

ADAM: Even amid such squalor and slaughter, the Knights Who Say Ni retain a stereotypically British fastidiousness about landscaping, ordering King Arthur to bring them a shrubbery, then yet another shrubbery, arranged to produce "the two-level effect with a little path running down the middle."

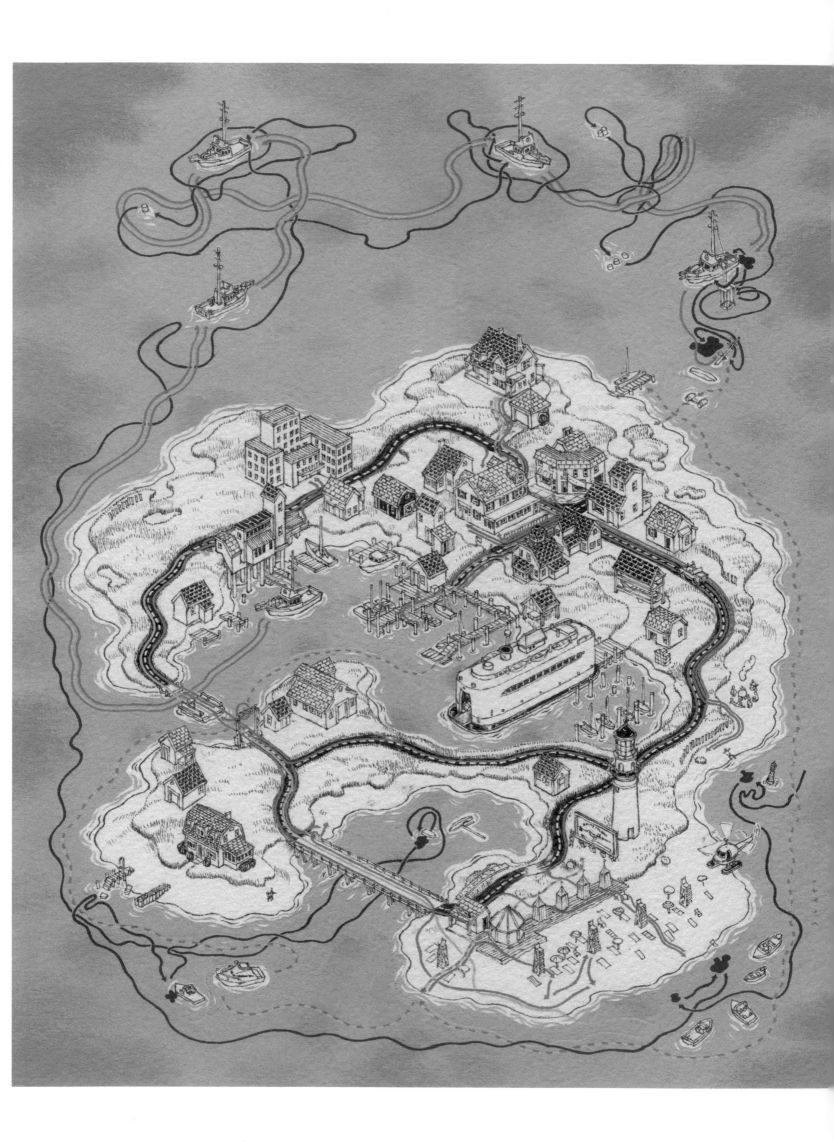

Jaws

DIRECTED BY **Steven Spielberg**

RELEASED IN **1975**

- ● MARTIN BRODY
- ● QUINT
- ● MATT HOOPER
- ● BRUCE (SHARK)

Paths of Amity (2014)
Ink and gouache on paper
8 x 10 in (20 x 25 cm)

It begins with a tracking shot: the camera roaming the ocean floor, prowling, pushing through beds of seaweed, John Williams's ominous score already doing its thing. We cut to naive teens on the beach, drinking and smoking, playing harmonica and guitar. Two lovers French-kiss before a fire, and already we're caught in the grips of Steven Spielberg's trademarked irony. With the exception of Alfred Hitchcock, has anyone had more fun making motion pictures? In every shot you can practically feel him behind the camera, mischievous, dreaming up some new way to thrill us. We track past the kissing teens to a young woman snacking on a crab leg. (Remember that.)

Another young woman, Chrissie, attracts the eye of a fella and dares him to chase her across the dunes. While he stumbles, she strips naked, diving cleanly into the water. She swims, pure elegance, raising her long left leg to heaven. Spielberg highlights the limb, beautiful and intact. Moments later, it's trapped in the title. The shark, felt but unseen—just like Spielberg—drags its victim every which way as her would-be beau passes out on the sand. The next day her body is found on the beach, the grisly remains obscured by sand and now a snack for (what else?) crabs. Her matted hair is like a tangle of seaweed, and Spielberg has returned us to where we started—which means now the film can really begin.

He never lets up. Chief Brody sits nervously on the beach, watching unsuspecting bathers. We're watching, too, wondering who

the next victim will be: The young couple with the dog? The middle-aged woman? The boy in the swim trunks the color of blood? The crowded deep-focus shots keep us guessing and scanning the frame—the same way that Brody, his senses heightened

THE LAND (below)

ADAM: The sea is always present in *Jaws*, even when we're on land—you can all but smell the brine. Beyond the fact that Amity is an island, its whole livelihood depends in one way or another on the Atlantic.

by what he's seen, keeps trying to peer past everyone, beyond the waves and into the deep. Just like us, he knows it's out there; just like us, he wants to jump up and shout, "For heaven's sake, get out of the water!" He can't, of course, because he's an outsider, a New Yorker, newly arrived and warned by the garishly suited mayor not to interfere with the tourist season. Amity Island, a summer town, needs its summer dollars.

What unfolds is a study in contrasts. The film's first half is set on dry land; the second out on open water. There are two boats: Hooper's high-tech marvel, equipped with the latest gear, versus Quint's leaky *Orca*. The crowds of the first sixty minutes disappear as we focus on three men, distinguished by their differences: the aquaphobe Brody, husband and father, who never learned how to swim; the rich young oceanographer Hooper, a college boy with "city hands"; and the grizzled sea dog Quint, a working-class vet and a drunk who scrapes chalkboards and bellows sea shanties.

Their mission is simple: kill the shark. The people of Amity Island have nothing to sell but access to their beaches. The shark shows up and threatens all of that; good nature, that which brings in the money, must be protected from the bad. Spielberg stages the battle via bursts of commotion followed by stretches of eerie calm, never letting us forget who's in control. With *Jaws*, he staked his claim to being the greatest director on the planet, beginning a marvelous run through at least *Jurassic Park*, a stretch of genius bookended by teeth.

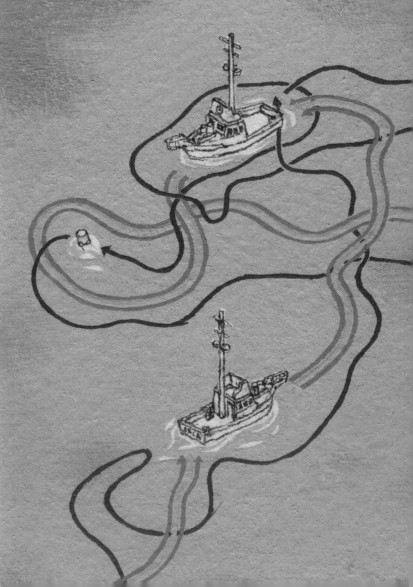

What makes *Jaws* scary forty years later—that is, what makes it *Jaws* and not *The Creature from the Black Lagoon*—is Spielberg's wise choice to keep the beastie out of sight. Instead, he displays its fearsome strength by having it drag docks and big yellow barrels. It helps that Amity feels so real. The characters live in bedrooms and kitchens that look lived in. And the sea is the actual sea, vast and threatening, concealing true threats. Furthermore, his heroes fumble. Nothing goes straight: Brody picks up the wrong telephone, awkwardly tips over jars of paintbrushes. Throughout his entire career, Spielberg has delighted in bringing characters to heel via something ancient, elements outside their control, whether it's extinct dinosaurs or biblical artifacts or great white sharks.

Jaws is fun through and through, unafraid to be silly at times. The premise was hokey and Spielberg knew it—hence all the winks, like the shot of the *Orca* framed through the bleached jaws of a shark, or the scene in which Brody's son mimics his dad at the dinner table. Or when Hooper slices open the tiger shark to find not just fish, but a crumpled tin can and a license plate. Yet in between are bits like Quint's monologue, which grows out of his scar-comparison contest with Hooper, as well as shots like the one of the severed leg, still sporting a sneaker, drifting to the seabed.

It's a perfect balance of preposterous and believable, goofy and scary. The shark hunts us and we hunt it back; a merry chase ensues, with limbs and ropes and harpoons flying all over as the shark, pure malevolence, gazes at us hungrily with its dead black doll-like eyes. First it circles the island, then the ship, before being destroyed in a mighty geyser of water and blood. The two survivors improvise a raft and paddle their way back to land, no doubt thinking of what an exciting tale they'll have for the Brody boys. The closing shot is of ocean waves gently lapping the seashore, carrying us back to where we started. In the end, *Jaws* is a ghost story, told round a fire. •

THE SEA (below)

ADAM: In the wild, orcas are capable of hunting and killing great white sharks. In *Jaws*, the crew of the *Orca* defeats the title beast, but only at the cost of the ship and its captain.

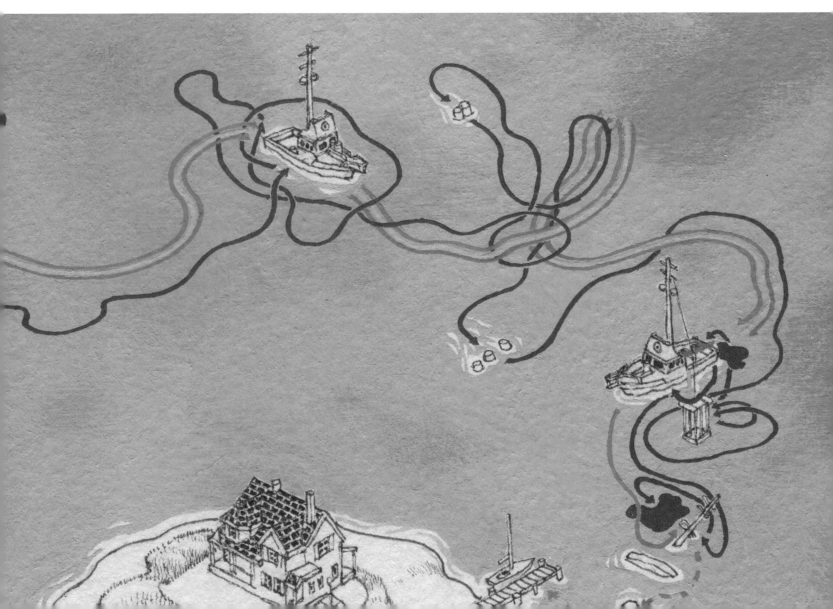

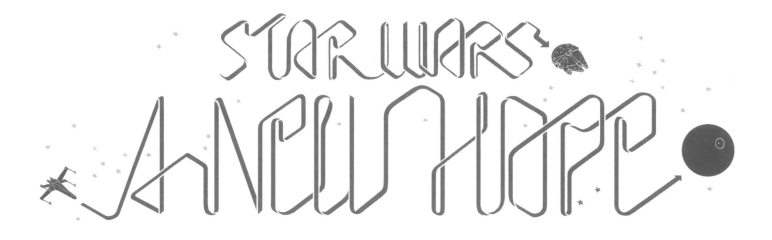

Long before Rey and Finn and BB-8, long before Jar Jar Binks and Padmé Amidala, long before Palpatine and the Ewoks and Boba Fett—long before Master Yoda, even—there was *Star Wars*, known only as *Star Wars*, pure and simple and straightforward.

Except that *Star Wars* has never been simple. Up close, things seem solid enough. A spaceship is a spaceship, and a lightsaber is a lightsaber. Blue milk is blue milk. Kick a rock and it doesn't budge. George Lucas traveled to Tunisia to shoot Luke's home planet, Tatooine, and to Guatemala for the Rebel hideout on the jungle moon Yavin 4. You can believe that R2-D2 and C-3PO, after they crash-land their escape pod, have to trudge through real canyons and endless sand dunes before getting picked up by the Jawas.

But take a few steps back and *Star Wars* goes hazy, becoming less literal, more metaphorical. Viewed through a squint, *Star Wars* looks more like the sci-fi movies of its time—big allegorical message movies like *Alphaville*, *Planet of the Apes*, *No Blade of Grass*, *Soylent Green*, *Logan's Run*. We know that Lucas admired those films. His first feature, *THX 1138*, is the tale of a man on the run from a dystopian underground society, where pharmaceuticals and religion are the opiates of the bald masses. The design of the Death Star is indebted to *2001: A Space Odyssey*, and Grand Moff Tarkin's meeting room recalls the war room in *Dr. Strangelove* (which was shot by Gilbert Taylor, the man who shot *Star Wars*). The two

DIRECTED BY **George Lucas**

RELEASED IN **1977**

- LUKE SKYWALKER
- PRINCESS LEIA ORGANA
- HAN SOLO
- CHEWBACCA
- DARTH VADER
- R2-D2
- C-3PO
- OBI-WAN KENOBI

Paths of Hope (2012)
Gouache on paper
18½ x 22 in (47 x 56 cm)

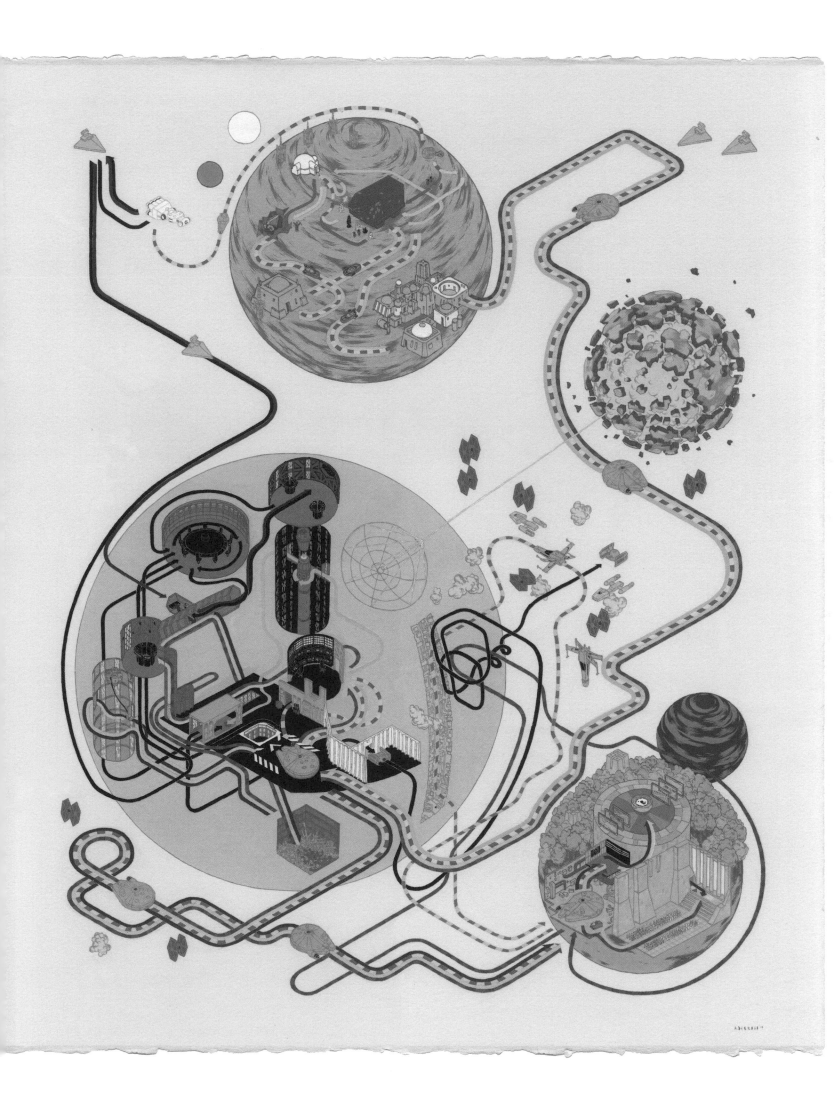

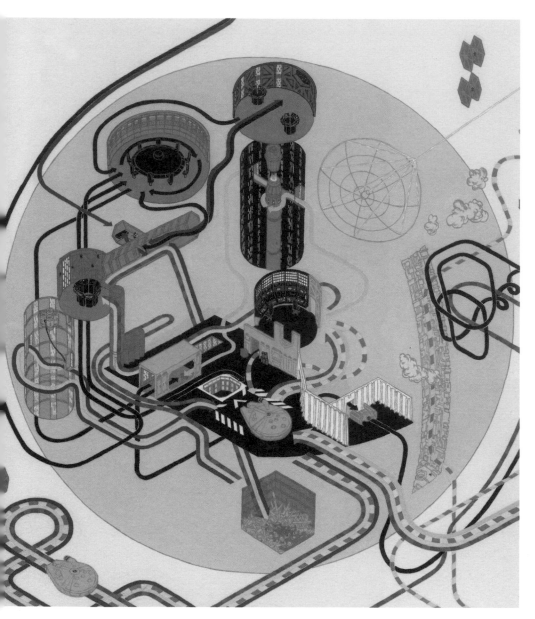

THE *DEATH STAR* (above)

DREW: The movement of characters is, at times, cramped. This film certainly asks you to use more of your imagination than the others, and it led to some finicky interior finagling in the Death Star.

droids, Artoo and Threepio, took inspiration from the lovable trio of robots that dogged Bruce Dern's heels in *Silent Running*. All of which is to say that even though many think *Star Wars* is just an action movie for kids both young and old, a means of shifting units of popcorn and plastic figurines and comic books and mountains of other merch, Lucas's love of moral messaging—made so obvious in his first films—remains on display. Consider the character names: Luke is for Lucas, of course, while Skywalker tells us where he wants to go, what he wants to do. Han

Solo prefers to be on his own, taking orders from just one person—himself (the exception being his pet walking carpet, Chewbacca). Darth Vader, stentorian and commanding, is an invader, stopping ships dead in their tracks and barging in. Porkins is porky. Greedo is greedy—green skinned, even. (He pays the price for his unchecked avarice.)

The geekiest *Star Wars* fans recoil from this kind of stuff, preferring that the movie be strictly realist. They want the rust and the carbon scoring, the grit and the grime, that allows them to dream they've hitched a ride on a passing moonbeam and flown to that galaxy far, far away, a long time ago, where they're now standing off to one side, watching history unfold. Droids and aliens shuffle past speaking foreign tongues, and monsters lurk around every corner. *Star Wars* is, in a word, otherworldly, and you don't need

the Force to see why it's inspired so many other authors to chip in, to contribute to Lucas's vision, expanding the saga in every conceivable dimension. They're right to complain that the more contrived stuff (then and now) gets in the way of their game of pretend.

But Lucas's tour de force has always been a blend of overt artifice and realism. Threepio, conked on the head early on, spends most of the film with a dent in his forehead—and such attention to detail is delightful. But at the same time the more contrived bits can't just be shoved down a garbage compactor. The settings, for instance, express how the central characters feel, working hand in glove with John Williams's romantic score. Luke is desperate, out of touch, a lonely child of the frontier, a teen from a backwater planet eager to fly away. That's why his home world is a desert, light years distant from the bright lights and action of the city (what he calls the universe's "bright center"). Meanwhile, the lord of the largest metropolis, Darth Vader, who has become "more machine than man," is a technocrat stalking the corridors of a sterile artificial planet. Obviously he embodies a fear of people being turned into computers; not for nothing does Obi-Wan urge Luke to switch his off. These settings embody the central conflict. Tatooine, "a desolate place," is like a junkyard where one makes do with hand-me-down droids, whereas the Death Star, antiseptic and shiny, is home to the latest tech—it *is* the latest tech. Luke comes to reject both places in favor of the Rebellion, a new hope that has set up shop in a temple amid a jungle lush and verdant.

Just like the *Millennium Falcon* (a "bucket of bolts," "the fastest hunk of junk in the galaxy"), and just like the battered and banged-up droids (C-3PO's lower right leg is silver, not gold), *Star Wars* is jury-rigged, cobbled together, greater than the sum of its parts. It doesn't always make perfect sense. Leia speaks with an occasional British accent. Biggs, Luke's best friend from back home, pops up suddenly during the trench run, having been cut out of most of the picture. Lucas, who famously wrestled for years with writing the screenplay, was clearly still figuring everything out right up till the end.

It doesn't matter because Luke, our surrogate, spends a lot of the film confused, in way over his head. Stray references whiz past—the Old Republic, the Senate, the Emperor, the spice mines of Kessel, the Clone Wars, Jabba. Luke struggles to keep up, to learn as much as he can from Ben, to become a Jedi like the father he never knew, even if what a Jedi is ain't exactly clear. Or what the Force is, for that matter. It's an energy field produced by living beings, involving feelings, and it can be with people or not . . . and it can be used, which involves letting go? A great deal is left to the viewer's imagination. It works because, like Luke, we get swept up in it, carried along on a great adventure.

Lucas made *Star Wars* because he wanted to redo *Flash Gordon*, but make it "good." It was a passion project, rooted in nostalgia for his childhood. By the time he got to work, however, his notion of good was complex—like Han, he could "imagine quite a bit"—and so he built *Star Wars* from every film that influenced him, from *The Wizard of Oz* to John Ford to Fritz Lang, from World War II flying movies to Akira Kurosawa to Jean-Luc Godard. That's why its galaxy is so crowded, spilling out in all directions; it's also why the tone is so exuberant, so infectious. Realist, expressionist, allegorical, arty, popular—*Star Wars* is Lucas's masterful tribute to them all. •

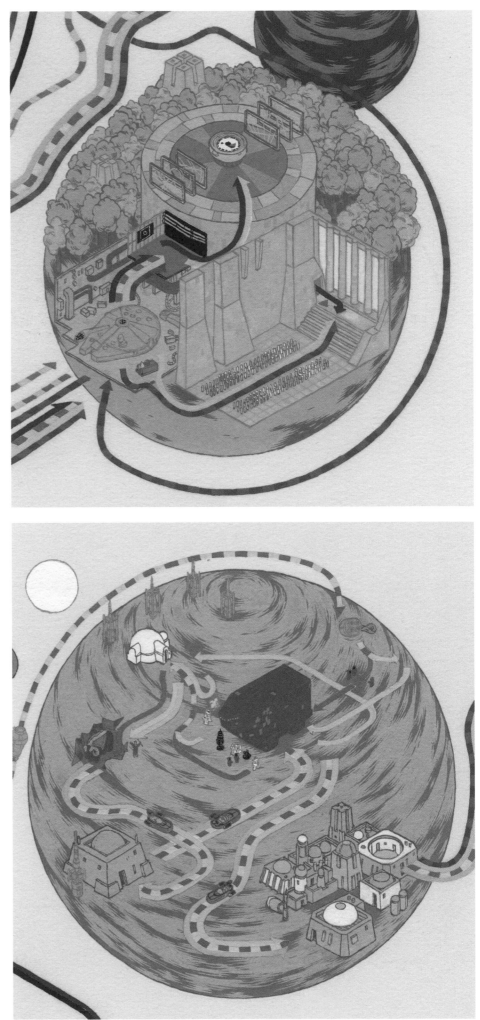

YAVIN 4 (top right)
ADAM: The ending of *Star Wars* gestures toward the beginning of *Raiders of the Lost Ark*, both films allowing George Lucas to indulge his fondness for ancient temples concealed by dense jungles.

GOING NOWHERE (bottom right)
ADAM: This is the scope of Luke's little world at the start of the film—a dirty, dusty place he rightly calls "nowhere," bordered by desert. Not pictured: Luke's sole refuge, Tosche Station, where he hung out with Biggs and his other friends, tinkering with his landspeeder. (Lucas cut the single scene set there from the film.)

ALIEN

DIRECTED BY Ridley Scott

RELEASED IN 1979

○ RIPLEY

● DALLAS

● LAMBERT

● BRETT

● KANE

● ASH

● PARKER

● THE ALIEN

● JONES

Paths of the Nostromo (2014)
Gouache on paper
8 x 10 in (20 x 25 cm)

Once the alien is out and on the loose, it sneaks around by means of the ship's vents—the secret spaces of the *Nostromo* where the crew never goes, never even thinks about. And right before that, of course, it snuck down poor Kane's throat and grew inside him. What is *Alien* about, then, if not interiors— spaces not outer, but inner? We are our bodies and yet our insides are mostly mysteries, just like vast stretches of the buildings that we live in. Is something growing inside the walls, slowly wrapping around the pipes? In our daily lives we deal with surfaces, which is why we feel such dread that something's going wrong underneath. Here's hoping the food we slide down our gullets won't come back to harm us, isn't nourishing something monstrous. Here's squeezing our eyes shut and praying that cancer or fungi or insects aren't growing, spreading, transforming, to someday emerge, catastrophic. Despite our culture and our machines, we're still only prisoners of nature, a species that dwells in cities infested with cockroaches and rats. Even our spaceships will have this problem. Why else would the crew of the *Nostromo* keep a cat?

That's what unnerves me to this day about Ridley Scott's original *Alien*, though its sequels have never scared me. James Cameron's *Aliens* is delightful in many ways, but its fundamental flaw is that its monsters don't need to be Xenomorphs. They function more like an enemy army. The space marines land and attack them, fail, and retreat. The aliens counterattack, and the space

marines retreat. Then Ripley sneaks behind enemy lines to rescue Newt. And all this happened because some colonists set up shop too close to a cache of leathery eggs. The solution, just as in *The Shining*, seems to be "build somewhere else."

But in *Alien*, there's no other place to build, no other place that one can escape to, because the threat is always internal, lurking inside the bodies and structures we call home. Not for nothing is the ship's computer named Mother, even as the bulk of the craft is a mess of pipes and steam. The best you can do is buy yourself a bit of comfort. The poorer employees, Parker and Brett, are tasked with repair work on the dingier lower decks, while the commissioned officers stick to the brighter parts. But the dark is still there.

The truer sequel to *Alien* is, appropriately enough, Ridley Scott's next movie, *Blade Runner*, similarly obsessed with what's inside. Is Deckard replicant or human? In the three years since *Alien*, it got a lot harder to tell. *Alien*'s Ash, like Deckard's nemesis Roy Batty, was a secret machine that passed the Turing test and lived and worked and ate alongside humans. But once cut open, you could see his guts were fake—milk and plastic tubes and marbles. Batty and his gang, however, looked like us within and without and could be detected only by their lack of empathy. And waiting behind *them* was yet another generation of robots, Rachael (and presumably Deckard), programmed to think that their feelings and memories were real.

Ash, then, was an earlier replicant. How might he respond to the Voight-Kampff test? We get a clue when he chooses to let the landing party back aboard, after Kane has been brought down, an alien spider-thing hugging his face. Ripley insists that everyone follow quarantine procedures, but Ash disobeys her and pops open the hatch. Why? Not, as he tells Ripley, out of sympathy for Kane, but because he's fascinated by Kane's attacker, a "tough little son of a bitch." He knows from his conversations with Mother—including a special order intended for his eyes only—that it's "a perfect organism," "a survivor unclouded by conscience, remorse, or delusions of morality."

The alien is pure malevolence, but it isn't humanity's replacement. Instead, it's Ash's—the android still feels something for his crewmates, his last words expressing sympathy. The Xenomorph is one step beyond that. Like the Tyrell Corporation's replicants—trained for "murder squads" or as "basic pleasure models"—the Xenomorphs were created to do work that no one would do on far-off worlds. Ripley intuits that straightaway, as well as the fact that her company wants the beast as a weapon. (It will obsolete space marines.) But that realization, oddly enough, links her with the monster who's hunting her: like all employees, she and her crewmates are of secondary importance. (Replicants who rebel and return to Earth are retired.)

So the scary thing about the aliens is their structural importance. They need us—but we also need them. Our very existence depends on them being out there, doing their terrible work. They're not just monsters under the bed or in the closet, waiting to gobble us up; they're something symbiotic. This is why Giger made them a fusion of flesh and machine, gunmetal gray and able to camouflage themselves amid pistons and pipes. They are cogs in the machine, part of the infrastructure we live in. They can't be cut out. The best we can do is look away, focus on other parts of the landscape, misty and blue. Out of sight is out of mind. •

THE *NOSTROMO* (opposite, top)
ADAM: The alien spaceship on LV-426, with its cargo of deadly eggs, resembles an upside-down horseshoe: bad luck. The *Nostromo*, by contrast, is a city floating through space. It's Metropolis, complete with upper and lower decks, the crew still chained to machines (which by now have become computers).

SPACE AS ART AND GRIT (below)

DREW: *Alien* remains one of my favorite art-directed movies. Ridley Scott's "working class" in space, mixing the influence of Ron Cobb and Giger—it has a beautiful earthy grit. I completed this painting as a mini-map, and someday I'd like to return to it and do all those great hyperactive interiors. The result would be a huge painting.

THE SHINING

For nearly nine months each year—October through mid-May—the Overlook Hotel is cut off from the rest of creation by the elements. It's too costly, we're told, to clear the snow on the twenty-five-mile-long stretch of mountain road that leads to the place. That winding road is the first thing we see, in a series of gliding aerial shots that serenely dissolve into one another as ominous music plays ("Dies Irae," of all things) and the film's titles smoothly and unnervingly slide upward. Far below us, small as an ant, hums the Torrance family car, as pitiful Jack makes good time driving toward his interview and his fate. He's hoping to land the job but even before he arrives he already has the job. As Grady will tell him in the middle of winter in the bathroom: "You are the caretaker. You've *always* been the caretaker." As for us, even before we arrive at the hotel we're already overlooking, watching from on high.

On closing day, over a dish of chocolate ice cream in the hotel's kitchen, departing head chef Dick Halloran explains to Danny (and to us) that, just like some people, certain places have the ability to shine. When someone burns toast, that leaves a trace. When something bad happens, that leaves a trace, too, although not everyone can sense it. Shining collapses time, flooding past and future into the present. It also shrinks distance. When Danny, riding his tricycle through the carpeted halls, stops outside and then enters Room 237, and nearly gets strangled to death by a

DIRECTED BY **Stanley Kubrick**
RELEASED IN **1980**

- JACK TORRANCE
- WENDY TORRANCE
- DANNY TORRANCE
- DICK HALLORANN
- STUART ULLMAN
- BILL WATSON

Paths of the Torrances (2014)
Gouache on paper
16 x 19 in (41 x 48 cm)

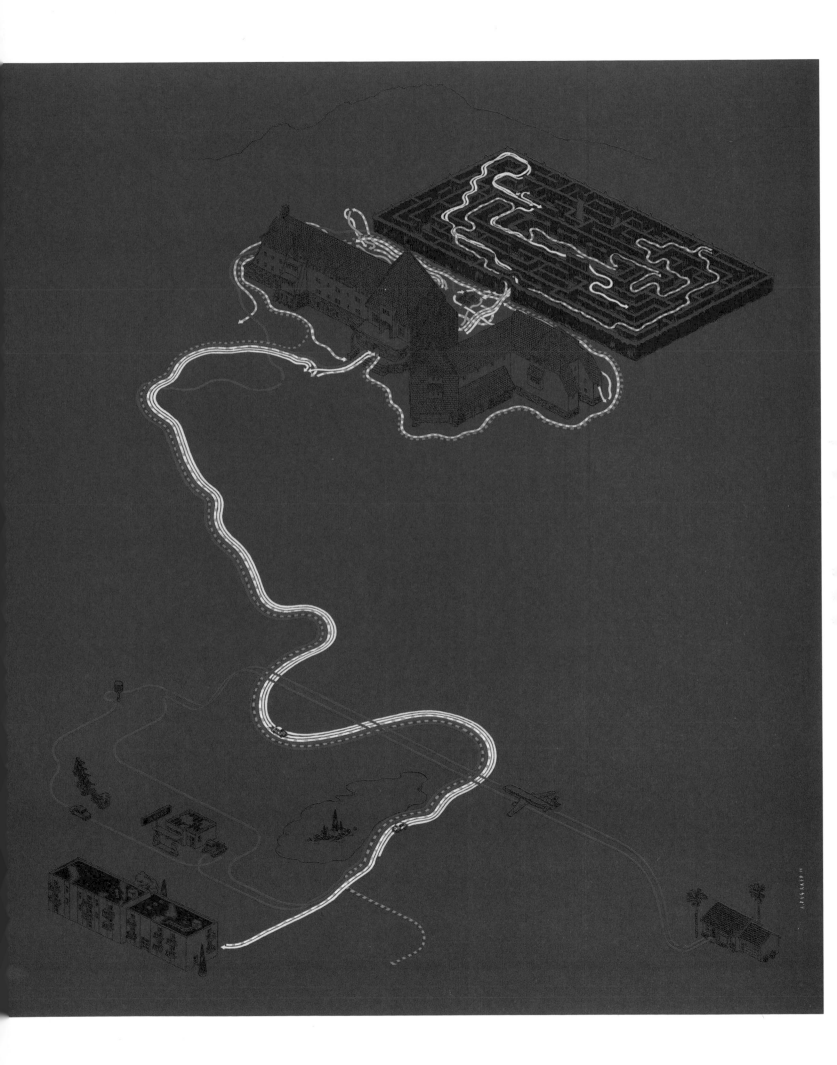

ghost, Hallorann, lounging on his bed in hot sunny Florida, knows what's transpiring—the same way he and Danny know that the Overlook Hotel, scenic and charming, is stained through and through by transgressions past. Shining, then, is like cinema; in particular, it's like cross-cutting, which unites scenes set in different times and places. Kubrick uses crosscuts to represent it: little flashes of the future. Other crosscuts are presented as lengthy dissolves, during which we see two places and times superimposed. (The film's called *The Shining* because that's what it does.)

Both shining and *The Shining* are means of bringing to light what would otherwise go unnoticed—what is impossible to notice. Dutifully brushing his teeth in Boulder, Danny is given a vision by Tony, the shy little boy who lives in his mouth, of what will happen when he arrives at the Overlook—what happens much later in the movie. And already other distant actions, done months ago in distant places, are haunting the present. Before the film starts, Jack dislocates little Danny's shoulder, then repents and swears off drinking—but we see the lingering effects, the strain that what Wendy calls an accident has put on him and his family. And before the jet set—"all the best people"—stayed and played at the Overlook, it was an Indian burial ground, defended (unsuccessfully) during the hotel's construction by natives no longer living there.

How many corpses are under the floorboards? And what does Jack sense? Why does the burnt toast choose to possess him? Midway through the picture, he shares our opening godlike view. Going mad, he peers at a model of the hotel's famous hedge maze and sees his wife and son gaily strolling within its labyrinthine confines. Small as ants, flanked by rows of vegetation, they echo the Volkswagen straining up the mountain road.

That road was really in Montana, not Colorado. And the Overlook we see in the finished film was not a real location but a fake, constructed at Elstree Studios, in England. Surely it's one of the greatest feats of production design in all of cinema. Kubrick insisted the sets be built on multiple soundstages, spreading out so he could shoot his film scene by scene. Production ran long and held up the filming of *Star Wars Episode V: The Empire Strikes Back*. That crew could get to work constructing Bespin and Hoth only when Kubrick, the famous perfectionist, called it quits. It's a hell of a thing: the two best movies of 1980 were filmed in the same place, back to back. What's more, while Kubrick was still filming, still calling for hundreds of takes, a soundstage caught fire, slowing his production even further. It was one of the unhappy Grady girls, I think, who did it, after getting her little hands on a matchbook.

Her father corrected her, and the set and soundstage were rebuilt. But the odor of charred wood and singed carpet never went away. Luke Skywalker, not yet a Jedi but strong with the Force, sensed it upon arrival on Dagobah. "Something's not right here," he said, having suddenly gone cold. "That place is strong," his master told him, "with the Dark Side of the Force." He waved his stick. And were the camera to follow that gesture, pushing past vines and snakes to slip inside the cavern, what would it find? You've sensed it, too: a black-and-white photograph on the far wall, depicting a younger, heartier Yoda, blowing a party horn at the Fourth of July Ball in 1921. Beside him, Jack Torrance, the past and future caretaker, dapper in his tuxedo, always there, kneels with his arms outspread, grinning madly. •

THE OVERLOOK

ADAM: The Overlook Hotel is a place of great abundance: before departing, Dick Hallorann regales Wendy with all the foods that her family can eat. I'm reminded of *Home Alone*, or *Dawn of the Dead*—fantasies of having everything at the cost of being all alone in the world. Later, Wendy brains Jack, then locks him in one of the storerooms with all those foods... so be careful what you wish for.

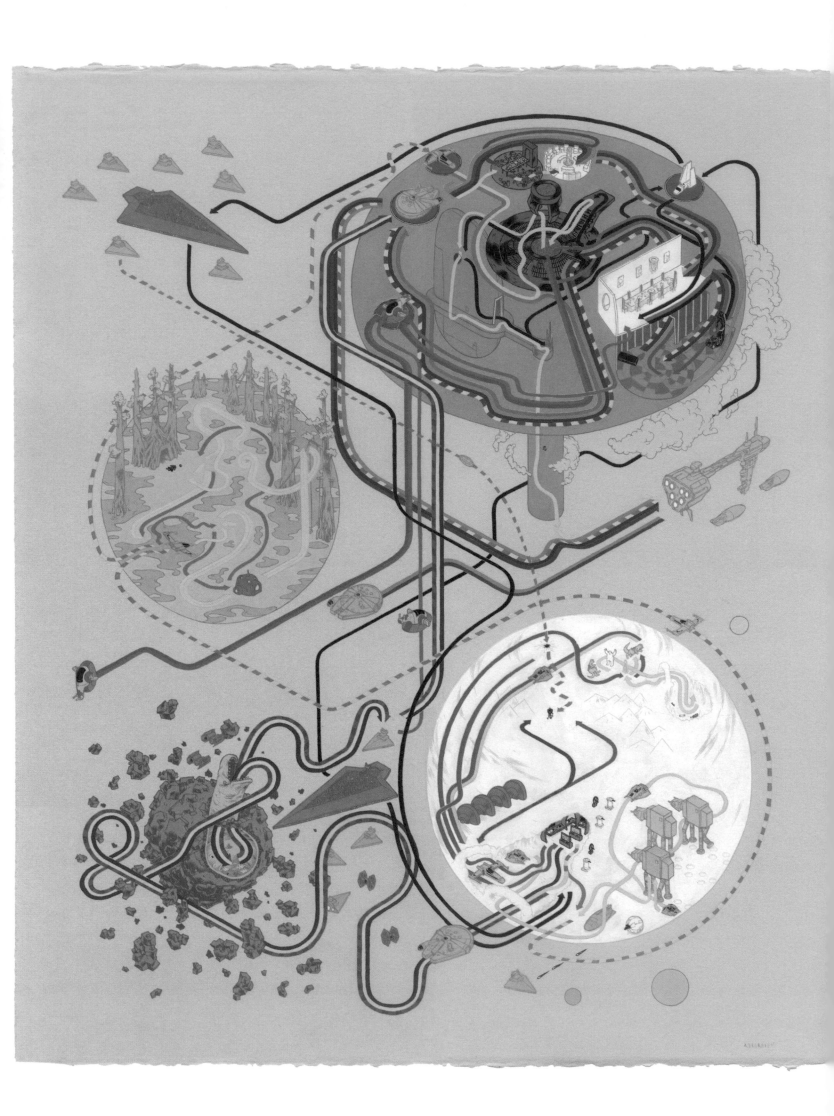

THE EMPIRE STRIKES BACK

DIRECTED BY **Irvin Kershner**

RELEASED IN **1980**

- LUKE SKYWALKER
- PRINCESS LEIA ORGANA
- HAN SOLO
- CHEWBACCA
- DARTH VADER
- YODA
- R2-D2
- C-3PO
- LANDO CALRISSIAN
- BOBA FETT

Paths of Empire (2014)
Gouache on paper
18½ x 22 in (47 x 56 cm)

Right from the get-go, off kilter everything is. The Rebels find themselves on the back foot, fleeing before Lord Vader's forces. Hoth, their icy, barren snowball of a base, is bombarded with meteorites. Its narrow, crooked caverns tremble, then crumble, with chunks of ice pelting Artoo as the elephantine Imperial walkers advance. And once Han and Leia et al. escape, the Imperial Fleet is in fierce pursuit, barraging their ship with laser fire. Han sets down inside an asteroid that possibly isn't entirely stable, then falls for Leia, who falls for him. Everything's falling, coming apart. The gang splits up; Luke follows his own path, just as Obi-Wan did on the Death Star, striking out in search of Yoda, a Jedi Master. He spends a lot of the film getting beat up, not to mention upside down: he's hung up by a yeti, does handstands with Yoda, and finally dangles from a weather vane at the bottom of Cloud City. The rest of the time he's tumbling down snowbanks, getting his hand lopped off, toppling over as he tries to balance Yoda, stones, Artoo. His X-Wing, mired in a swamp, sinks even further. All is despair.

Nothing is what it appears to be. The Rebels are hiding underground. The *Falcon* ("What a piece of junk!") escapes by imitating garbage. Yoda leads Luke on for a while, stealing his lamp and nibbling his supper, pretending to be a mischievous scamp. What seems like a tunnel in an asteroid turns out to be a space worm's gullet. And Bespin, Cloud City, supposedly peaceful, and outside

the purview of the Empire, proves to be a trap—not once, but twice—as Lando, all smiles and hugs in his beautiful blue-gold cape, signs what he thinks will be a fair deal with Lord Vader. Which Vader immediately starts changing.

Dark and moody, it's the trickiest of the three films. The cinematographer, Peter Suschitzky, casts the foregrounds into shadow, creating silhouettes in front of saturated backgrounds. No matter where the characters go, they're frequently backlit. *Empire* is epic, romantic, Wagnerian. Where the first *Star Wars* ran hot, its sequel runs cold, favoring glaciers over desert, beginning and ending with people freezing. It's also less arid. Water is everywhere—Luke, a former moisture farmer, is now surrounded by the stuff. You could call it more atmospheric. Even space seems damp and moist. Inside the asteroid, bat-like creatures ("mynocks") glide eerily out of the dark to chew on the *Falcon*'s power cables. Han and Leia step outside to clean them off, wearing oxygen masks but no other protective gear—a depiction of space reminiscent of George Méliès's silent classic *A Voyage to the Moon*. (They learn, to their horror, that they're inside the massive worm.) "It's like something out of a dream," Luke says. He means a nightmare. We're privy to one of his fantasies, a vision in which he squares off against Vader, who when beheaded is wearing Luke's face. (This is the only *Star Wars* film to feature slow-motion.)

Some say that nothing happens in it, but they're wrong. A great deal happens; it's just that no one gets what they want. There is a sense that time isn't passing. Moments echo: the leathery myncocks mirror the bats on Dagobah; Chewie hauls Threepio in a backpack the same way Luke carries Master Yoda. The yeti-like Wampa loses an arm, Luke a hand. Things keep failing: bodies, machines. R2 gets swallowed by a swamp snake, then spat up. Onshore, he vomits brackish water. Leia and Han take refuge at Bespin, an art deco city that keeps changing colors. Threepio's ambushed, disappears. Time breaks down further: surely Luke spends longer on Dagobah, climbing vines and leaping over rocks with Yoda, than Han and Leia do on the run and schmoozing with Lando. Uncertain the future is, Yoda tells us—but

uncertain everything is. C-3PO winds up in a junk pile, then gets jumbled up in a box. Luke, impatient, bumps his head in Yoda's hut. Bespin is evacuated. Darth Vader chokes his way through a series of underlings. Our heroes get tortured, but no one asks them any questions. Even the Emperor feels a disturbance in the Force.

The Empire Strikes Back retcons *Star Wars*, rewriting the first film, taking away things we thought we knew. It turns out that Obi-Wan, that trustworthy bearded gentleman, lied to Luke: Darth Vader didn't murder Luke's father, Anakin Skywalker; Anakin Skywalker *is* Darth Vader. Now that ominous man wants to summon Luke to his side to rule the galaxy together as father and son. "If only you knew," he intones, his gloved hand clenching the air, "the power of the Dark Side!" Luke screams in denial, wind howling around him as he presses his cauterized wrist against his chest—but the scales are falling from his eyes. The epic of *Star Wars* is revealed to be courtly drama, a family affair. At last Luke knows who he really is: the true heir, a prince disguised as a pauper. Unable to handle the weight of this knowledge, he chooses to fall, to be destroyed. But dying doesn't come so easily. The city saves him, catching him inside a tube. A trapdoor opens below. He falls again. His grief knows no bottom. He clings to the weather vane, calling to Ben, who doesn't reply. So he calls to Leia. Only then do things start going right. The Princess hears him, orders the *Falcon* to double back. And for the first time in the film, we see someone rise: Lando, standing on a platform, into white light. He catches Luke, brings the youngster inside the ship, back into his circle of companions. Artoo repairs the *Falcon*'s hyperdrive, and our heroes leap out of sight. Darth Vader, watching from his command ship, does a

BESPIN (right)

ADAM: References to *The Wizard of Oz* run throughout the *Star Wars* trilogy. The Emerald City memorably contains a horse of a different color, a mare that keeps changing hues. In *The Empire Strikes Back*, George Lucas borrowed the horse and mapped it onto the city in the clouds, Bespin, which keeps changing colors.

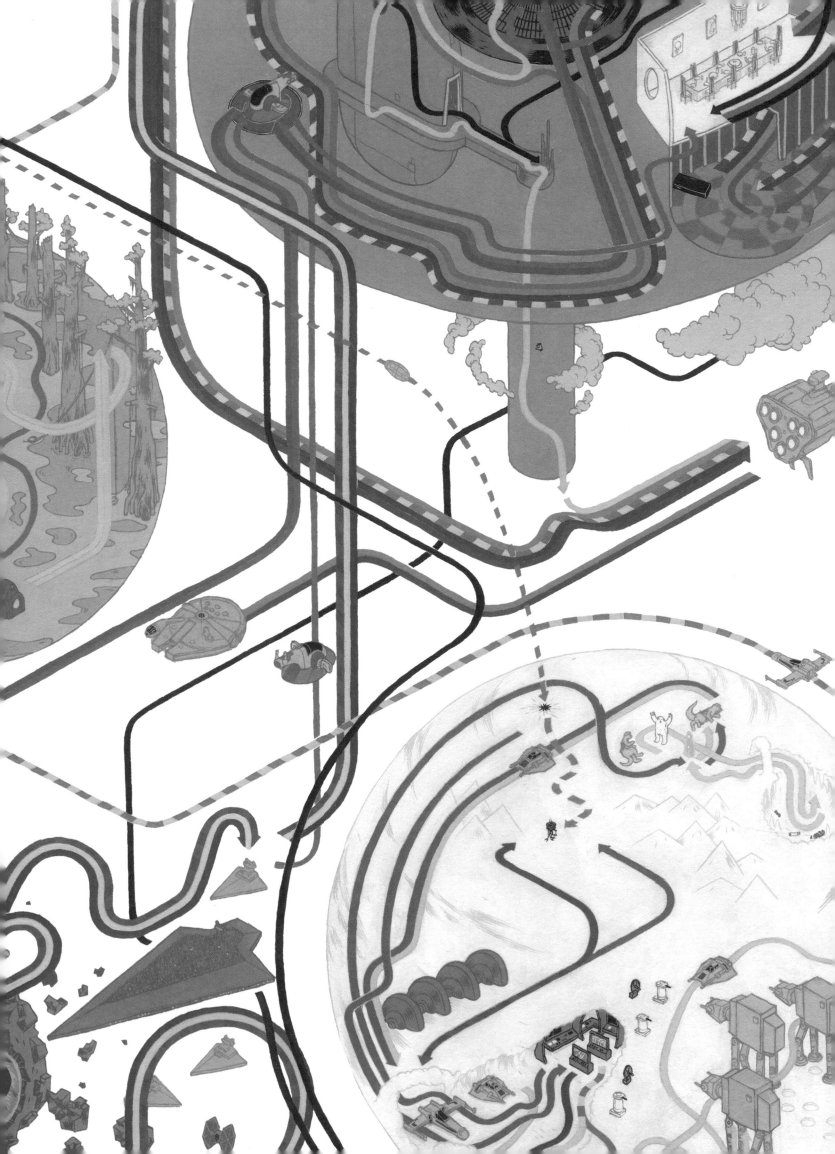

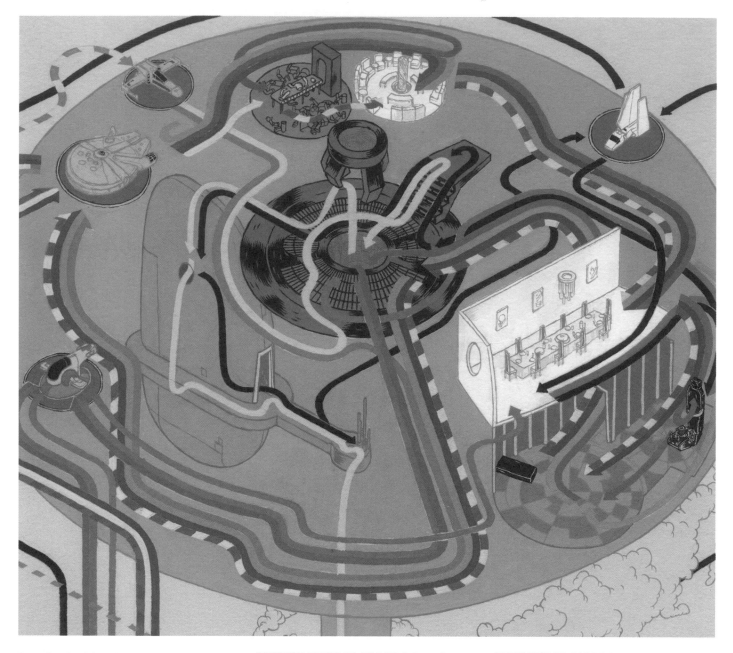

lengthy double take, staring sullenly into space. What's on that brooding dark Jedi's mind? We don't learn; he turns and quietly strides off screen, his minions cowering beneath him.

From there, things stabilize. Luke gets a replacement hand, and the Rebel Alliance steadies itself and regroups. We realize the film has brought us full circle, having been structured around an inversion. In the first shot, a Star Destroyer launches probes as Vader scours the galaxy, looking for Luke. Now, at the end, Luke and Leia stare out a window, his arm around her, all the galaxy before them. As Lando and Chewie fly away, Leia is wondering where Boba Fett has taken Han, while Luke is thinking about Vader. This penultimate shot reverses not only the start of the film, but also the ending of *Star Wars*: Luke and Leia,

SUBWAY MAPS IN SPACE (above)

DREW: These paintings were definitely inspired by Massimo Vignelli's New York City subway-map design: I wanted them to feel clean, geometric, and basically neutral, with lines creating the flash of color. Lucas's retelling of the knight's tale and the hero's journey is also archetypally comforting and so rooted in friendship and destiny that the "rules" governing the *Star Wars* maps seemed to write themselves.

joined by the droids, form an incomplete portrait, their backs turned toward us, looking determined and grim instead of grinning in triumph. The film has depicted its title's promise: retaliation. They've weathered the blow. The silver lining in the ending, *Empire*'s new hope, is that the Rebellion is still standing. •

HOTH UNDER SIEGE (opposite)

ADAM: The Rebel base on Hoth falls after being besieged by the AT-ATs, mechanical elephants that lumber slowly but ominously across the frozen landscape, crunching snow and ice beneath iron feet. I'll bet that Lucas was inspired by the Second Punic War, in which Hannibal famously marched his elephants across the snowy Alps, into Italy. After all, Lucas filmed some of *Star Wars* in Tunisia, which a long time ago was none other than Carthage, Hannibal's home.

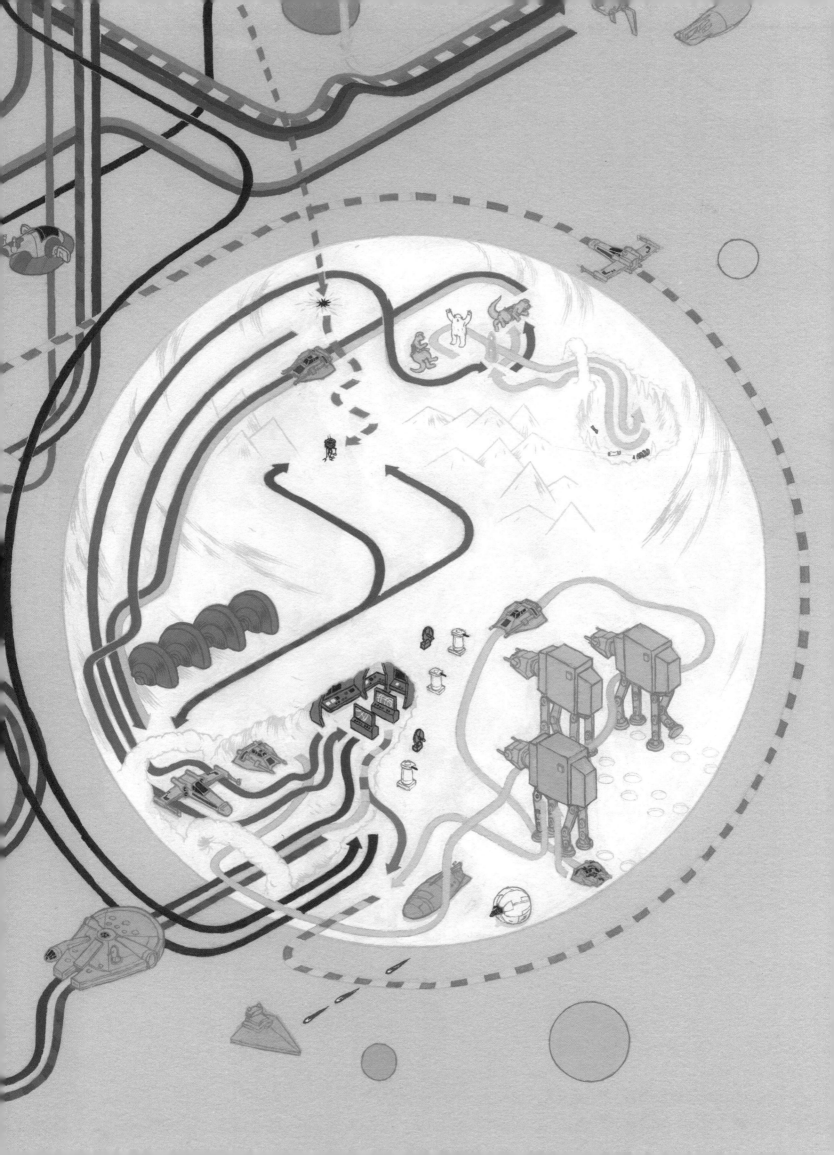

Raiders of the Lost Ark

There's an ancient American legend about how Steven Spielberg, after *Close Encounters of the Third Kind*, was keen on making the twelfth James Bond picture, *For Your Eyes Only.* When he wound up not getting the gig, his pal George Lucas said not to worry—he had something better. With Philip Kaufman, he'd whipped up Indiana Smith, a two-fisted archaeologist who scoured the globe for valuable lost artifacts while punching out Nazis. Heartened, Spielberg changed Smith to Jones and, after Lawrence Kasdan hammered out a script, went off on safari.

Indiana's debt to Bond is immediately apparent. There's an opening action sequence, followed by a briefing in which Indy gets his real mission. He spends the rest of the movie running from country to country, narrowly dodging certain death by exotic means. He meets and woos a lady (one instead of Bond's two—Indy is more focused on his work) while preventing the villains from obtaining a super-weapon, which he delivers into safer hands. And though the end credits may not say so, we exit buoyed by the sense that Indiana might return.

That pattern is what allowed Indy to show up fully formed, stepping out of the shadows in his fedora and leather jacket, toting his pistol and his bullwhip. But the devil is in the details, and he's hardly a simple Bond rip-off. Although he's a man's man, dashing and stubbly, he's also soft-spoken, understated, and vulnerable. He never succeeds on the very first try; there's always a setback or two,

DIRECTED BY **Steven Spielberg**
RELEASED IN **1981**

- ● INDIANA JONES
- ● MARION RAVENWOOD
- ○ DR. RENÉ BELLOQ
- ● MAJOR ARNOLD TOHT
- ● SALLAH
- ● COLONEL DIETRICH

Paths of Raiders (2012)
Gouache on paper
18½ x 22 in (47 x 56 cm)

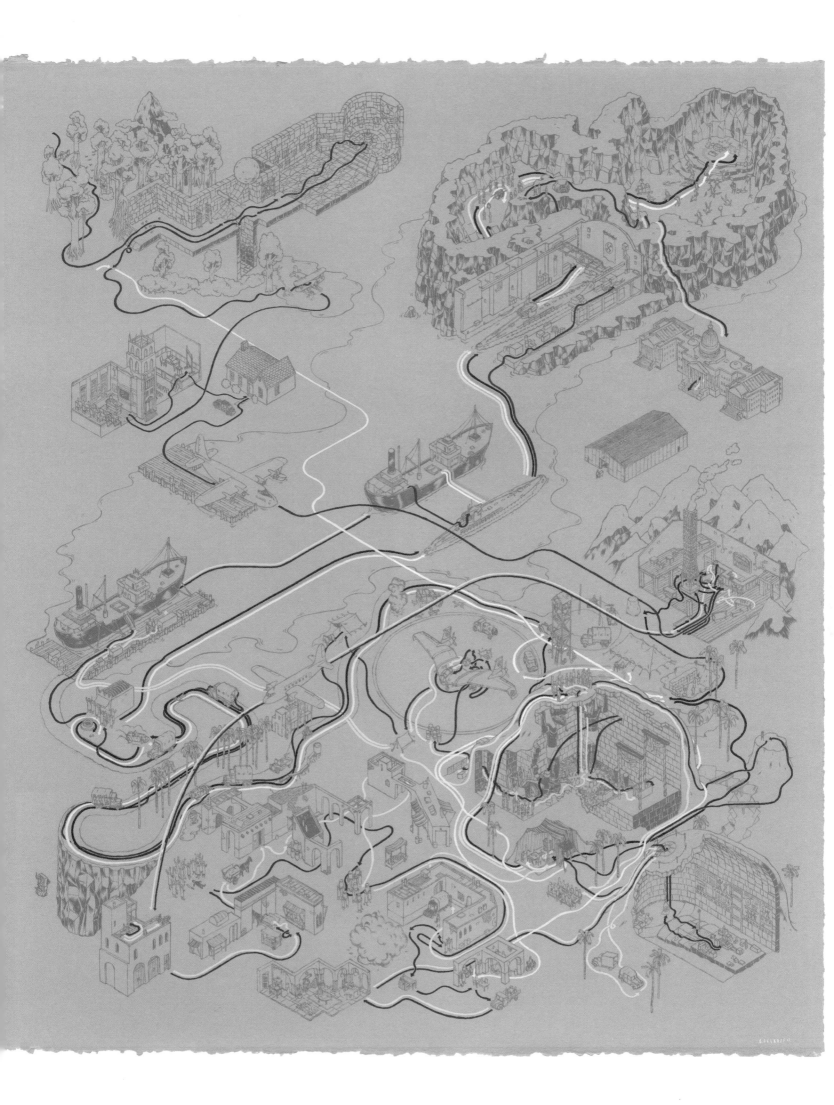

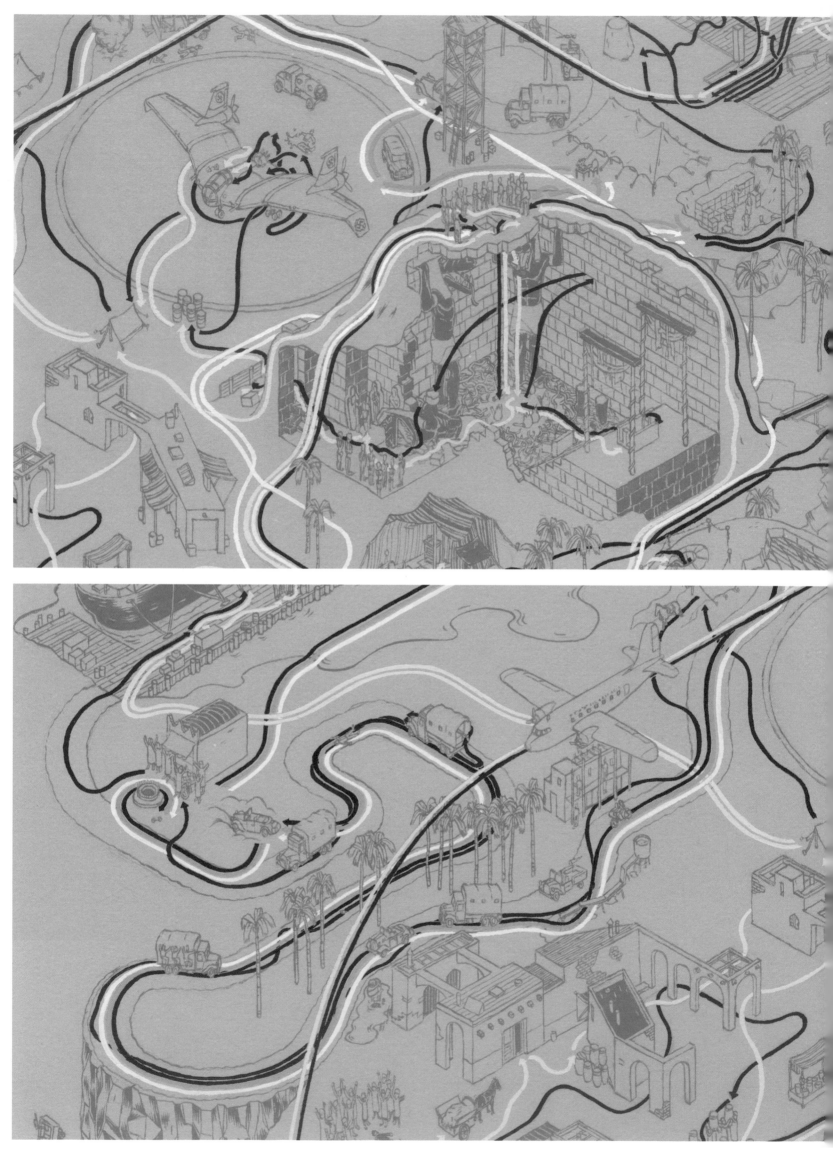

THE FLYING WING (opposite top)

DREW: The Nazi flying wing was a fictional craft, invented by production designer Norman Reynolds and the great cartoonist Ron Cobb. Both artists also worked on the *Star Wars* and *Alien* films.

A FINE LINE BETWEEN LIFE AND DEATH (opposite bottom)

DREW: My goal when mapping the Indiana Jones trilogy was to capture its frantic, fast-paced nature. Using a finer line for the characters allowed me to depict more detailed action, especially handy when it came time for Indy to go under the truck. It also made the characters seem more vulnerable—despite the good-natured humor in the film, the body count is staggering.

THE WELL OF SOULS (above)

ADAM: In the Well of Souls, Indiana Jones uses a miniature model of a city to learn where the Ark of the Covenant is buried. He's luckier than Jack Torrance in *The Shining*, who gazes upon a miniature model of the Overlook's famous hedge maze only to see the site of his impending death. Fortunately for Indy, he knows when to close his eyes.

some slip-ups and double-crosses. And where Bond was a Cold War spy, Indy's a throwback to the serials of the 1930s (which is why his films are set in that decade). He's a leader of expeditions, an obtainer of "rare antiquities" from crumbling booby-trapped ruins; he doesn't go after plans for satellites or lasers, slinking about in undersea bases or hollowed-out volcano lairs. Brushing aside thick tangles of cobwebs, casually knocking tarantulas off his and others' backs, Indy is more comfortable in the field than in civilization. What makes him stammer and sweat (besides snakes) are the starry-eyed coeds who hang on his every word during lectures. Bond would have taken them all out to dinner, formed a harem. Indy, once bitten and now twice shy, learned from his dalliance with Marion Ravenwood not to mess with younger women.

But Indy's M.O. is unearthing the past, so it makes perfect sense that his mission would lead him back to Marion. She's out-drinking men twice her size in the mountains of Nepal, trying her best to forget the man who done her wrong. When he reappears, casting his silhouette into her bar and asking about a bronze medallion, she leaps at the chance to turn the tables, making herself his goddamn partner. Propelled by John Williams's rousing score, they fly off to see what Hitler's minions are doing digging in the desert outside Cairo, racing to beat them

to the Well of Souls and the Ark of the Covenant. Enlisting the help of Indy's jovial pal Sallah, they rail against Toht, a Nazi sadist, and Belloq, Indiana's rival, a charming Frenchman who claims there is nothing that Indy can find that he can't take away. The ensuing contest pits our heroes against chases, asps, explosions, a fascist monkey, and a dish of very bad dates. To say it all went over well is an understatement. One of the greatest films of the 1980s, it launched a thousand imitations, including a shot-for-shot remake by kids who loved it so much that they wanted to live it.

Perhaps because it is so perfect and so beloved, in recent years the film has inspired backlash. A new school of thought proposes that it is flawed because Indy doesn't affect the outcome. That is to say, if you cut Dr. Jones out of the picture, the Nazis would still find the Well of Souls and dig up the Ark, and open it up, and melt off their own faces. Which is true. But this line of thinking misses the deeper point. Spielberg didn't need Indy to massacre the Nazis; the power of God, which has no equal, can take care of that. Spielberg didn't even need Indy to find the Ark, which is, as Marcus Brody argues, best left undisturbed. Rather, Spielberg has something else in mind for the man. Bond is forever frozen in rakish impudence, doomed to eternally drink martinis and make dirty jokes and tease Miss Moneypenny. But Indiana progresses. His character arc (if you'll permit me) sees him transform

from a secular scientist, dismissive of Judeo-Christian "magic" and "superstitious hocus-pocus," into someone who wins not by strength of arms, but by literal deus ex machina. He closes his eyes at the movie's climax and shouts to Marion to keep hers shut, too, that they be spared God's almighty wrath. The archaeologist devoted to digging things up comes to learn that some things cannot be obtained—things not of this earth, rare antiquities that are meant for God's eyes only. His close encounter with the divine makes cynical Indy a true believer, which is exactly what Spielberg wanted, the man's whole design: to get Indiana Jones, the American James Bond, a goy whose name combines the heartland with the everyman, to *convert*. •

DIRECTED BY **Nicholas Meyer**

RELEASED IN **1982**

- ● JAMES T. KIRK
- ● SPOCK
- ○ KHAN NOONIEN SINGH
- ● LIEUTENANT SAAVIK
- ● LEONARD MCCOY
- ● PAVEL CHEKOV
- ● UHURA
- ○ HIKARU SULU
- ● SCOTTY
- ● CAROL MARCUS
- ● DAVID
- ● CLARK TERRELL

Paths of Khan (2014)
Gouache on paper
16 x 19 in (41 x 48 cm)

The opening titles reveal that the time is the good old twenty-third century, and the opening shot returns us to the USS *Enterprise* bridge, but the captain is somebody named Saavik, a young and (to viewers in 1982) entirely unknown Vulcan. Uhura tells Saavik she's received a distress call from the *Kobayashi Maru*, a neutronic fuel carrier that's powerless after striking a Neutral Zone mine. Saavik must figure out what to do. She orders her people to enter the Zone and assist the ship, which reveals that the whole thing is a trap. Three Klingon cruisers swoop in and fire, tearing the *Enterprise* apart. Consoles erupt in showers of sparks and smoke as first Sulu gets killed, then Uhura, then Mr. Spock.

Something's obviously not right. The lights come up, heavy doors whisk open, and James T. Kirk—now an admiral—strides onto the bridge, revealing that the whole thing was a test, a no-win scenario designed to reveal insights into a Starfleet officer's character. It's also pretty convincing theater, indistinguishable from real combat, which *Star Trek II*, in the scenes to follow, offers its viewers plenty of. After *Star Trek: The Motion Picture*, Robert Wise's odd mash-up of *Star Trek* and *2001* (fans dubbed it *The Motionless Picture*), Paramount looked for people to bring the ailing franchise back to life. They turned to two men who knew nothing about *Star Trek*, Nicholas Meyer and Harve Bennett, whose solution was to take it back to its roots. The result is a swashbuckler—"Horatio Hornblower in outer space"—that still offered plenty of room

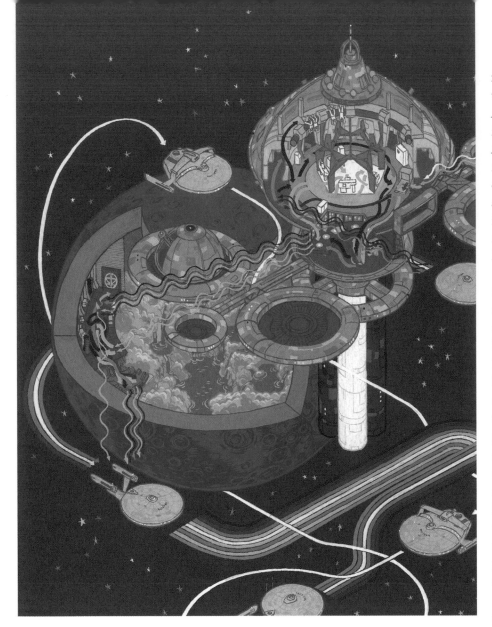

SPACE, THE ULTIMATE RESOURCE
(above)

ADAM: Many fans have made maps of the space depicted in *Star Trek*, pinning down where each space station is and who owns what. But the major advantage of that setting is its endlessness. It's the ultimate writer's (and painter's) resource—a blank, black canvas that can be populated with ships and space stations as needed.

for Kirk and Spock and Bones to sit around and talk about aging and how the needs of the many outweigh the needs of the few.

The theme is vengeance. The plot kicks off when the *Reliant*, home to First Officer Pavel Chekov, stumbles upon the *Botany Bay*, a cargo ship that was deeply familiar to *Star Trek* fans, unlike Saavik. They first saw it in 1967, when the *Enterprise* came across the vessel drifting in space, ferrying ninety bodies in cryogenic

sleep. Those sleepers were outlaws from Earth's past, genetically engineered supermen led by one even greater, Khan Noonien Singh. Played by none other than Ricardo Montalbán, Khan is the closest thing *Star Trek* has seen to a James Bond villain, suave and genteel and utterly ruthless. In *Star Trek*'s history, he ruled a quarter of the Earth, from the Middle East to Asia, back in the 1990s, before he was deposed and frozen and exiled into space.

Khan, super-smart and super-strong, makes a prisoner of poor Chekov and his captain, then subjects them to one of the most disturbing torments in science fiction, slipping larvae from the snarling Ceti eel (it looks like an antlion) into their ears. The slimy grubs, Khan purringly tells them, wrap themselves around a person's cerebral cortex, transforming them into obedient slaves, before the victim succumbs to insanity, then death. Thus Khan takes over the *Reliant* and raids a space station, stealing the Genesis Device, a

fancy marvel of technology he intends to use as a weapon. But his real goal is killing Admiral Kirk, who's been tasked with inspecting the *Enterprise* and its new crew. Aboard that spaceship things still aren't right, its decks lit with shadows, its corridors melancholy. Kirk sits brooding, surrounded by wooden ships and antique firearms. It's his birthday but, as Bones remarks, popping open a bottle of Romulan ale, the mood is funereal.

Back in the 1960s, *Star Trek* functioned as allegory, providing a mirror to a society wrapped up in issues like race relations, overpopulation, and obsolescence by computer. The genius of 1980s *Star Trek* was to turn the mirror around, to look at itself. Kirk feels listless and despondent because he has nothing to do, what with *Star Trek* off the air. Khan's reemergence is the birthday present he needs, the excuse to return to the captain's chair and do what he does best: lead his crew on an adventure. Sherlock Holmes isn't Sherlock Holmes unless he's investigating clues, with Watson in tow. And Kirk isn't Kirk unless he's perched at the edge of his chair, pausing dramatically before giving the order to . . . "Fire!"

A game of cat and mouse ensues, a sci-fi version of submarine combat, involving deceptions and more explosions, characters flinging themselves from panels and staggering back and forth as the camera tilts and shakes. Khan does his best to enjoy his revenge (served cold as space). Kirk bellows Khan's name; ships slip past each other inside a nebula as their lights turn red and their viewscreens fill with static, and radiation starts to leak.

The end of the film, as everyone knows, sees the death of Spock, the logical Vulcan sacrificing himself for the needs of the *Enterprise* crew. But that was hardly the last of him. Characters, unlike you and me, can't really die. Sir Arthur Conan Doyle tried to kill off Holmes, pitching him over Reichenbach Falls during a battle with Moriarty. "I must save my mind for better things," Doyle famously wrote. Leonard Nimoy, too, was eager to move on to different parts. But Doyle's readers wouldn't let Sherlock Holmes stay dead, and after a decade his writer gave in, bringing the sleuth back via the mystical art of "baritsu." Nimoy took much less

convincing. The moment he saw what a rousing tale he'd helped make, he agreed to revive Spock in the very next film (which he even directed).

As well it should be. We want our favorite characters always doing their thing—not larger than life so much as *simpler* than life, unlike us, frail beings always in decline. In the thirty-five years since *The Wrath of Khan*, some of its actors have passed away: Ricardo Montalbán, James Doohan, DeForest Kelley, Leonard Nimoy. The rest, I fear, will not be with us that much longer. But Bones and Scotty and Spock—and Uhura and Sulu and Chekov and Captain Kirk—will always be in the prime of their lives, setting their phasers to stun and consulting tricorder readings way up there while we're stuck down here. Decades from now they'll still be darting about in their sleek silver starship, seeking out strange new worlds and new life forms and civilizations, thrilling us as they explore not outer space, but the farthest reaches of whatever we dare to imagine. •

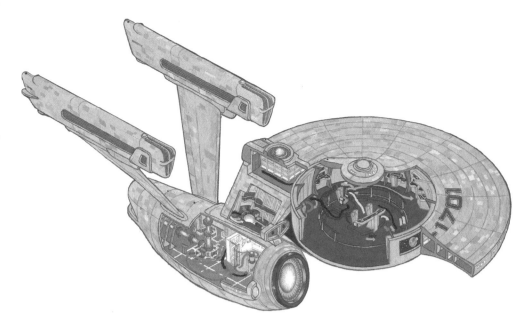

THE USS *ENTERPRISE* (above)
ADAM: The Federation's flagship is arguably humanity's greatest achievement: a model UN in space that also allows us to leave our planet. In trying to destroy the famous craft, Khan attempts to undo that historical progress, to return to the more barbaric 1990s, when he ruled a quarter of the Earth.

A BLOODY BACKGROUND (below)
DREW: I work on paper, which limits my background colors. In this case, I selected burgundy to represent the film's military tone, with its depiction of outer space combat as being akin to submarine warfare. While painting, I realized I was also thinking of the bloody handprint that Spock leaves on Kirk's red uniform, an image that's stuck with me since childhood.

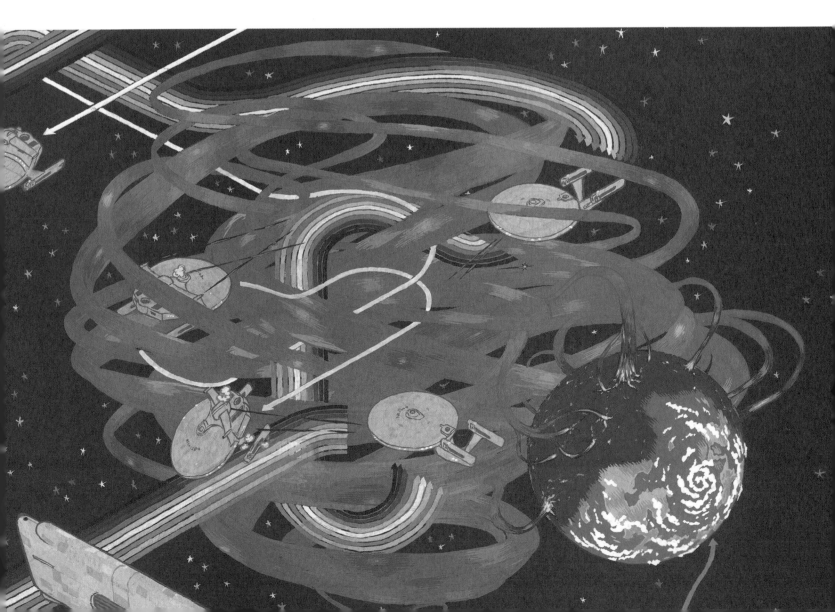

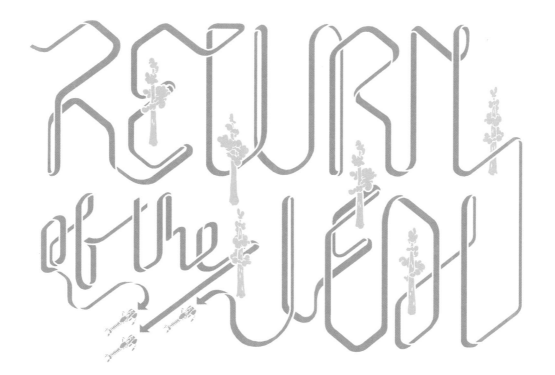

Return of the Jedi

They all begin with "the ritual." First, the 20th Century Fox logo fades into view, stone letters and numbers adorning a building as searchlights scrape a stormy sky. A fanfare sounds—and such is the power of this ritual that whenever I hear that music, I think I'm about to watch one of these films. Next comes the Lucasfilm logo, followed by the words, fuzzy and blue, looking almost like black light: "A long time ago in a galaxy far, far away " Then the series logo, very startling, receding quickly into the stars. John Williams's famous music plays. And finally the opening crawl: angled yellow text that fills us in on what's happened since the last part.

They all start like this, but what follows is always different. The first one, later subtitled *A New Hope*, was Lucas's means of synthesizing his many interests, which included World War II films. "It is a period of civil war," the crawl informs us before proceeding to describe both sides and their tactics. Luke, a farm boy who doesn't poke in his shaggy head until the seventeen-minute mark, is but one combatant. In the battle against the Death Star, he isn't in charge; he's just one of the pilots, "Red Five," a call sign in a flurry of names and faces. His squadron gets whittled down: "We lost Tiree, we lost Hutch," one pilot reports before his own ship is blown to pieces by Darth Vader. The film conveys the sense of a bustling galaxy paying no attention to Luke: the opening battle, the Mos Eisley spaceport and cantina, the Death Star's hallways and hangar bays.

DIRECTED BY **Richard Marquand**
RELEASED IN **1983**

- LUKE SKYWALKER
- PRINCESS LEIA ORGANA
- HAN SOLO
- CHEWBACCA
- DARTH VADER
- THE EMPEROR
- R2-D2
- C-3PO
- LANDO CALRISSIAN
- BOBA FETT

Paths of Return (2012)
Gouache on paper
18½ x 22 in (47 x 56 cm)

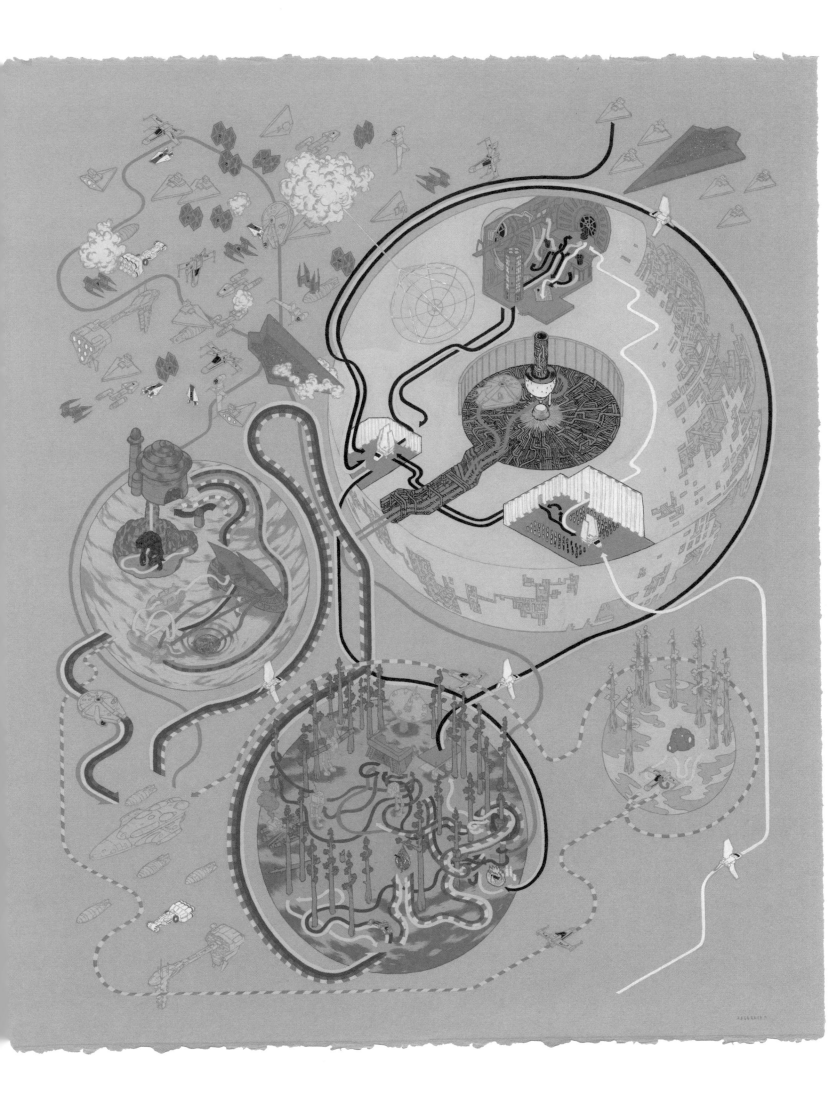

The Empire Strikes Back, not content to be *Star Wars II*, grew more personal, focusing on the central players. The war recedes, becoming backdrop. After fleeing Hoth, the Rebel Alliance disappears until the last scene, while the Imperial Fleet is caught up in a single task: capturing Luke. Darth Vader is obsessed with finding his son. No wonder the second Death Star, incomplete and lonely above the remote forest moon of Endor, slips behind schedule. Bothans are dying to bring the Rebels information, but there's no mention of their mission, no hint of Mon Mothma or Crix Madine or Admiral Ackbar.

The third installment, then, was faced with a difficult task: to wrap up both films, concluding not only the war but also the family drama. The Rebels, having survived the Empire's counterstrike, needed to score a decisive victory, while Luke had to find some means of saving his father's soul. The film had to wage a battle on two fronts: the physical world of Han and Leia, and the spiritual realm inhabited by the Jedi.

Does it succeed? I think it's fair to say that any problem is with the first part— the sequel to *Star Wars*. Whatever else *Jedi* is, it isn't much of a war film. People are quick to lay blame with the Ewoks, toyetic bucktoothed teddy bears who, armed merely with sticks and stones, defeat a legion of the Emperor's finest troops. But all of *Jedi* is a cartoon when it comes to war. Han Solo, upon being made a general, sends away his squadron while looking for Leia, then taps stormtroopers on their shoulders and sprints in the opposite direction. It's like *G.I. Joe*, and it's not hard to see in this a prequel of the prequels—premonitions of *The Phantom Menace*'s battle between the droid army and the Gungans, blue balls bouncing every which way while Jar Jar bumbles.

Odder still, *Jedi* opens with a third film, a half-hour short in which key players in the Rebellion call a time-out to rescue Han Solo, pursuing a plan that seems to involve them all getting captured. At least it's lovely: the Arabesque den that is Jabba's palace pays homage to both Frank Herbert and Edgar Rice Burroughs, topping the first film's cantina scene, with green pig guards and a smooth jazz band and

SHIFTING SCALES

DREW: I couldn't approach *Jedi* the same way I had its predecessors, since the film features both sweeping space battles and intimate lightsaber duels, as well as the battle on Endor.

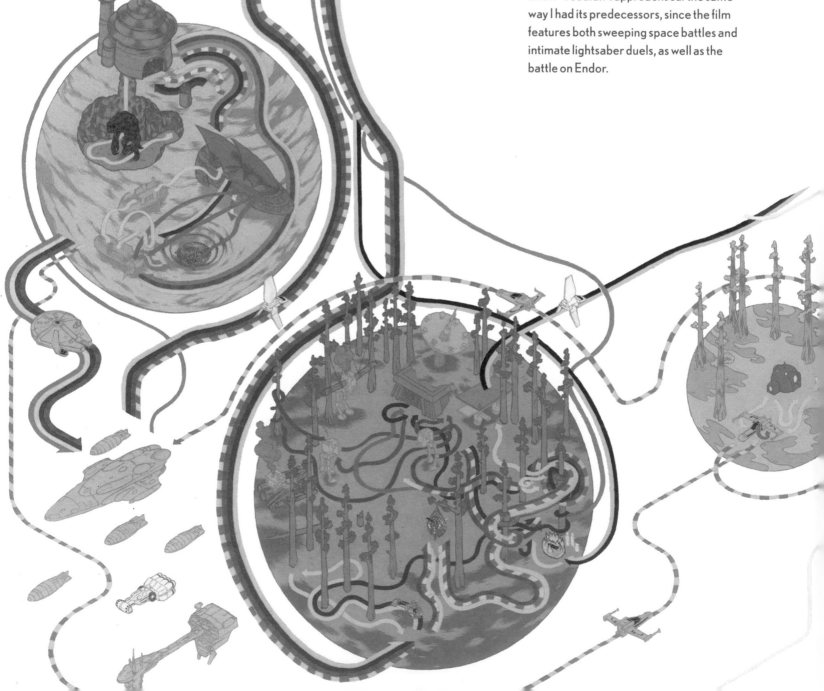

dancing slave girls and the rancor, plus lots of drooling (a tremendous amount of drooling). It's never boring, and Jabba is arguably the best puppet in the movies. Full of frogs and high on his hookah, he leads his entourage to the Dune Sea on his sail barge, like spring breakers embarked on a party cruise. Artoo is reduced to serving drinks, and Leia is forced to wear an indelible gold bikini. It works to bring Han back into the fold, and to show off how Luke, now clad from head to toe in black and claiming to be a Jedi Master, has newfound powers. (Mark Hamill's performance is underrated.)

Lest you think I'm down on *Jedi*, I actually like it quite a bit. (When I was a kid, it was my favorite of the three films.) That said, as soon as Luke leaves the gang to surrender to Vader, the plot perks up. The two men go to see the Emperor, perched as pretty as you please before a rose window, looking like nothing so much as a spider at the center of its web. The wizened elder removes Luke's handcuffs and places his lightsaber temptingly near, then needles the youngster, goading him to give in to his anger and hatred and strike him down: "I am defenseless." All that has transpired is his doing, wheels within wheels, dark machinations within machinations. Luke watches the Rebel fleet arrive, the shield still in place. A battle to end all space battles begins. ("It's a trap!" rasps Ackbar.) What's the last of the Jedi to do?

Of course Han and Leia, helped by the Ewoks, manage to blow up the shield generator, and of course the Rebels, led by Lando and Ackbar, manage to blow up the Death Star II. We never doubted them for a second. The real drama comes from Luke's battle with Vader, a series highlight. He bludgeons the cyborg into submission, knocking him back against a bridge and lopping off his hand, avenging their *Empire* duel. Then, regaining his senses, he turns off his lightsaber, shaking his head. "I am a Jedi," he proclaims, "like my father before me." You could just swoon! "So be it," the Emperor spits angrily, dropping his patronizing passive-aggressive act and raising his withered hands to assail Luke with lightning bolts. This whole part is just perfect: Vader deliberates, torn between his master and his

child, between malevolence and good, before casting the Emperor down a shaft, then asking Luke to remove his mask so that Vader can see his son with his own eyes. Luke complies, revealing the pasty-white scarred face, no longer terrible, looking lovingly paternal. Vader is vanquished; Anakin Skywalker is reborn.

That's the real end to the story, so *Jedi*, despite its flaws, proves a fitting finale. Luke sets his father's remains alight and rejoins his fellows. The final shot (the third in a series of portraits) presents the gang looking jolly: Lando clapping, Leia grinning rather broadly with her hair down. Even old sourpuss Han is smiling. Luke smiles, too, having just winked hello (or is it goodbye?) at the trio of Force ghosts flickering just outside the frame. The iris closes, horns ringing in the closing credits. Whatever else Endor may have been, it proves to be "the end". . . Or a new beginning, as we feel the urge to start over, replaying *Star Wars*, invoking the ritual anew. •

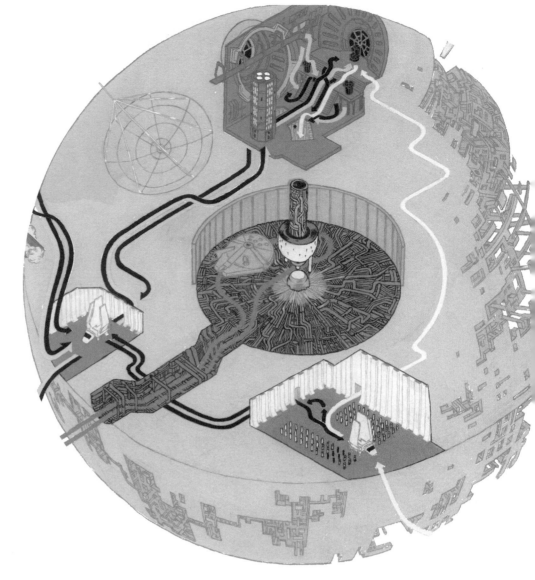

THE DEATH STARS (above)
ADAM: Both Death Stars are artificial worlds, utterly devoid of nature—indeed, they obliterate nature (i.e., entire planets). Which makes it all the more perverse that the Empire is constructing the mighty thing at Endor, a virginal forest moon.

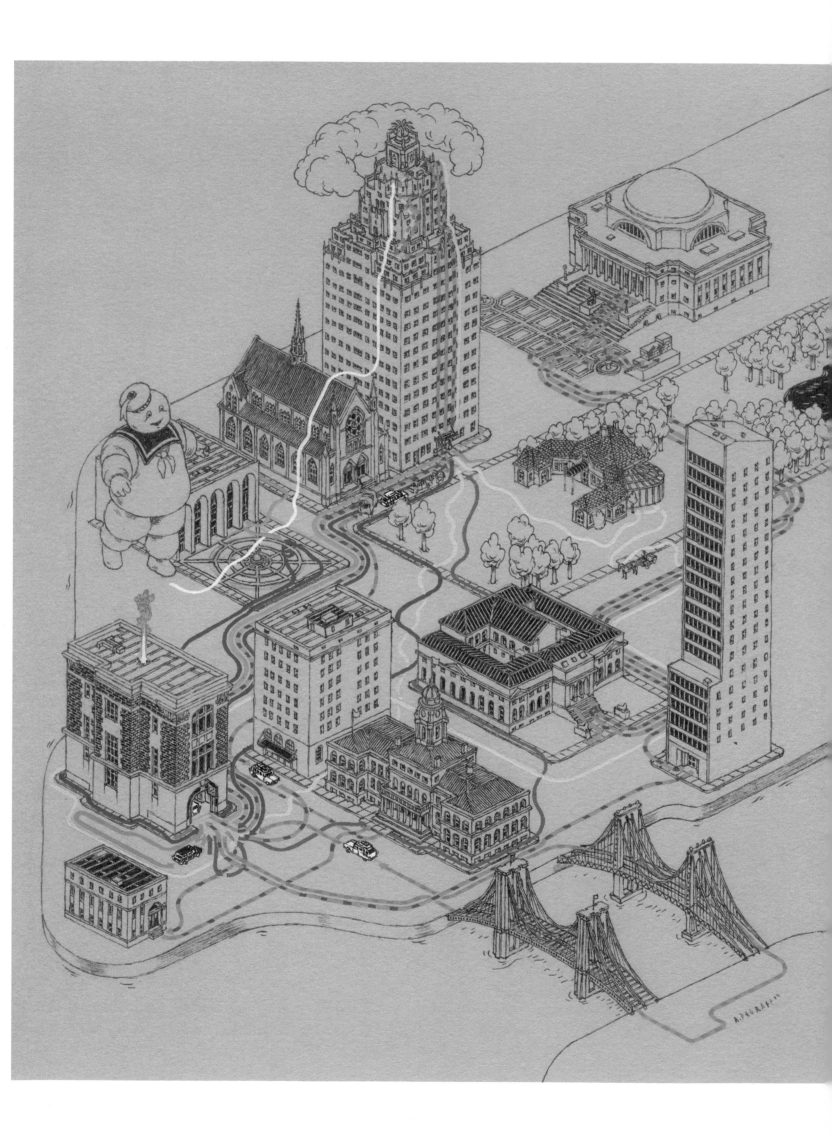

GHOSTBUSTERS

DIRECTED BY **Ivan Reitman**

RELEASED IN **1984**

- ● DR. PETER VENKMAN
- ● DR. RAYMOND STANTZ
- ● DR. EGON SPENGLER
- ● WINSTON ZEDDEMORE
- ● DANA BARRETT
- ○ LOUIS TULLY
- ● JANINE MELNITZ
- ● WALTER PECK
- ○ STAY PUFT MARSHMALLOW MAN

Paths of the Ghostbusters (2014)
Gouache and ink on paper
8 x 10 in (20 x 25 cm)

hosts are residue, spooky bits of the past that stick around, outlive their welcome. The Ghostbusters—Ray, Peter, Winston, and Egon—come in and clear the specters out with their PKE meters, proton packs, and hinged-top traps full of light. Unlike real exterminators, who get rid of pests like termites and mice, the Ghostbusters clean away reminders of the past, frightful spirits, making room for the present and the future. (This is why they drive a hearse.)

Everything can't be new. How many people came before us, lived in our houses, our apartments? One hundred years ago, who walked our city streets, ate lunch with your dish and cup and spoon, sat in the seat I choose on the subway or at the park? William Faulkner famously said, "The past ain't over—it ain't even past" (I'm paraphrasing), but we do a good job pretending the present is all there is. The dead had their time, their day in the sun. Now the world belongs to us, and we're pleased to pretend that now will last.

One of the odder pleasures of cinema, then, is how it takes us back. And part of *Ghostbusters'* charm is how it captured an older New York City, a place now lost. Early on, in the library scenes, books glide between shelves and form wobbly stacks, but I bet what amazes kids today is the card catalogue, a bank of shelves spewing entries into the air. They must tug at their parents' sleeves and ask, "What on earth is *that*?"

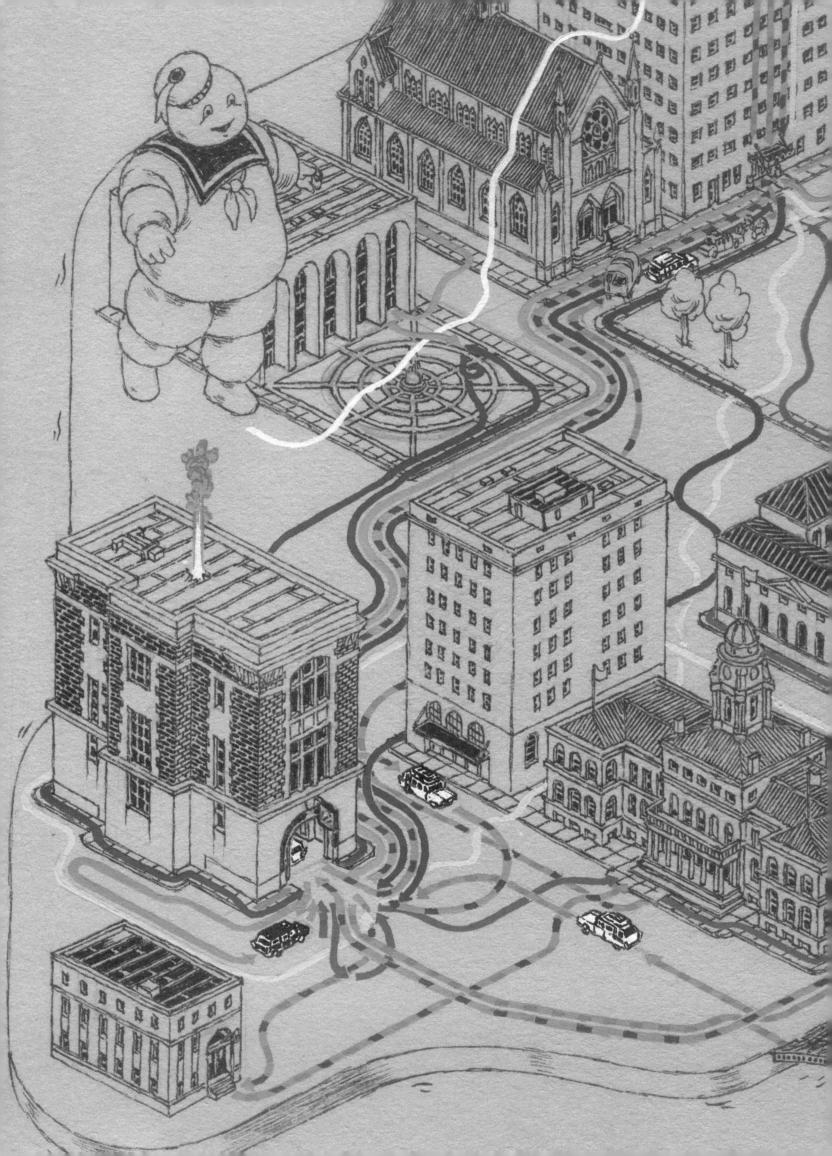

Things change. Dana Barrett (Sigourney Weaver) comes home to find her TV set on—a big boxy thing, airing an ad made by the Ghostbusters. Forced out of academia and into the private sector, they've gone into business, renting a crumbling firehouse that should be condemned. Egon rattles off a litany of complaints: serious metal fatigue in all load-bearing members, substandard wiring, a surrounding neighborhood like a DMZ. There are also cobwebs. But it has a pole that they can slide down, so they take it. They're like big kids, which is why kids then and now adore them, want to be them. Despite their three mortgages and occasional sips of beer, they're not real adults, but what kids imagine adults to be. I mean, they run around shooting laser beams at ghosts! And colorful twisty lasers at that, demolishing walls and carts and ballrooms. The only adults are squares and stiffs, jerks like Walter Peck, whom Venkman teases for not saying the magic word, "please."

The only likable grown-up is Dana, and even she has a fridge full of junk food (when there isn't a demon dog in it, lit up from within and barking "Zuul!"). She has a sweet tooth, as evidenced by the groceries we see in the famous scene where the eggs fly right out of their shells to fry themselves on the kitchen counter. Lying beside them is a bag of sugary cylindrical confections. What was she planning to make for dinner? A lettuce and Stay Puft Marshmallow omelet?

She's interrupted by a spirit and calls the weirdoes she saw on TV. A great deal of wackiness ensues, all played straight, delivered deadpan. It's a master class in understatement. My favorite bit is Louis Tully's breathless monologue about Gozer, capped off with the immortal line, "Many Shuvs and Zuuls knew what it was to be roasted in the depths of the Slor that day, I can tell you!" (It's the "I can tell you!" that makes it.) But there are so many brilliant bits: Venkman, quipping even when slimed. No-nonsense Janine. Dan Aykroyd staring agog at Slimer, a cigarette dangling from his lip.

Ghostbusters is genuinely spooky. Its vaporous apparitions scared me witless as a child, as did its gargoyles that burst open to reveal glowing red eyes. Even Slimer is pretty disgusting, neon green and gobbling down everything in sight—and anticipating, in a weird way, the Teenage Mutant Ninja Turtles, who had just sprung to life in the pages of indie comics and were still hiding down in the sewers, covered in ooze. Between them and Slimer and the Gremlins, the 1980s were a green and sticky place.

Fads come and go and, fittingly, *Ghostbusters* is obsessed with resurrection. The main villain, Gozer, is a forgotten Sumerian god, banished from this mortal plane by Tiamat (I read this somewhere), now trying to find itself a new body. It nearly succeeds when its flunkies possess Dana and Tully; she vamps around and levitates four feet above her bed while he talks to horses and rubs pizza on his cheek. Gozer is also unwittingly aided by Peck, who barges in (again foregoing the magic word) and shuts down our heroes, unleashing a pinkish-purple lightshow. But after a brief stint in a jail cell, the Ghostbusters give Peck his comeuppance and get to go free. Now hailed as heroes, they return to the crowded streets and, wearing unlicensed particle accelerators on their backs, surmount the ghost-collecting building at Central Park West, where they win the day by crossing the streams.

In more than one ancient myth, people grew older but didn't die. The earth became crowded with the elderly and the young, everybody jostling for space. The youngest people prayed to the gods, "Please give us room!" That's how death came to be among us: it was a gift. The present belongs to the living, but living never lasts. We are always dealing with death. Harold Ramis passed away in

SPOOK CENTRAL (above)
ADAM: Egon tells us that Ivo Shandor built his apartment complex as an antenna, a means of attracting the supernatural and thereby bringing an end to this world—which is why it becomes "Spook Central." One of the defining characteristics of *Ghostbusters* is how it merges the spiritual with the technological, treating ghosts as just another natural force, comparable to radio waves or electricity.

2014, and someday we, too, will disappear, surrendering our belongings and surroundings to the legions of kids playing grown-up. Will they love *Ghostbusters* like we do? With each passing year, the film will look older, more out of date. But I believe it will endure. Most of history we try to forget, shoving its mess and inconvenience into an attic or a basement. But some parts of the past we keep around, to flicker ghostlike on our TV sets and walls, the dead restored to life, our elders rejuvenated. Temporarily resurrected, they drift in and out of our lives, friendly poltergeists that amuse us, doing only the smallest of harms. •

1980s NEW YORK (opposite)
ADAM: The neighborhood around Ghostbusters headquarters, we're told, is in pretty rough shape, and the fire department, a social service, has pulled out. This is 1980s New York, a period marked by white flight and urban blight—it's the city whose escalating crime rates inspired both the *Death Wish* series and *Escape from New York*. The ghosts that the Ghostbusters battle must be New Yorkers from the previous generation. Perhaps they were murdered?

INDIANA JONES AND THE

Temple of Doom

The first Indiana Jones film opened by matching the Paramount Pictures logo with a mountain in Peru. *Temple of Doom* repeats that trick, this time cross-dissolving the logo with a mountain on a gong. So far, so familiar. But instead of Peruvian jungle, we find ourselves inside a Shanghai nightclub ("Club Obi Wan"). Smoke billows forth from a fake dragon's mouth, its nostrils breathing satiny flames. A blond woman slinks through the fumes, then launches into a Cole Porter number in Mandarin as showgirls fan out bearing fans, their smiles beaming. The singer, American Willie Scott, resplendent in crimson and gold, delivers the chorus in English: "Anything goes!"

This will not be mere retread. The first time around, we met Indy outdoors, sporting his classical appearance: leather jacket and fedora. Now he saunters down a staircase in evening dress, clean cut and wearing a white dinner jacket—Humphrey Bogart in *Casablanca* as James Bond. He's just retrieved ancestral ashes for a gangster, which he's agreed to exchange for a diamond the size of an egg. He gets double-crossed. A fight breaks out, involving a flaming kebab and champagne and a thousand balloons, Spielberg's attempt to outdo the soldiers–sailors brawl in the dancehall in *1941*.

Raiders was structured as a chase, setting its sights on the Ark and on heaven. *Temple* is structured like a trapdoor built over hell. Willie Scott turns and hurries back inside the dragon's mouth, where

DIRECTED BY **Steven Spielberg**
RELEASED IN **1984**

- INDIANA JONES
- WILLIE SCOTT
- SHORT ROUND
- MOLA RAM
- SHAMAN
- CAPTAIN BLUMBURTT
- CHATTAR LAL
- LITTLE MAHARAJA
- CHIEF GUARD

Paths of Doom (2012)
Gouache on paper
18½ x 22 in (47 x 56 cm)

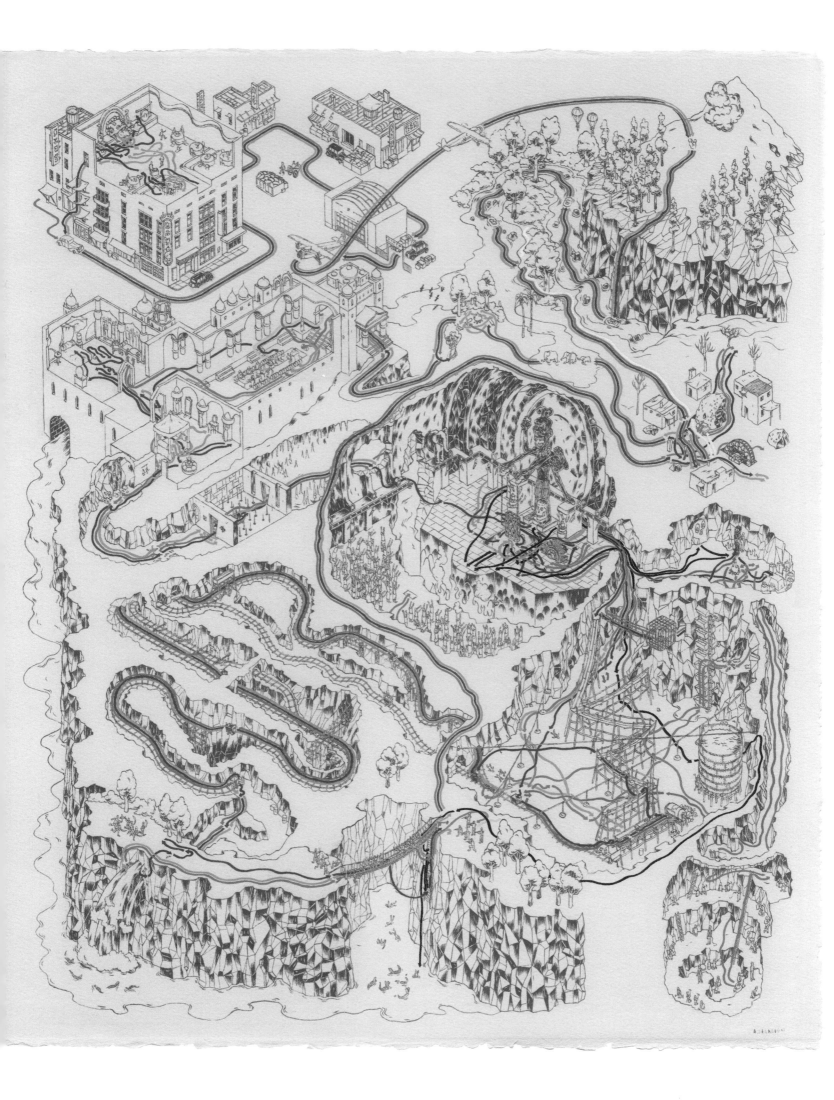

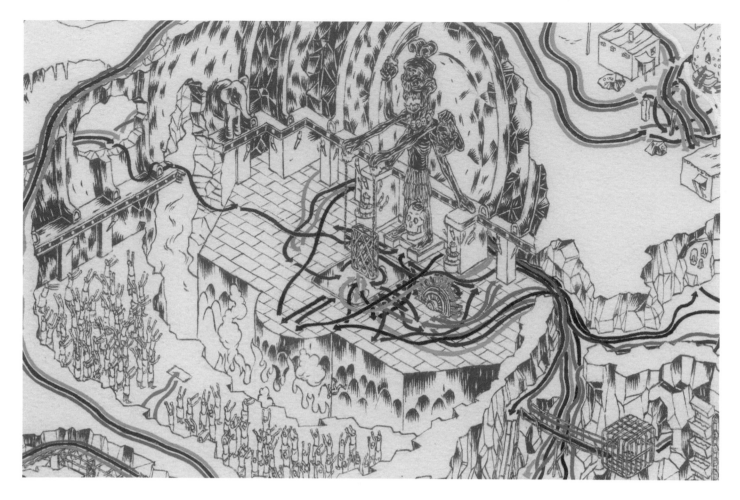

THE TEMPLE OF DOOM (above)

DREW: I knew this would be the toughest Indy movie, and it was. Why? *Interiors.* The problem with drawing interiors in this format is that you can really only show two walls of a normal room. You can show all the floor space, but how many times do the characters come in or out of that same space? How confusing do you want it to get? *Temple of Doom* had its own wide-ranging fights and chases, but it's all underground. This was certainly the longest map to plan out: the secret passage, the main chamber, Short Round's escape, the mine car chase... so many cutaways!

her chintzy number transforms into something far more spectacular. Space expands and distorts, failing to correspond, either spatially or logically, to what's without—Spielberg's version of *Doctor Who*'s TARDIS or the Black Lodge in *Twin Peaks*. The brunette chorus line disappears, replaced by blondes in spangled leotards and top hats. Glitter dazzles as the gals do precision high kicks and splits on a vastly wider stage—Willie's fantasy of being a Broadway star, instead of a Chinese gangster's girlfriend.

Initially, George Lucas set the film inside a Scottish haunted castle. When Spielberg rejected that idea, Lucas shrugged and made the castle an Indian temple. Space is plastic. Giant vampire bats fill the sky; an elephant's trunk becomes a snake. Time runs backward—we're in 1935, not '36. Indy gets poisoned in the first scene, and while he quickly gulps down the antidote, he's poisoned a second time by the Blood of Kali in the second half of the film. The strange goings-on could be his fever dream. It's an imaginary film about imaginary places; the Shanghai and India depicted never existed except onscreen. Spielberg confesses this in the first shot: fake silver mountain. We're traveling deeper inside the artwork, where nothing is ever as it seems. The cargo plane Indy tries to escape in belongs to the gangster. The pilots bail, leaving Indy and Willie and Shorty to make a leap of faith in a yellow raft. That they survive is completely outrageous, which isn't the problem so much as the point. *This isn't real.*

They wind up in India, or "India," where much of what happens is borrowed from *Gunga Din*. It's as racially sensitive as you'd expect, having been derived from

Hollywood's take on Kipling. Tasked with retrieving a sacred stone for a dying village, the trio ventures to Pankot Palace, once abandoned, now brought back to life by a child prince. The kid maharaja treats his guests to a feast of bugs, eyeball soup, live snakes, and, for dessert, chilled monkey brains. Willie faints. Years later she married Steven Spielberg. From what I hear, their wedding reception served a slightly different menu.

Genres give way and dissolve, bleeding into one another: musical number, action sequence, gross-out horror. After dinner comes screwball comedy as chaser, as Indy and Willie get hot and bothered in their bedrooms. They're interrupted by an assassin, then the discovery of a palace below the palace, the temple of doom. Hell itself, it bears no resemblance to anywhere real.

One hour exactly into the film, our heroes pass through a blood-red cavern whose stalactites and stalagmites are clearly fangs—the dragon's mouth. Beyond lies a fantasy land of insects and deadly traps, human sacrifices and flames and a whirlpool of magma. Pankot Palace, as it turns out, is just a front for a Thuggee cult that kidnaps kids and makes them dig

for sacred stones. Its leader, Mola Ram, is a monstrous priest of Kali who wears a cow skull on his head, on top of which is a shrunken head. He's in the habit of stroking its hair and pulling men's still-beating hearts out of their chests—as well as torturing people with voodoo dolls and floggings and pretty much anything Lucas could dream up. (When the enslaved kids, toward the end, turn on their captors and pelt them with stones, you know he was thinking about the Ewoks.)

Michael Cimino set *The Deer Hunter* in an invented Vietnam. *Temple of Doom* takes place in Lucas's and Spielberg's imaginations, amid half-remembered and half-digested bits of beloved movies and books. Anything goes, and the more unreal it is, the better. That so many viewers recoiled from the film's casual racism surprised both men. A few years later, Spielberg all but disowned the picture, calling it "too dark, too subterranean . . . it out-poltered *Poltergeist*." But as Bertolt Brecht said of *Gunga Din*, although the film is "utterly distorted" in its depiction of Indians, it's nonetheless "an artistic success." Thirty years later, *Temple of Doom* should be remembered not as a failure, but as a burnt offering to Indiana Jones's artistic ancestry, warts and all—a dark shrine devoted not to Kali, but to movies. •

A TRUE ROLLER COASTER RIDE (top right)

ADAM: Film critics frequently compare summer action blockbusters to roller-coaster rides, but *Temple of Doom* contains an actual roller coaster—even if it's a rickety old one made out of wood. One of Steven Spielberg's specialties is chase scenes, from *Duel* to *Sugarland Express* to the *T. rex* chasing the Jeep in *Jurassic Park*.

THE VILLAGE (bottom right)

ADAM: Its sacred lingam stone stolen, and all its children kidnapped, this Indian village withers, the wells running dry, crops failing. Indy and Willie return both stone and kids, then make out, the movie being a modern-day fertility ritual.

THE Breakfast Club

DIRECTED BY **John Hughes**

RELEASED IN **1985**

- ● JOHN BENDER
- ● CLAIRE STANDISH
- ● ANDREW CLARK
- ○ ALLISON REYNOLDS
- ● BRIAN JOHNSON
- ● RICHARD VERNON
- ● CARL REED

Paths of the Club (2014)
Ink and gouache on paper
8 x 10 in (20 x 25 cm)

Hey, hey, hey, hey! Straightaway, Simple Minds implore us: "Don't You Forget about Me." But who is me, and who is you? There's also a quote from David Bowie, an excerpt from "Changes," containing cryptic lyrics addressed to his elders, about how the children they spit on "are immune to your consultations." And then there's a letter, addressed to the assistant principal, Richard Vernon, a response from the film's five principal characters. It's their take on his assignment ordering each to write a thousand-word essay on just who they think they are.

That's a lot to unpack on a Saturday morning: specifically, Saturday March 24, 1984, as five teens converge on Shermer High School to serve detention. Each teen belongs to a different clique: the Brain, the Athlete, the Basket Case, the Princess, the Criminal. They also hail from different economic classes, a point made clear from the cars their parents drive (or don't drive), as well as the lunches they bring (or don't bring). But as Andy Warhol once noted, rich or poor, we all drink the same Coke—and now, for one reason or another, these misfits are being forced to spend nine hours in the school's library, in the presence of an unbearably ugly sculpture. It feels like eternity to them. When you're a teenager, how many Saturdays have you had? Less than a thousand.

What does *The Breakfast Club* think it is? What did John Hughes think he was making? *My Dinner with Andre*, but for teens? The premise is simply an excuse to get a quintet of kids into one room

so they can converse. They bicker at first, almost coming to blows, before they loosen up and talk. Most of the pleasure is getting to know them as they get to know one another. There's Brian (Anthony Michael Hall), a wimpy but endearing nerd; Andrew (Emilio Estevez), a wrestler who does what his father orders; Allison (Ally Sheedy), a goth who squeaks like a mouse and emits other strange noises; Claire (Molly Ringwald), a preppy prom queen who'd rather be shopping. And then there's Bender (Judd Nelson), a juvenile delinquent who's the monkey wrench in the mix. In his fingerless black gloves and layers of denim and flannel, he's determined to make the day a living hell for the hard-ass assistant principal, Vernon, sabotaging a door hinge and telling Vernon to eat his shorts (a line that must have inspired Bart Simpson), then ripping pages from a copy of Molière. Just like the French playwright, he has the fault of being more sincere than is proper.

At first belligerent, Bender emerges gradually as the movie's protagonist, convincing the others to join his rebellion. While Vernon moseys about, Bender leads them to his locker to retrieve hash, then run through the halls. "Being bad feels pretty good, right?" he asks Claire rhetorically. She must agree because later on she smokes with him, boasting through ladylike coughs about how popular she is. The

COMING AND GOING (below)

DREW: Unlike Ferris Bueller's freewheeling day off, which races to Chicago, *The Breakfast Club* remains stuck in school, making mapping it tricky. The characters keep coming and going, exiting and reentering, tangling up their paths, the same way the film tangles up their lives.

others puff, too; soon even the jock is rocking out, stripping off his varsity jacket and hurdling bookcases. What brings them together is a common foe, the elder, who acts like a commandant in a prisoner-of-war film, something Bender makes explicit when he gets his fellow students to whistle the "River Kwai March"—insinuating, perhaps, that Vernon has only got one ball.

The Breakfast Club was John Hughes's day of detention before *Ferris Bueller's Day Off* ditched school altogether. The plot is chiefly a melodrama, almost classical in its depiction of youth put upon by an obtuse elder, and it's unafraid to engage in some slapstick and lots of schmaltz. At times it lays it on pretty thick, as in the montage sequence where the kids dance goofily. Other bits, like when Allison builds a gross sandwich, are more distinctive. Hughes plays some scenes more subtly, for example when Carl the janitor, the insitution's eyes and ears, observes how Vernon is afraid of his pupils because he's afraid of getting older. That scene finds an echo when Andrew wonders, "Are we gonna be like our parents?" "It's unavoidable," answers Allison. "When you grow up, your heart dies."

That exchange takes place in the film's centerpiece, a twenty-minute scene during which the five teens sit in a circle, confessing their weaknesses and insecurities as well as the crimes that earned them detention. The truest moment comes when Claire states that although they might be friends at that moment, come Monday morning they will all return to their cliques. More specifically, she means that the Princess will no longer deign to get high and dance with the commoners. In the meantime, however, she gives Allison a makeover, wiping away layers of black smudge to transform the Basket Case into a virginal vision in white. Andrew, smitten, kisses Allison, who tears a varsity patch off his jacket. Bender sneaks back to the supply closet where he's been exiled, but Claire, still beneficent, sneaks after him to give him a hickey. A few scenes later she bestows upon him one of her diamond earrings, which finds a home in his left ear. Brian, meanwhile, writes their collective essay, through which they declare that they're no longer five people, five different high school stereotypes—the

way Vernon sees them—but one and the same: "The Breakfast Club."

Will their newfound solidarity last? The film doesn't say, and there's reason to think that Claire is right—cliques and classes are real, after all. But John Hughes thinks there's a chance, and *The Breakfast Club* is a movie about redemption—namely, Bender's. At first a rebel without a cause, he accepts Claire's proposal as well as her kiss. In the famous last shot, he walks toward the camera, raising his right fist in triumph before the image freezes. But what exactly is he celebrating? Who does Bender now think he is? He's on the football field, directly under a goalpost. He's imagining the rafters full of a crowd that is cheering his name. Moments ago he scored a touchdown. Just as Claire changed Allison into a preppy girl, she remade Bender into a jock. No longer playing the part of a rebel, he now feels accepted by the school. He'll come back on Monday and clean up his act, settle down and behave. Everyone has a price. His is acclaim. What would you do for a million dollars? *The Breakfast Club* is class warfare by other means. •

BENDER'S JOURNEY (right)

ADAM: Bender enters Sherman High defiantly, striding head-on, as if on a collision course with the high school's bricks and mortar. He exits in a similarly rebellious fashion, veering left while the others go right, since no car, no parent, is waiting to drive him home. We get the sense that he can go anywhere he wants to—but isn't that nowhere? A rebel at heart, Bender fancies himself beholden to neither authority nor routine, but that leaves him a perpetual outsider. If he doesn't return to the school on Monday, he'll effectively disappear.

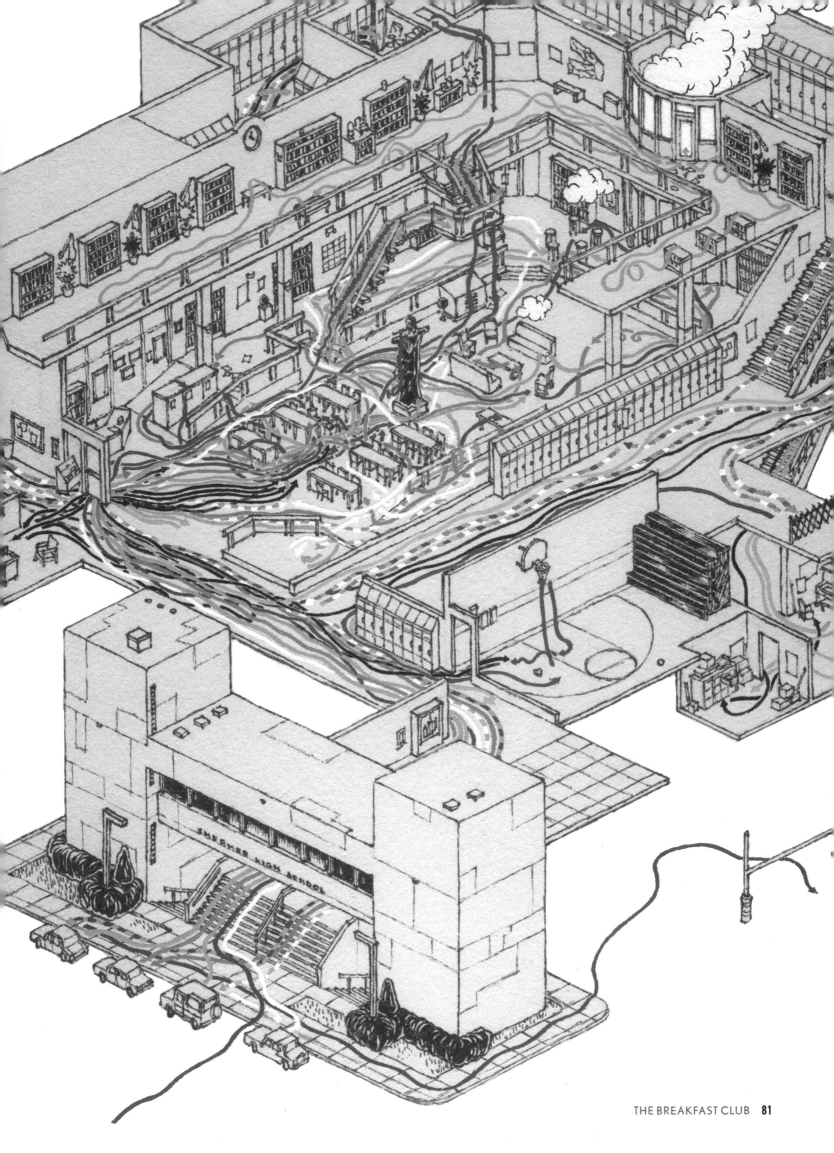

ack to the Future is the story of Marty McFly, a teen out of
time who dreams of someday becoming a rock star, not just
because he loves to rock, but because he desires a better life.
He wants it all: a beautiful girlfriend, a brand-new truck, and the
chance to prove his principal, Mr. Strickland, wrong—that he,
unlike all the other McFlys who've lived in Hill Valley, isn't a
slacker. More than anything else, Marty wants to escape from the
suburb, Lyon Estates, where he lives with his family. We meet
them at one of the most depressing meals in the movies. George,
the father (Crispin Glover), is a weakling who kowtows to his
boss, Biff Tannen, a bully based on none other than Donald John
Trump. (Somehow Zemeckis knew . . .) George weathers beat-
ings and degradations, consoling himself by eating whole bowls
of peanut brittle while laughing at retro TV until he can barely
breathe. Marty's mother, Lorraine (Lea Thompson), stumbles
back and forth between the kitchen and the table, subsisting on
vodka. The two other kids are bereft of prospects, and a jailbird
uncle, mentioned but unseen, might be better off in prison.

No surprise then that Marty wants better. His problem,
though, is that when it comes to rock 'n' roll, he's not very good.
His band, the Pinheads, sounds like a tuneless, louder version of
Huey Lewis and the News. It's true that rock is always getting nois-
ier, but Marty doesn't know when to quit: the first thing we see him
do is blow out an overamped speaker, knocking himself into a

DIRECTED BY **Robert Zemeckis**
RELEASED IN **1985**

- ● MARTY MCFLY
- ○ DR. BROWN
- ● LORRAINE MCFLY
- ● GEORGE MCFLY
- ● BIFF TANNEN
- ● THE DELOREAN
- ● EINSTEIN THE DOG
- ● TERRORIST VAN
- ● JENNIFER PARKER

Paths of the Future (2014)
Gouache on paper
16 x 19 in (41 x 48 cm)

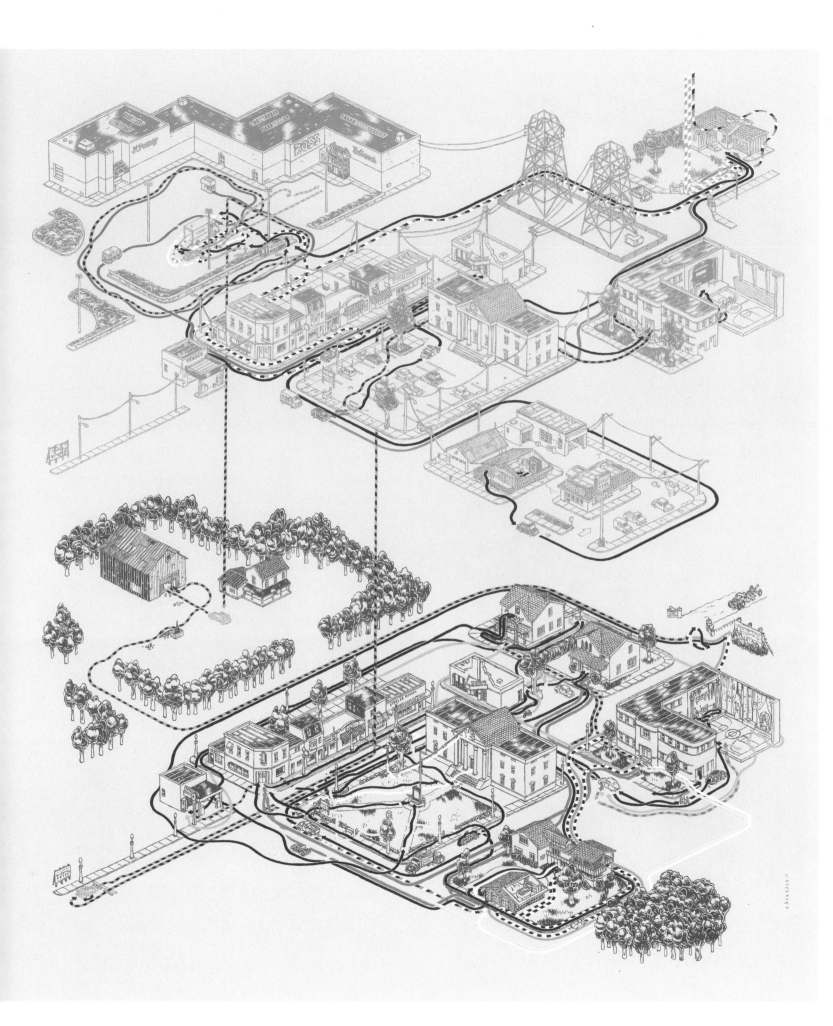

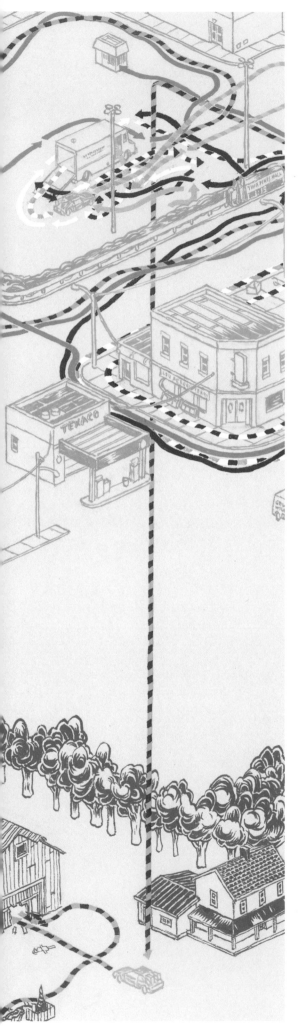

wall of shelves. The Pinheads fail to impress the judges, don't make the cut for the high school's battle of the bands. But luckily for Marty his best friend, Doctor Emmett Brown (Christopher Lloyd), has just built a time machine from a DeLorean. ("If you're gonna build a time machine into a car," he says, "why not do it with some style?") After testing it on his dog, Doc plans to travel twenty-five years into the future, to the year 2010, to see what the world will be like. (It sounded more exotic back then.) But Libyan terrorists interfere and murder Doc, and it's Marty who winds up getting sent somewhen else, accidentally, to "a red-letter date in the history of science," the fifth of November, 1955. Great Scott!

Zemeckis mines the movie's concept for all it's worth, showing off how different 1955 was from 1985 (though he was born in '52, so this is a fantasy of nostalgia). Upon his arrival, Marty gets to see firsthand how much better and brighter his hometown looked three decades prior. Instead of *Orgy American Style*, the downtown theater is screening *Cattle Queen of Montana*, starring Barbara Stanwyck and Ronald Reagan, and the streets are packed with patrons—the mall and the suburbs have yet to be built to lure away foot traffic. (And if the whole place looks unreal, that's because it is: Hill Valley is the Universal back lot, seen one year earlier in Joe Dante's *Gremlins*, where it stood in for Kingston Falls.)

Marty never considers staying, so the plot sees him trying to get back . . . back to the future! The challenge is how to obtain the 1.21 "jigawatts" required to power the time machine's flux capacitor. He must also get his mom and dad to fall in love, having disrupted their first meeting; this involves getting his dad to act

tough, as well as evading his mom's advances, since she's fixated on him. I don't need to tell you it turns out well because you've seen it—everyone's seen it—and the sequel kind of redoes it in its own peculiar way (although Crispin Glover and Claudia Wells got recast—I blame an altered timeline). Along the way, Marty gets a fresh crack at becoming a rock star, filling in on lead guitar with Marvin Berry and the Starlighters, and although he almost screws up "Earth Angel" (though to be fair, he's disappearing from existence), his parents still kiss, restoring the timeline. Marty then wows the assembled teens (not to mention Chuck Berry) by leading a cover of "Johnny B. Goode"—until he repeats his mistake of getting too noisy and too loud, leaving the bobbysoxers befuddled.

Not that it matters. Marty returns to the present day to find that even though Hill Valley is still a dump, his family's fortunes have vastly improved. The new truck he wanted is parked in the driveway, being attended to by Biff. And his siblings and parents are happy and healthy, no longer the gang of losers crowding the dinner table. What's more, his father has become an author—Biff bursts in with a bulging box of George's debut novel, a sci-fi retelling of his courtship of Lorraine, *A Match Made in Space*.

Except that title's not quite right: we know their match was made in *time*. And the name on the volume is also wrong:

TIME TRAVEL (left)
DREW: Time travel is tricky to map. I was pretty happy with the "planar overlay" of the 1955 and 1985 versions of Hill Valley. Unlike what I did for *Star Trek*, which required me to create a new way to show a timeline (although the same thing happens here), this film is wonderfully concise. It's a tightly wrapped package of adventure and humor, with little extraneous noise.

TWIN PINES RANCH (opposite top)
ADAM: Twin Pines Ranch is the site of the later Twin Pines Mall, which becomes the Lone Pine Mall after Marty runs down one of the pines. In that way, the mall remembers the countryside it replaced. It was owned by Old Man Peabody, a reference to fellow time travelers Mr. Peabody and his boy Sherman.

PINKS AND BLUES (opposite bottom)
DREW: For me, the '80s was a darker rebirth of the '50s, an idea that may have been cemented by *Back to the Future*. There is a palette similarity, and this film seemed like a great place to apply it. The pinks, baby blues, teals, and bright yellows of the '50s seemed totally at home in the '80s.

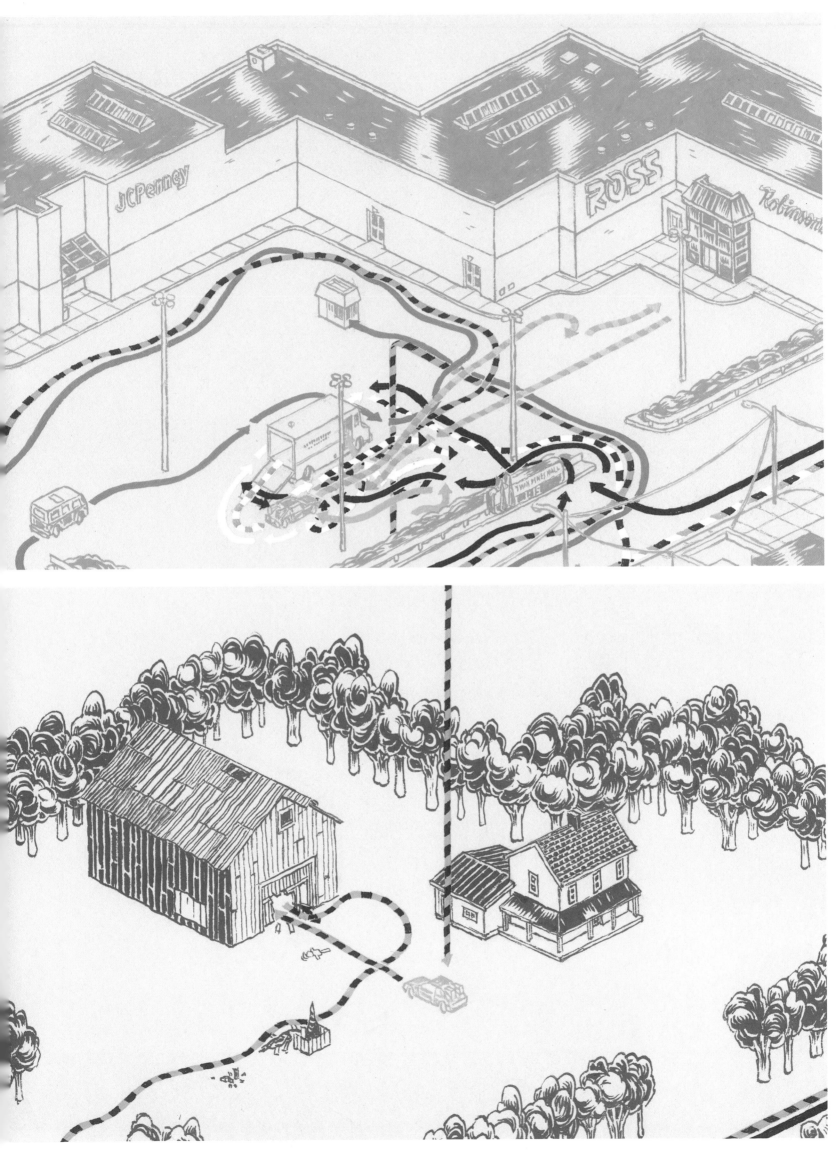

SAVE THE CLOCK TOWER

ADAM: Marty donates a quarter to the "save the clock tower" fund, but in reality he's trying to buy some peace so he can get back to making out with Jennifer. He should've been more generous—once he's stuck in 1955, the clock tower winds up saving him.

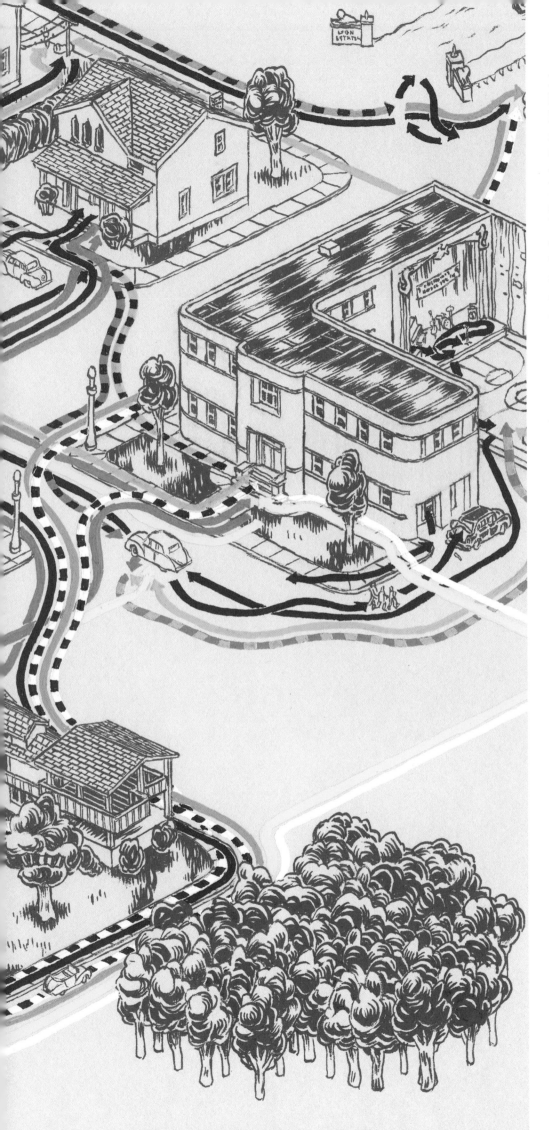

Marty is the true author of the book, having made that particular match (at least the better version of it). We see right away from the cover image that George's inspiration was Marty's nighttime visit, done so that George would stop being a sissy and ask Lorraine to the high school dance—the bit where Marty blasted Van Halen through his Walkman and claimed to be "Darth Vader, an extraterrestrial from the planet Vulcan." And few people know this, but George, embarking upon his career, attending science-fiction conventions, told fellow artists about what he'd heard that fateful night. Those nerdy companions—Gene Roddenberry, George Lucas, Steven Spielberg—were inspired, too, and went on to make the TV shows and the movies we know them for today. Which is a paradox, I'll admit—but that's time travel for you.

So Marty McFly is the ultimate science-fiction author, having inspired three beloved works of the genre. Music was never the kid's true calling; it was clear that as a rock star, he wouldn't amount to all that much. He got what he wanted—the girl, the truck, the wealth—when he ditched his electric guitar and chose a different, better medium to work in: time itself. •

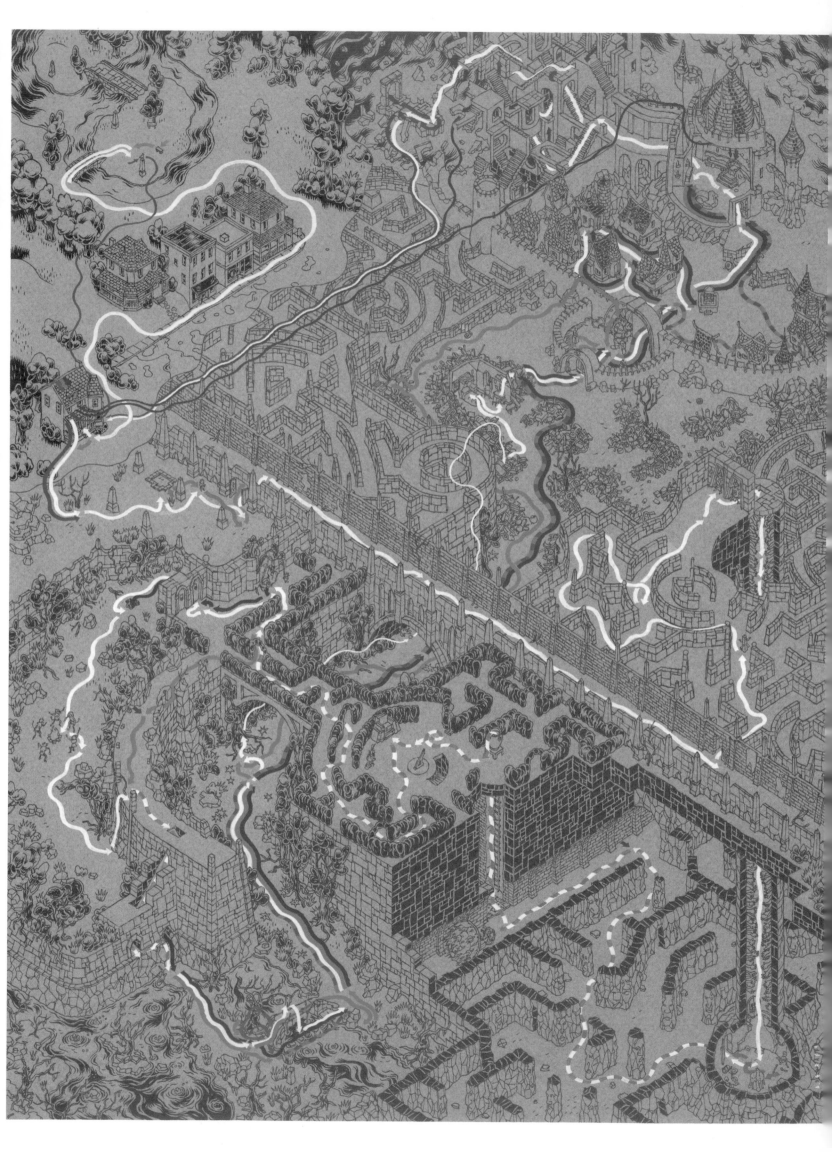

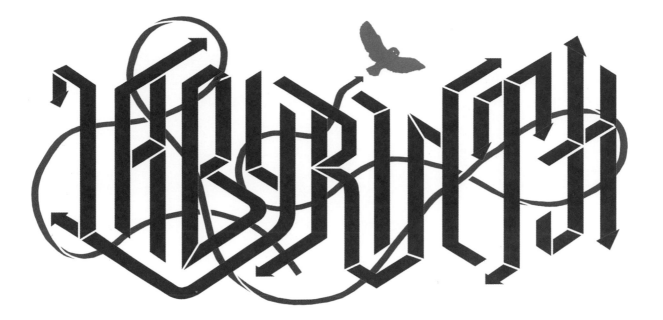

DIRECTED BY **Jim Henson**

RELEASED IN **1986**

○ SARAH WILLIAMS

● JARETH THE GOBLIN KING

● HOGGLE

● LUDO

● SIR DIDYMUS

● AMBROSIUS

Paths of the Labyrinth (2017)
Gouache and ink on paper
11½ x 15¼ in (29 x 39 cm)

A mid all the music and the merriment, the Muppets and the mayhem, it's easy to miss that the late, great David Bowie played not one, but *two* roles in *Labyrinth*. We all remember his turn as Jareth, the Goblin King, bouncing baby Toby on his knee, coolly lounging about his castle in his fright wig and codpiece and tights. As for his second part, it's easy to overlook—I didn't notice it for years.

Well, to be fair, there's a great deal going on. The final film directed by Jim Henson, *Labyrinth* is a storehouse of all his passions: singing, dancing, riddles, wordplay, elaborate production design, and (it goes without saying) puppets. It even recalls an hour-long film he made for television in 1969, *The Cube*, an existential drama in which a man can't figure his way out of a room, even as others come and go freely. This time it's a young girl named Sarah who's trapped in a maddening place where others know the lay of the land, a place where time and space break down and the rules seem made up on the spot.

She's a kindred traveler, of course, to Dorothy and Alice—*Labyrinth* isn't shy about its numerous influences. An early tracking shot through Sarah's bedroom shows us she's read both Baum and Carroll, as well as Sendak, Andersen, Grimm. That shot (plus a later disturbing scene set in a junkyard) suggests her adventure is just a dream—her dolls resemble the monsters she meets in the course of her journey. She's reviewing her past, as well as other fantastical works.

Turn one corner, she's in *Through the Looking Glass*; turn another, she's in *Where the Wild Things Are*. Turn another, she's in *Monty Python and the Holy Grail*—one character, Sir Didymus, is a cross between the Black Knight, the Knights who say "Ni!" and the killer Rabbit of Caerbannog . . . mixed with a healthy dose of Fraggle (and Don Quixote).

A lot of people helped Henson with the screenplay, including Terry Jones and George Lucas and Elaine May, so it's no surprise the film wound up such a mulligan stew. Someone—presumably Bowie—swiped a routine from the 1947 film *The Bachelor and the Bobby-Soxer* ("You remind me of a man . . . "), which became the intro to the musical number "Magic Dance." It's more than a random reference. That screwball comedy was about an older playboy (Cary Grant) who winds up ordered by a court to date a teenage girl who's less than half his age (Shirley Temple)—the logic being that this will cure her schoolgirl crush. Similarly, *Labyrinth* sees Sarah infatuated with Bowie's Goblin King—but who could blame her?

She tells her baby brother, Toby, that the Goblin King fell for her and would do anything for her, her dramatic declarations accented by lightning and thunder. But that is clearly her fantasizing, a dream she struggles to believe in while putting on lipstick in front of her bedroom's vanity.

In Greek myth, Daedalus built the labyrinth for King Minos as a prison for his son, the monstrous Minotaur. Why does Sarah build her labyrinth? What is she trying to keep locked up? At the start of the film, we see her playacting in the park, looking like a medieval maiden, reciting lines. We quickly realize, though, that this is the modern day, and she's rehearsing a part in a play entitled *The Labyrinth*. And not just any part, but the role her mother, Linda Williams, played onstage. It's hard to tell, but this detail really is in the film: in Sarah's bedroom, there's a scrapbook, which contains newspaper clippings about the absent woman, alongside stickers and hearts and the word "MOM" in big block letters. Linda is missing from the film because she ran away with Jeremy, her costar in the play, who as

it happens figures in those clippings, too, although we glimpse his image only fleetingly. But it's long enough to see that he looks exactly like David Bowie.

What's Sarah up to? Her father has remarried, and fathered a son, but Sarah's not ready to move on. She's playing the role her mother played in more ways than one, pretending that *she* bewitched Mr. Bowie. She thinks, in other words, that life is just like art—that life follows from art. Her mother ran off with her handsome costar because that's what happened in *The Labyrinth*, which is about a young woman who enchants the Goblin King. Now, on the verge of womanhood, it's Sarah's turn—and she's preparing for her part.

LIVING ROCK (below)

ADAM: Jareth the Goblin King's Labyrinth is many things, including a self-portrait, Jareth having hidden his face throughout his twisted creation. The most obvious likeness is a series of standing stones that line up to form Jareth's face when viewed from the proper angle.

Doing so means that she treats her father's new wife, Irene, like a wicked stepmom and tries to wish away her new half-brother, Toby—again, by pretending the play is real.

Any puzzle can be figured out; any labyrinth can be completed. Routes can be plotted, different paths followed. All Theseus needed was some yarn. The most devious riddle is the one you don't want to solve. That's Sarah's problem: she'd rather live in a land of make-believe. Before she gets lost in the labyrinth, she's already lost in *The Labyrinth*. Seduced by the artwork, she does whatever is written down. Jareth knows this, states it plainly: "I ask for so little. Just fear me, love me, do as I say and I will be your slave." It isn't until the movie's end that Sarah remembers the crucial next line: "You have no power over me!" The moment she says that—the moment she grasps that life is life, whereas art is art—Jareth collapses, becoming an owl, and the labyrinth disintegrates around them.

Back in her home, Sarah runs upstairs to find baby Toby asleep in his crib. And in her own bedroom, she dismantles her shrine to her mother, which is also a shrine to Jeremy. Growing up means finding one's own way. But it doesn't mean forsaking art (a claim Jim Henson would never make). She catches a glimpse of her monstrous companions in the mirror, her toys' imaginary reflections. "Should you need us," one of them says. "I need you," Sarah interrupts. "Every now and again, for no reason at all." Nietzsche said that "life without music would be a mistake." And life without labyrinths would be wrong, too. It's fun to get lost in them on occasion—provided one knows how to get out. •

ILLUSIONS AND ALLUSIONS (right)
ADAM: As the raspy-voiced blue-haired worm tells Sarah, the labyrinth is a place of riddles and snares, as well as enchantments and illusions. It's also a constant set of allusions to other artists, from Lewis Carroll to L. Frank Baum, Maurice Sendak to M. C. Escher.

PREDATOR

I t's easy to forget (I always forget) that *Predator* opens in outer space, with a shot of the title character's ship sidling up to Earth. This is the one thing that I'd change, though I understand why, ten years after *Star Wars*, four years after *Return of the Jedi*, they started the picture the way that they did. But *Predator* is above all else a masterpiece of simplicity, a minimalist triumph, and it should open and close with helicopters, nothing but helicopters. ("Get to the chopper!")

In between there's just the jungle, lush and cryptic, crawling with God only knows what, a lawless space made all the creepier by Alan Silvestri's demented score, which sounds at times as though the orchestra is having a seizure. Accompanied by staccato strings and timpani rolls, our heroes arrive, flying low in helicopters. Led by Arnold Schwarzenegger's Dutch, who wears mirrored shades and puffs on cigars, they're a tight-knit group, able to come and go as they please and choose which missions they accept—more like members of G.I. Joe than actual soldiers. There's Billy, a Native American tracker who casually slices open vines to drink milky sap; Mac, silent and brooding and prone to obsessive shaving; Blain, who fails to get anyone else to chew tobacco (despite its potential to make them, as he so colorfully puts it, "a goddamn sexual Tyrannosaurus"); Poncho, the bland demolitions expert; and Hawkins (Shane Black), looking geeky in his glasses and telling crass jokes about a girlfriend who I think we can surmise does not

DIRECTED BY **John McTiernan**

RELEASED IN **1987**

- ● DUTCH
- ◐ THE PREDATOR
- ● GEORGE DILLON
- ◐ ANNA
- ● MAC ELIOT
- ○ PONCHO
- ◑ BLAIN
- ● BILLY SOLE
- ◐ RICK HAWKINS
- ◑ GENERAL PHILLIPS

Paths of the Predator (2014)
Gouache on paper
11 x 14 in (28 x 36 cm)

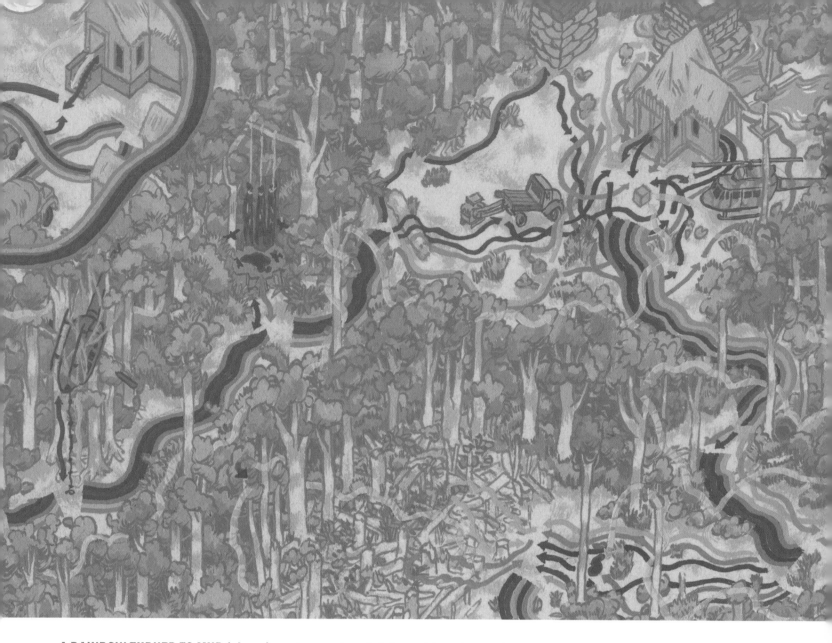

A RAINBOW TURNED TO MUD (above)

ADAM: Left to the mercy of the Predator, the multicolored band representing our heroes is steadily whittled down, like a rainbow that's fading, until only one color is left: the red stripe, representing Dutch. That man becomes one with the jungle, coating himself in mud and assembling booby traps from trees. It's like a bulked-up Ewok battling a Stormtrooper—another way in which *Predator* recalls *Star Wars*.

exist. Supposedly Black ad-libbed those bits, having been cast because *Lethal Weapon* (which he wrote) was a hit for Joel Silver. And, hey, the Predator needed victims.

The jungle awaits. They get their mission from Carl Weathers (George Dillon), but only after Dutch pits his strength against his old friend in an arm wrestling match that's one of the greatest moments in all of cinema. This time around, their job is to rescue a cabinet minister taken

hostage by rebel forces. They ship out listening to Little Richard, riding inside a helicopter that could double as a darkroom. Much of the pleasure of the film is watching them work: they easily sell us on the notion they've been doing this all their lives, coolly rescuing dignitaries while wiping out stray guerilla encampments. Streaked with greasepaint, communicating via hand signals, they creep through the brush, alert to all but afraid of nothing, never complaining about the heat despite its constant, oppressive presence. *Predator* is one of the sweatiest movies ever made, pure humidity onscreen—even though it was frigid during filming.

The mission's details are unimportant, as is the plot twist, when it comes, that it's all been deception. Dillon can't out-wrestle Dutch (who could?), but he easily fools the Austrian Oak into doing the CIA's clandestine bidding. The real mission involves retrieving information before it falls into Soviet hands, or

something like that. In other words, it's a Cold War proxy, a version of Vietnam we can win. Of course, it's also science fiction, this being 1987, and there's an alien running around. (Every film had at least one back then.) The creature watches silently from its perches, passing unseen, using thermal-imaging goggles that render Dutch and his men blobs of yellow and red and green against the electric blue-black of the jungle. Just hours before, it took out the first team that Dillon sent, Green Berets, skinning them and disemboweling them ("no way for no soldier to die"), then leaving their ghastly remains to dangle in the nonexistent breeze.

As it happens, *Predator* is not so different from *Alien*, in that the good guys show up to get murdered one by one. Small wonder then that those two franchises later joined forces, even if Arnold disappeared. Perhaps they'll eventually cross paths with the Terminator? There's still time.

THE FINAL SHOWDOWN (above)

DREW: *Predator* proved challenging due to the monolithic nature of the jungle, an overwhelming sea of dense green foliage. So I was relieved to get to the ending, where the jungle opens up, making room for the final showdown.

Predator works because it's simple—clean, straightforward, muscular film-making, a quintessential late '80s entry to the canon. Hyper-masculine, lean and taut, it reserves its mystery for its bad guy, about whom we learn extremely little—just that it's ugly and it appears when the weather turns hot, hunting for sport, making trophies out of men. Leaping from tree to tree like an ape, its mandibles opening and closing under its mask, it patiently watches, looking for weaknesses it can exploit. Dutch and the others have muscles and guns and jungle camouflage and their wits, but the Predator has a bag of

tricks straight out of *Star Trek*. Still, when injured, the creature stains the broad tropical leaves with fluorescent ichor—leading Dutch to grimly intone, "If it bleeds, we can kill it."

After *Predator*, John McTiernan went on to make *Die Hard*, another minimalist masterpiece; he did his best work when constrained by space, whether submarines or jungles or office towers. And where *Predator* is like *Alien*, *Die Hard* is its reverse: high tech and corporate instead of wild, and set indoors instead of out. Holed up inside Nakatomi Plaza, John McClane, on his little old lonesome, takes out terrorists one by one—he has the alien's role, swooping in, then disappearing, wreaking havoc. By 1989 *Star Wars* was starting to fade, taking with it the need for shots of outer space. *Die Hard* would establish a new paradigm, inspiring films like *Under Siege* and *Speed* and *The Rock*. Dutch retreated from our view. But I like to think that he's still out there, slowly smoking his

cigar while scanning the heavens, knowing that the next time the weather gets very hot, another Predator will arrive. Maybe someday we'll get a rematch. If so, there'd better be helicopters. •

THE Princess Bride

DIRECTED BY **Rob Reiner**

RELEASED IN **1987**

- ● WESTLEY
- ● BUTTERCUP
- ● INIGO MONTOYA
- ● FEZZIK
- ● VIZZINI
- ● PRINCE HUMPERDINCK
- ● COUNT TYRONE RUGEN
- ● MIRACLE MAX
- ● VALERIE
- ● THE ALBINO

Paths of True Love (2014)
Gouache on paper
16 x 19 in (41 x 48 cm)

Smarmy Prince Humperdinck schemes to have Princess Buttercup killed on their wedding night, which also happens to be the 500th anniversary of his picturesque country, Florin. This dastardly act will allow him to go to war with his sworn enemy, Guilder, the country across the bay, similarly picturesque. Why does he want to provoke this conflict? What brought these lands to such dire straits? We'll never know. In writing *The Princess Bride* (which first saw life in 1973 as a novel), William Goldman claimed to be not its author but its editor, the inheritor of a classic penned by S. Morgenstern. Supposedly Goldman's father read him only the exciting parts of Morgenstern's hefty text, leaving out the economics and political intrigue. Now Goldman is doing the same for his own son, trimming down the book to just the good bits. In the film, this scenario formed the basis for the frame tale, in which the grandfather reads to his grandson, skipping the sections with the kissing as well as other boring stretches. So in both versions, all the history goes missing, and we're stranded in the present of the tale. Florin hates Guilder, a fact we have to take on faith.

Perhaps the rift was caused by a trade dispute? As a kid, I didn't realize that Guilder and Florin aren't real countries, but Goldman's inventions. I looked in a dictionary one day to find that a guilder was the Netherlands' unit of currency until it adopted the euro. What's more, its symbol, *f*, was derived from the florin, a coin

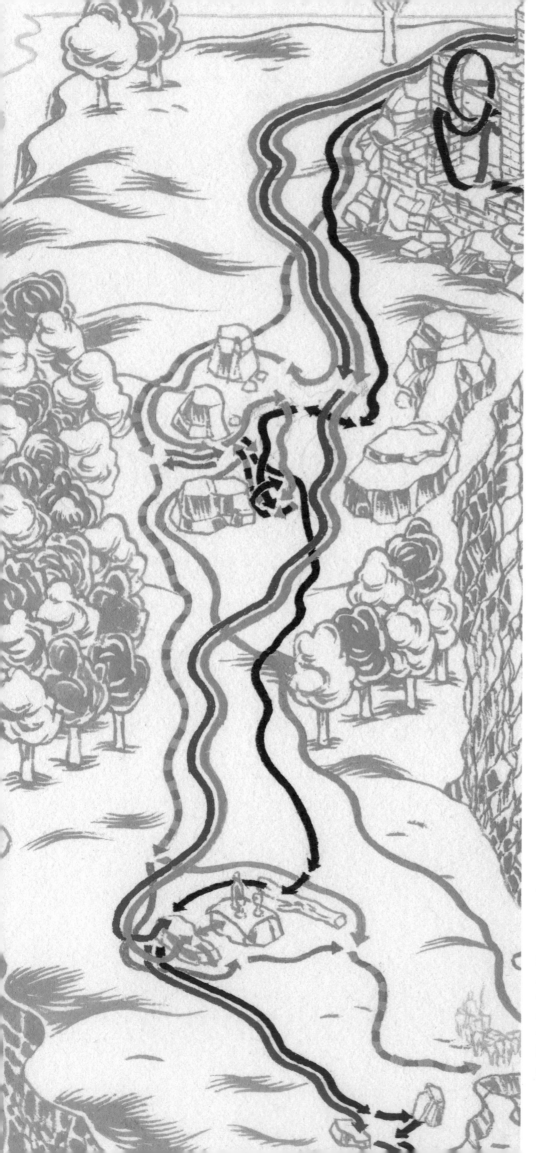

first minted in Florence a thousand years ago. The warring countries then were two sides of the same coin. I was slow to catch on, I think, because both the movie and the book made those countries seem part of the real world: Vizzini announces himself as Sicilian and threatens Fezzik with abandonment in Greenland. Inigo Montoya is a Spaniard, and the deadly and odorless iocane powder hails from Australia. One can imagine the roads that brought those strange people and things into Florin and Guilder, though such routes cannot be found on any map.

That's the charm of *The Princess Bride*. By pretending to edit the text, Goldman provides an excuse for not writing history, divorcing his tale from our world even as he connects it in other ways. He crosses the boundaries separating his fiction from us. Typically, fairy tales are works of high adventure—stories of knights setting forth from castles to seek the Holy Grail and battle dragons, proving their purity on behalf of virtuous maidens. The quests don't debase themselves by including everyday things or ruder humor. *The Princess Bride*, a bathic masterpiece, parodies those tales; it's a descendant of *Don Quixote*. The first thing we hear as the film begins is someone coughing; the first shot we see depicts a baseball video game. Rather than finding ourselves in a castle or an enchanted forest, we're in a little boy's bedroom in Evanston, Illinois. And what's more, that little boy is sick and in a bad mood. Only reluctantly does he put down the joystick and agree to hear a story.

The geography of the film is solely of the imagination, assembled from real locations in Ireland and England as well as stages at the legendary Shepperton Studios, in Surrey. One of its most impressive sections sees Fezzik hauling himself and his companions hand-over-hand up a cliff via a rope, all while pursued (inconceivable!) by a mysterious man clothed in

INCONCEIVABLE! (left)

ADAM: Vizzini and his associates go first, followed by the Man in Black, who's close on their heels. Later comes Count Rugen, who stops to puzzle out what we've seen happen. Being on horseback, Rugen quickly closes the gap.

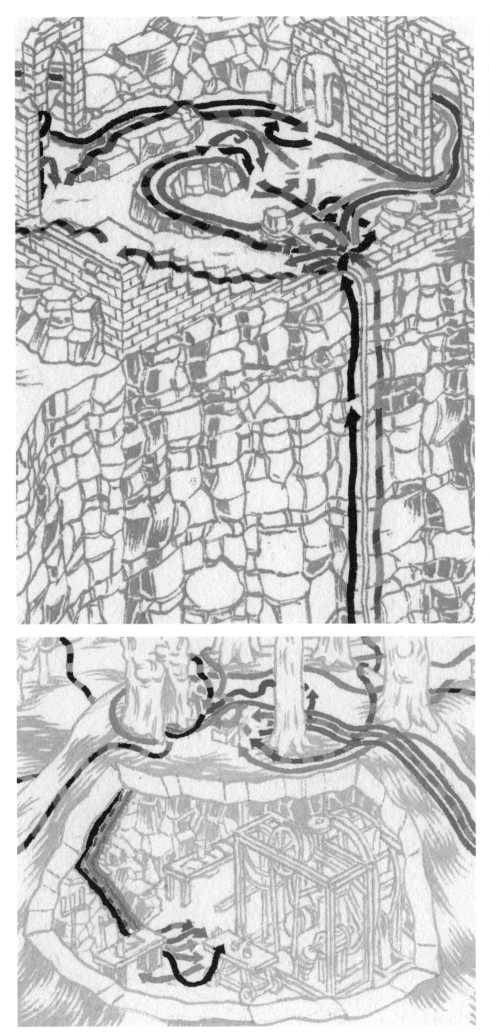

black and wearing a mask. The seaside cliff bottom was manufactured at Shepperton and involved the use of a water tank. (It's a fake-looking sea, with fake-looking shrieking eels.) Also fake is the clifftop, with its castle ruins. (Whose castle was it? Why did it crumble? Another boring bit of history we'll never learn.) The middle part of the climb was filmed at the Cliffs of Moher, in County Clare, Ireland—or so the internet tells me. And there are two more shots—one looking up, the other one looking down—which were mostly done with matte paintings.

In the novel, Goldman waxes nostalgic about those cliffs—but remember his shtick, pretending to edit the book his father read to him when he was a kid. He claims that this scene in *The Princess Bride* inspired him to write the bit in *Butch Cassidy and the Sundance Kid*, in which the two leads escape a posse by jumping off a cliff. "I can't swim!" Sundance complains. Butch bursts into incredulous laughter. "Are you crazy? The fall will probably kill you!" But those two made their leap in 1969, four years before Goldman published his mischievous tale. So Fezzik and Westley climbed because Butch and Sundance leaped.

Or was it the other way around? There's no way to be sure. Maybe somebody knew once, set it down in a book. But this detail has been lost to history. •

SWORD FIGHT AS STORY (top left)

DREW: Fight scenes are always tough to represent, but this swordfight is more narrative than ferocious, a choreographed routine set in crumbling ruins. I had a blast tracing out the ups and downs, as well as the feats of gymnastic one-upmanship, replaying the duel on the page.

THE PIT OF DESPAIR (bottom left)

DREW: The machine found in the Pit of Despair is a fantastical nightmare, able to suck years away from a person's life. Yet as scary as the machine is, in the end it couldn't do anything to Wesley that Miracle Max couldn't cure with a pill—one in chocolate coating, no less.

Each Indiana Jones film starts with a game. In *The Last Crusade*, the first thing we see is a string of Boy Scouts riding on horseback through Arches National Park in Utah. Two Scouts dismount to explore a cave where, in a scene straight out of *Tom Sawyer*, they encounter a gang engrossed in digging. One of the figures is wearing a jacket and a fedora, hands on hips, his back to the camera. Of course we think it's Dr. Jones—location aside, this is the same way we met him in *Raiders of the Lost Ark*. But then he turns and we see it's a stranger; Indiana is one of the Scouts, only thirteen years old and played not by Harrison Ford, as we (reasonably) expected, but by River Phoenix.

It's 1912. The teenaged Indy, outraged by the thieves, steals what they've found (the golden Cross of Coronado) and scampers off. The ensuing chase involves horses, cars, and a circus train and recounts how our hero got his bullwhip, the scar on his chin, his fear of snakes, and his fedora, as well as his deeply held commitment that relics belong in a museum. (Quite a day.) He loses the cross, but via a clever match on action, we cut to 1938 and the Portuguese coast, where Harrison Ford is back in the hat. We sigh in relief as the music swells—we're once again in the realm of the familiar—at which point a goon socks Dr. Jones across the jaw.

That sequence demonstrates in miniature the secret to the franchise. We all know the basic shape of the plot, which was modeled on James Bond. What brings us back, and keeps us watching, are

DIRECTED BY **Steven Spielberg**
RELEASED IN **1989**

- ● INDIANA JONES
- ● PROFESSOR HENRY JONES
- ● DR. ELSA SCHNEIDER
- ● MARCUS BRODY
- ● SALLAH
- ● WALTER DONOVAN
- ● COLONEL VOGEL
- ● KAZIM

Paths of Crusade (2012)
Gouache on paper
18½ x 22 in (47 x 56 cm)

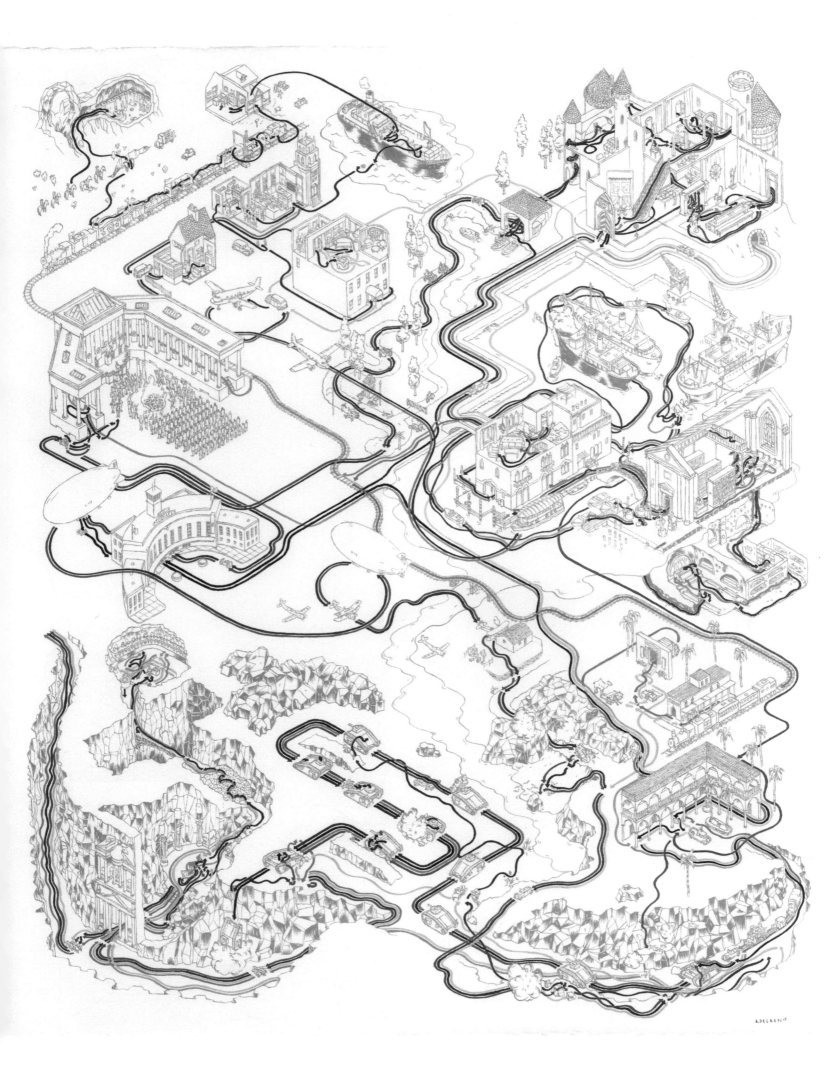

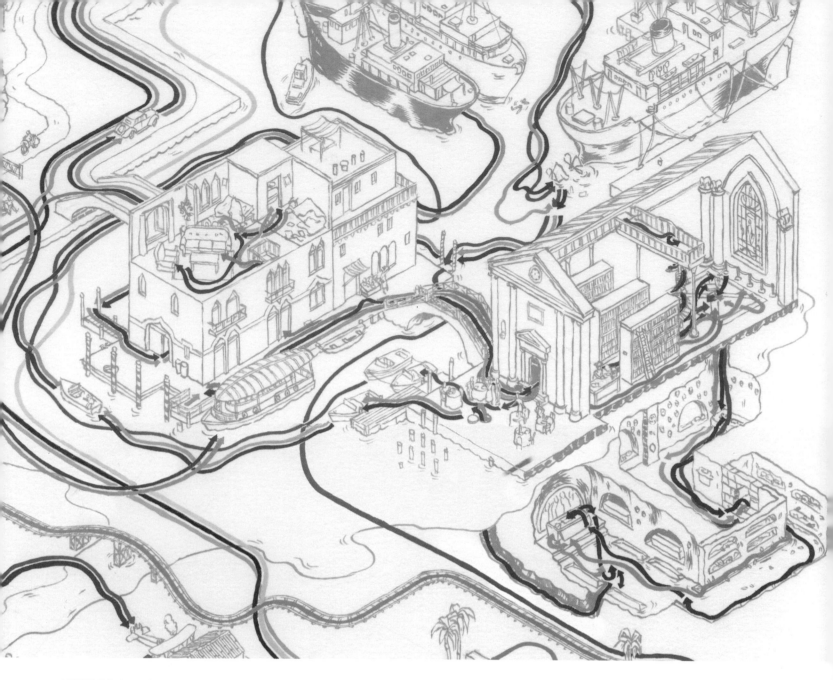

VENICE (above)

ADAM: Indy has a knack for finding fortunes underground, unearthing in Venice, of all places, an oil reserve—he mentions sinking a well and retiring. That's another hint that *Last Crusade* was meant to be the final film in the trilogy, and another way in which it resembles a Western.

the variations at play. What will Spielberg do this time to delay Indy's intro? And what other genres will he invoke? *Raiders* drew from safari films, traipsing around in jungles and archaeological digs. *Temple of Doom* replaced those with gross-out horror, being set in a haunted house (essentially). *The Last Crusade* dips its toe into westerns. The first things we hear are drums and chanting—American Indians after Indian Indians. And it closes with our four heroes riding off into the sunset.

But for the most part it remakes the first film—*The Last Crusade* is the New Testament follow-up to the Old Testament of *Raiders*. Less invested in Yahweh's anger, it chases redemption in the form of the Holy Grail, the cup that caught the blood of Christ at the crucifixion and now bears the gift of eternal life. Indy is charged with tracking it down before Hitler does, though really he's looking for the previous generation. *Raiders* saw him set out in search of Abner Ravenwood, Marion's father. This time around he's seeking his own dad, Henry Sr., from whom he's estranged. He flies off to Venice, dragging with him Marcus Brody (reimagined as comic relief), where they meet up with Dr. Elsa Schneider, an Austrian art professor with Willie Scott's blond locks and Marion's pluck.

The action takes them under the city into a hidden tomb with petroleum and

rats, then into the harbor, chased by a brotherhood in fezzes and suits with carnations. It turns out that Henry is being held captive on the German-Austrian border, in a castle—at long last Lucas got one in, even if it isn't haunted, or in Scotland. He compensates by having Indy affect a (terrible) Scottish accent—a sly nod to the character's roots. For Henry Sr., when he finally appears, is the true Scotsman, Sir Sean Connery, best known for having played James Bond (of course). Spielberg surrounds the legend with other alums from that franchise: Walter Donovan is portrayed by Julian Glover, who played the villain in *For Your Eyes Only*. And Elsa Schneider is Alison Doody, who made her film debut (decked out in riding gear) in 1985's *A View to a Kill*.

At the castle, we learn that Donovan is a Nazi, and that Elsa is also a traitor (and a somniloquist). Indy and Henry

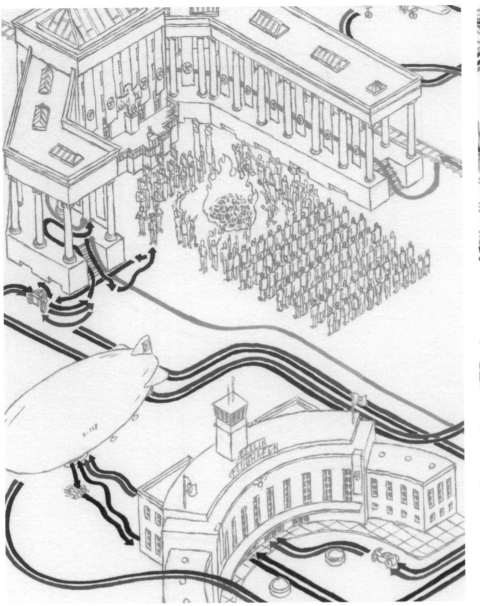

A LITTLE BIT OF EVERYTHING (above)

DREW: The challenge with mapping this film is its raw scope: the opening in the American West, the university, Italy, Austria, Berlin, the desert chase and Alexandretta. Plus it's got a little bit of everything: chases, crashes, trains, blimps, sewers. Just fitting it all in felt more like Tetris than mapping.

escape by means of motorcycle, dirigible, and biplane, bickering and bonding, as well as snagging Hitler's autograph. The film's last third involves a race across the desert, where Spielberg attempts to outdo the famous truck chase in *Raiders*. The final challenge tests Indy's faith, just as in *Raiders*—this is Bond-style continuity, in which the sequels reset the hero to square one. A skeptic who scoffs at the Grail legend (surely sublimated anger toward his dad), he outwits "three traps of such lethal cunning" by first acting penitent before God, then spelling the deity's name in a high-stakes game of hopscotch, and finally making a literal leap of faith. Reaching the chamber that holds the Grail (as well as a lot of other cups), he chooses wisely (unlike Donovan) and drinks deeply, as does his dad. They ride off together into history as the sun sets.

That ending, as well as the movie's title, implies that this installment was meant to be Harrison Ford's swan song. It should have been. The man was forty-six when he made it, and though it's the mileage and not the years, a two-fisted fellow like Indy racks up a lot of mileage. Sure, it's tough to imagine someone else wielding the bullwhip. But if Bond can be recast, then so can Indy (something else the opening sequence demonstrates). It's the formula that matters—hitting the beats while finding clever variations, new chances for peek-a-boo with Indiana's face.

Since 1989, both Harrison Ford and Sean Connery have grown older, as all men must. But Indiana Jones, the world-renowned archaeologist, remains forever young. Or forever old, or in between—he's whatever we want him to be, whatever age we want to imagine. James Bond is still out there, downing martinis and outmaneuvering other spies, so Indiana, once recast, will return triumphantly to the big screen, pursuing his penchant for punching out Nazis and then impersonating them, dressing up in their clothes. And that's the true Grail—forget all the business with the cup. Bond and Indy, father and son, now and forever, those two dashing, daring men of action will outlive us all. •

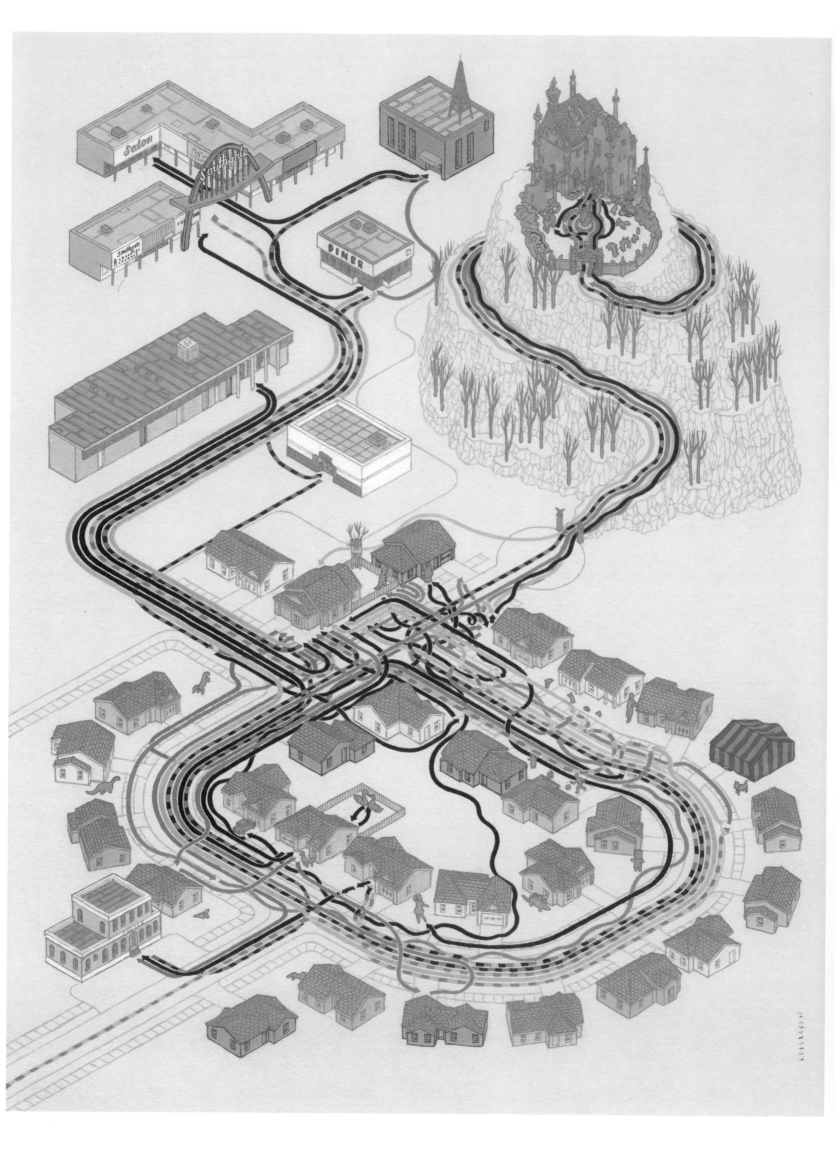

EDWARD SCISSORHANDS

DIRECTED BY **Tim Burton**

RELEASED IN **1990**

- ● EDWARD SCISSORHANDS
- ○ KIM BOGGS
- ● PEG BOGGS
- ● JIM

Paths of Edward (2017)
Gouache on paper
11½ x 15¼ in (29 x 39 cm)

Unable to find any takers in the suburb where she lives, Avon saleslady Peg Boggs (the incomparable Dianne Wiest) adjusts her sedan's side-view mirror and sees, looming over her cul-de-sac, a crumbling Gothic mansion. She drives up its winding dirt road and ventures inside, peeking her head through the doorway: "Avon calling!" The cavernous building is dusty, cobwebbed, and abandoned but for a curious resident, Edward Scissorhands. An artificial man, he is the final invention of the mansion's late owner (Vincent Price), who educated his creation with readings from books on etiquette and poetry but passed away before he could give him human hands. Now Edward, an orphan, keeps to the shadows and watches the suburbs from on high.

Of course he's a stand-in for the director. How often did young Tim Burton peer out his bedroom window at the residents of the bland Burbank suburb where he grew up, during breaks between Hammer horror flicks and hours spent mussing up his hair? Bound by leather straps secured with oversized buckles, Edward is a model of repression. He also resembles Cesare, the somnambulist slave in the German Expressionist classic *The Cabinet of Dr. Caligari*. He's more Pinocchio than villain, though. "I'm not finished," is what he tells Peg, sounding like a lost little boy. Skittish, he's prone to accidentally cutting himself, his pale face a tapestry of scars. Peg, pragmatic, nonplussed, takes him home and gives him some of her husband's old clothes, then applies an astringent.

Soon Edward's the talk of the pastel town, entertaining its gossipy housewives with his talent for topiary. From there he expands into dog grooming, then cutting women's hair. By and large, he becomes accepted—there's even talk of his opening a salon with Joyce, a bored and lusty neighbor who specializes in ambrosia salad and seducing handymen. But two dark clouds appear to mar the sunny horizon. The first is the suburb's kooky religious zealot, Esmeralda, who's convinced that Edward is satanic. The second is Kim (Winona Ryder), Peg's teenage daughter, who shows up around forty minutes in (she was off camping with some friends). Returning home late one night to find a monster in her waterbed, she panics, and soon she's being teased by her brother Kevin and her jealous bully of a boyfriend,

Jim, for having a crush on Edward.

The movie derives most of its power from its fish-out-of-water concept. Could anything look more out of place in the upbeat suburbs than gloomy Edward? The contrast is echoed by Danny Elfman's moody score, which gets interrupted here and there by Tom Jones tunes. But the film's aesthetic contains an insight: the suburb is not so much the *opposite* of the Victorian era as it is the *product*. Via flashback we learn that Edward's creator ran a small assembly line, producing tinned foods and cookies. He made Edward out of one of his robots (designed for chopping veggies—hence the scissor hands), transforming it, part by part, into a flesh-and-blood human being. It's as though a worker living in 1860 fell asleep and woke up a century later to marvel at

what the Industrial Revolution had wrought. Edward struggles at dinner to eat peas that are the products of a factory, packaged by robots who are later versions of him. Other Edwards in other factories made the cosmetics that Peg keeps applying to his face to cover his scars (which are industrial accidents). And the cars that everyone drives, the cars that enabled the creation of the suburbs, are the work of Henry Ford, the Inventor's heir. *Edward Scissorhands* thus depicts a timeline of sorts, with Edward marking its oldest end; he's the suburb's ancestor. If he fits in, it's because he can still be exploited, given cookies in exchange for the marvelous work he does grooming shrubberies and manes. Peg's husband Bill protests: "You can't buy a car with cookies." And Bill is right—but Edward's role is to build cars,

TWIN OBSESSIONS

ADAM: *Edward Scissorhands* combines Tim Burton's twin obsessions: the Gothic and 1950s kitsch. By the time he was growing up, suburban sprawl was paving over former farmland, allowing the middle and upper classes to flee city centers, which crumbled. The Gothic manors that they left behind fell into disrepair, becoming stereotypical haunted houses.

not buy them. When he tries moving up, by means of his own salon, he can't get a loan; he has no credit. All he has is himself: his pale pasty body and his scissors.

Edward's fate is to work forever—until he falls in love with Kim and tries his blades at carving ice, fashioning images of the teenage girl as an angel. She dances beneath them as the shavings fly every which way, pretending they're snowflakes—real snow, as opposed to the rolls of fake foamy stuff that Bill staples to the roof. Such is Burton's whimsical logic—Edward's heart, after all, is a Christmas sugar cookie.

Alas, such whimsy is not to be. Edward gets driven out of the suburbs by a mob, winding up back at the manor where he started. But he does more than come full circle. A worker who failed to become a bourgeois, he becomes a bohemian instead; he becomes an artist. The film begins and ends with a frame tale, set many years later, in which an elderly Kim tells her granddaughter that it snows because Edward is carving ice statues of her, statues in which she's forever young, the way he remembers her. Sometimes, she tells the little girl, she can still be caught dancing in the shavings—and for an instant, we see her doing so, rejuvenated, glowing. Art suspends time, prolongs ecstasy. Kim and Edward are not to be, but their bittersweet love affair produces a singular offspring: the movie itself. Tim Burton's most autobiographical creation, *Edward Scissorhands* tells how an unhappy boy from the suburbs transformed his misery into bliss. •

AMBROSIA SALAD

ADAM: Joyce's specialty, ambrosia salad, is a metaphor for the subdivision. Supposedly divine (being named after the food of the gods), it's in fact a sickeningly sweet concoction filled with colored marshmallows that resemble the suburb's houses, squat and identical except for their garish pastel paint jobs.

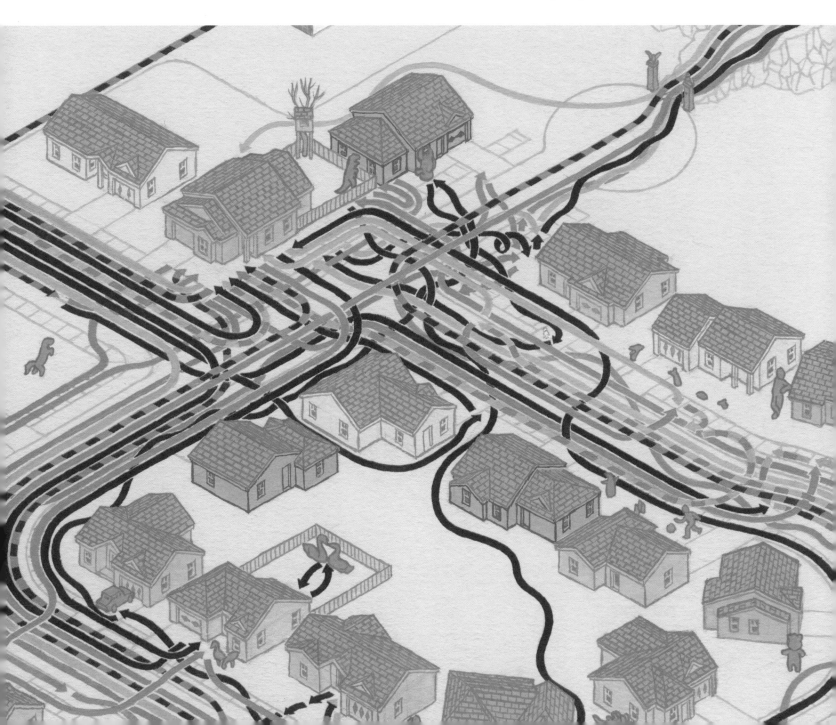

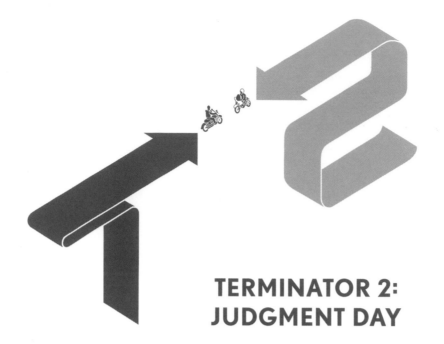

TERMINATOR 2:
JUDGMENT DAY

*T*erminator 2 is an anxious film, moody and melancholy, predominantly blue, at times bordering on the monochromatic. James Cameron said his inspiration for the franchise was a nightmare in which a metallic skeleton stepped out of flames and strode toward him, pinning him down with its beady red eyes. For this sequel, *Judgment Day*, Cameron wed that dreadful vision with an image of Armageddon: Sarah Connor, a modern Cassandra, grips a chain-link fence and screams as innocent children are wiped out by nuclear warfare, burning up like paper. Taking stock, then: a computer in the form of the Grim Reaper, obeying inexorable logic, turns our ultimate weapons against us. It's pretty disturbing.

But there's another concern underneath, even more unnerving: an unease over what's authentic. Sarah Connor gets locked up in a mental asylum because her dire predictions make her seem insane. (How could she know what's going to happen?) She passes the hours doing chin-ups in her cell, knowing that each rep brings her closer to Judgment Day—August 29, 1997—when Skynet becomes self-aware and launches its nuclear strike. She's also afraid that the future Skynet will send another killer robot back in time to murder her son, who will grow up to lead the human resistance.

Her fears are well-grounded. The wind picks up, starts blowing trash and papers around, as electricity sizzles and crackles. A dark

DIRECTED BY **James Cameron**

RELEASED IN **1991**

- ● THE TERMINATOR
- ● SARAH CONNOR
- ● JOHN CONNOR
- ○ T-1000
- ● MILES DYSON

Paths of Judgment (2016)
Gouache on paper
16 x 20 in (41 x 51 cm)

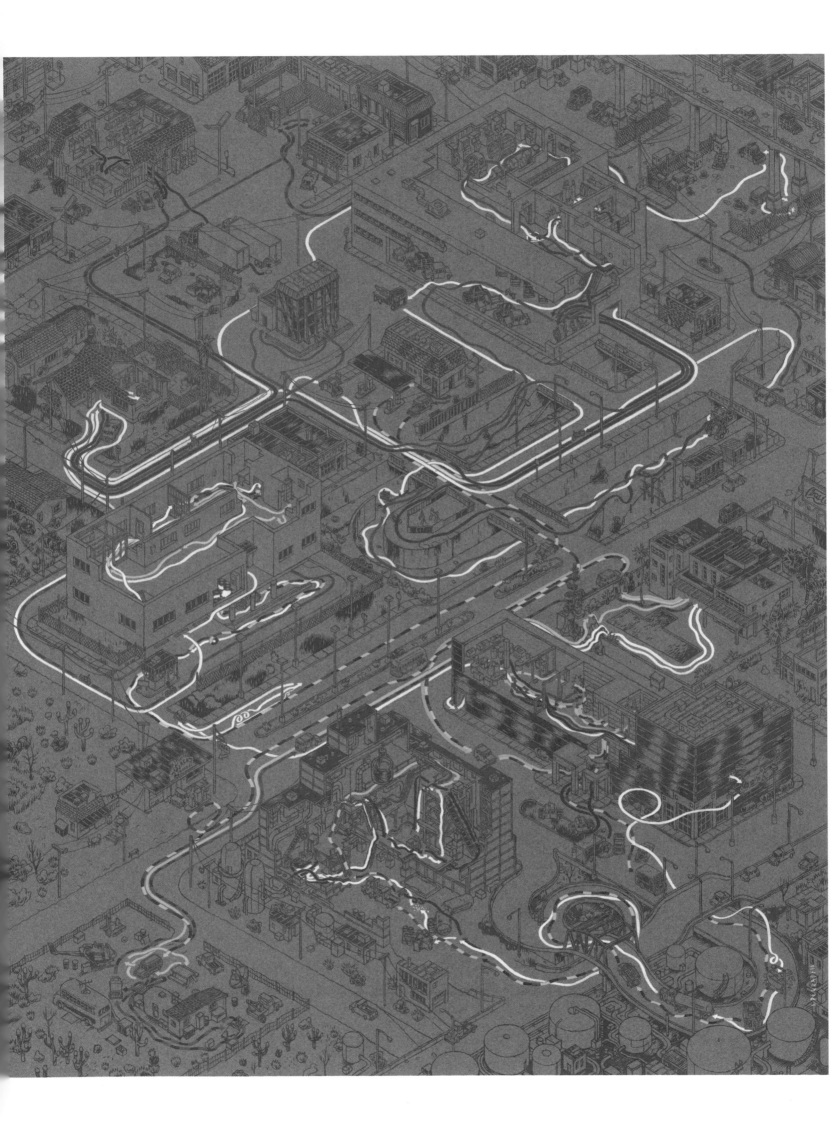

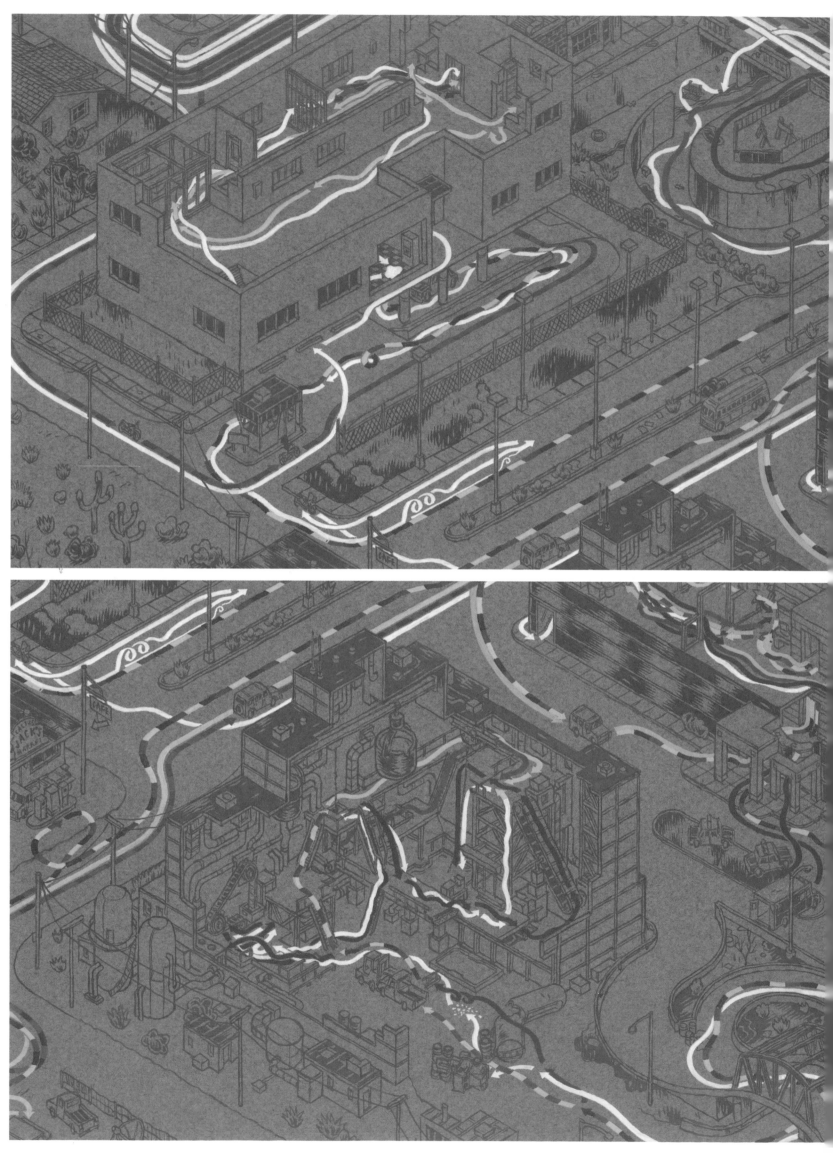

globe appears, like a tiny black hole, biting through steel before collapsing in on itself. In its place, an enormous man is crouching, muscular, naked. We've seen this before; we know precisely what it is: the T-800, an unstoppable cyborg assassin. The soundtrack amplifies our suspicion he's "bad to the bone." He beats up some biker dudes and steals a leather outfit, a motorcycle, and a shotgun, plus a wicked pair of shades, then sets out, cruising the streets of L.A. in search of Sarah's son—but this time, it's for humanity's good. The real threat is the next guy who arrives, Robert Patrick's T-1000—smaller, lither—a Porsche, as James Cameron put it, to Schwarzenegger's tank. That more advanced liquid-metal robot adopts the guise of a policeman and noses around, asking if anyone's seen John Connor. People (mostly naive young children) answer his questions, being deceived by his appearance.

Cameron takes his time getting to the showdown, drawing things out, putting the players in their corners and winding them up, calculating which trajectories will, when the robots finally collide, cause the most devastation. Caught in the middle, as blithely unaware as the little kids at the playground, is young John Connor. In 2029 he might be a brilliant general, leading the pushback against the

A DEADLY PLAYGROUND (opposite top)
ADAM: A child of the '80s, John Connor grew up in a landscape laced with machinery and computers. Where his mother sees those devices as a steadily gathering threat, John treats his surroundings more like a playground, ripping off ATMs and besting video games, honing the skills that will later allow him to reprogram Terminators.

THE BIRTH AND DEATH OF INDUSTRY (opposite bottom)
ADAM: Both *Terminator* films wind up in factories because those are the only places capable of destroying a Terminator. In other words, the only way to get rid of a robot from the future is to lure it to a present-day manufacturing facility—unmaking it at the spot that will eventually become its place of birth.

mechanical onslaught that grinds human skulls to powder, but in 1991 he's mostly a whiny preteen punk in a Public Enemy tee on a dirt bike. Rather than prepping for the future, he's ripping off ATMs with a buddy in a mullet, a permanent sneer contorting his lips as he talks back to his foster parents.

Destiny finally catches up with him at the mall. He runs but finds himself trapped between the converging cyborgs. The cop reveals itself to be bad; the T-800 clad all in leather turns out to be good, defending John with a shotgun it pulls from a box of roses. The film tumbles forward, revealing itself (like its predecessor) to be a chase: Eddie and Arnie (and Sarah Connor, once they break her out of her cell) on the run from the steely fake killer cop.

Which is where, for many people, the movie goes south, and by that I don't mean the Mexican border. On the run with Eddie Furlong, the T-800 becomes a combo surrogate father and robot pet. Schwarzenegger, by now a huge star, no longer wanted to play the villain or murder folk. So the ultimate killing machine was reduced to shooting people in the knees, taking orders from a brat you want to slap. The unapologetically violent films of the '80s were giving way to kinder, gentler '90s fare—see the *Star Wars Special Edition*, where Greedo fires at Han before the smuggler shoots him back.

It's enough to make you gag, horror turned treacle—but though it's sappy, the buddy story of John and his stoic "Uncle Bob" forms the crux of the film. At the end, at the steel mill, the high-tech Frankenstein's monster tells his master he knows now why he cries, even when that remains something that "I can never do." That line has been mocked by thousands of hipsters, but what does it mean? Well, what are tears? The product of grief, they just spill out of us, unbidden—we don't turn them on, and we don't turn them off. That's why they indicate genuine sorrow . . . unless we're dealing with a mimic and the arts—and Terminators. The T-800 imitates John's voice on the phone with the T-1000, which is imitating the young boy's foster mother. The T-1000 is more advanced not only because it's liquid metal (and totally awesome), able to reassemble itself and heal any wound, but

because it's a better impersonator—it's made from "mimetic polyalloy." In other words, it is liquid *mimesis*, pure imitation, with no authentic shape of its own. So maybe it could, unlike the obsolete 800 model, fake a smile and shed a few tears, but they would be crocodile tears that its metal body would then reabsorb.

The sharp divide, then, between the humans and the robots is the divide between the authentic and the fake—in other words, the distinction between real life and art. The robot understands John's grief in a logical way, but being artificial, unnatural, he can't partake. Even more distressing is that we can never really know if he's telling the truth—he does understand—or whether he's saying what he thinks the kid wants to hear. And more distressing still is that it doesn't matter: it might be true, and it might be a lie, but either way John can't stop crying. That's the genuine threat in *T2*: the inauthentic seeming authentic. The human resistance in the future uses dogs to sniff out the Terminators that infiltrate their camps. But humans aren't dogs. We can be fooled by our creations.

James Cameron never named the source of his bad dream, but I know what it was. In 1963, when Cameron was nine years old, he saw the fantasy movie *Jason and the Argonauts*. At the end, the villain Aeëtes summons, by sowing the Hydra's teeth while invoking Hecate (as well as the stop-motion master Ray Harryhausen), a cadre of skeletons equipped with blades and shields. Like so many other kids, Cameron was frightened out of his wits by the scene, even as he adored it. Twenty years later he hired Stan Winston, and the two men made their own version—imitation, after all, is the sincerest form of flattery. How many hours did they labor, fussing to get the look of their own killer skeleton right? What's important is that they succeeded, producing a film that went on to scare and delight so many, becoming its own object of imitation and adoration. That's what's so powerful, as well as disquieting, about art: it seems real. We fall in love with it, *ooh*ing and *aah*ing in the dark. But no matter how much we cry, or how much we laugh, art is never real. And it can never love us back. •

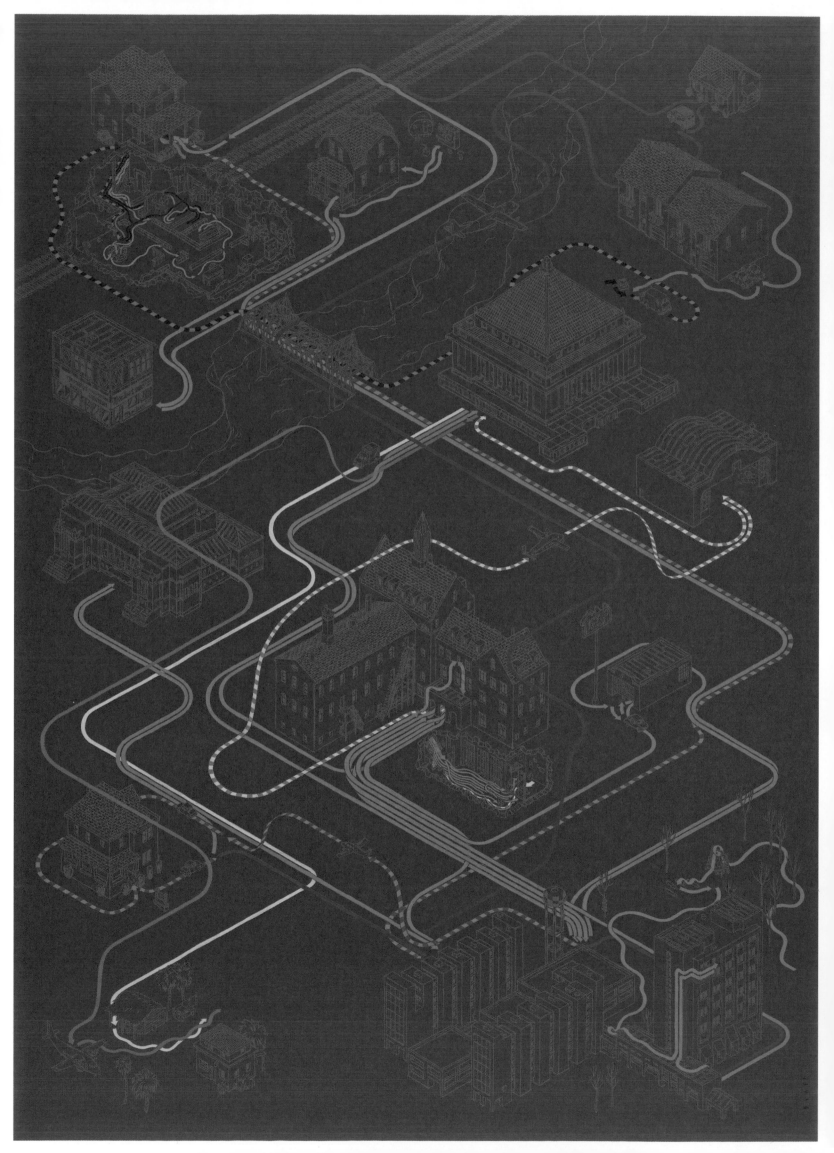

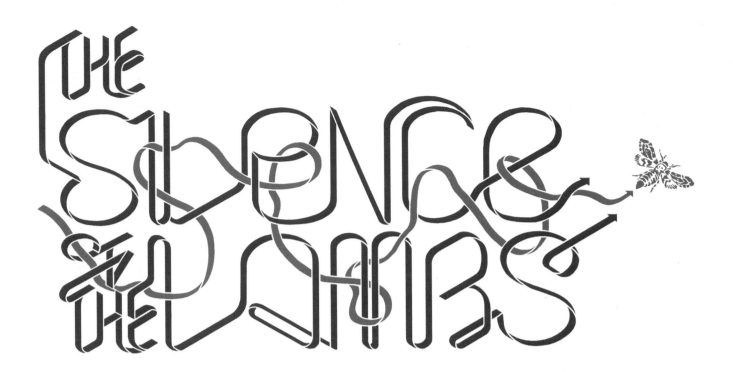

THE SILENCE OF THE LAMBS

DIRECTED BY **Jonathan Demme**

RELEASED IN **1991**

- CLARICE STARLING
- DR. HANNIBAL LECTER
- JAME "BUFFALO BILL" GUMB
- DR. FREDERICK CHILTON
- CATHERINE MARTIN
- JACK CRAWFORD

Paths of the Starling (2017)
Gouache on paper
14 x 19½ in (35 x 49 cm)

Lurking in the shadows, a serial killer dreams of transformation—no, not Buffalo Bill (who's a sideshow, if anything), but the cannibal Dr. Hannibal Lecter, who in *The Silence of the Lambs* found his chance to transition from supporting player to star. Anthony Hopkins won an Oscar for the part, and ever since we've dispensed with the pretense that Lecter isn't the main attraction. What finally did it, without doubt, is the outrageous fashion in which the bad doctor escapes from the Tennessee courthouse in which he's cooped up: unlocking his handcuffs with a tube from a pilfered pen, then butchering two careless cops, then eluding an entire police squad and a SWAT team by wearing one of the dead cops' faces as a mask. All utterly ridiculous if not for the fact that we believe in Hannibal Lecter, a modern-day bogeyman who's hiding under the bed, or down in the basement, or—oh my God, he's right behind you!—always one step ahead of his foes, outwitting them, dismembering them, and then calmly snacking on their livers.

He commands our full attention from the moment he shows up, standing erect in his dungeon of a jail cell, nasal and sibilant, his thinning hair greased back, his eyes open wide and unblinking, his tongue darting out between a pair of lips parted slightly in perpetual delight. Cultured, articulate, well mannered, as attuned to forensic details as Sherlock Holmes, he makes a deal with FBI trainee Clarice Starling, quid pro quo, demanding details about

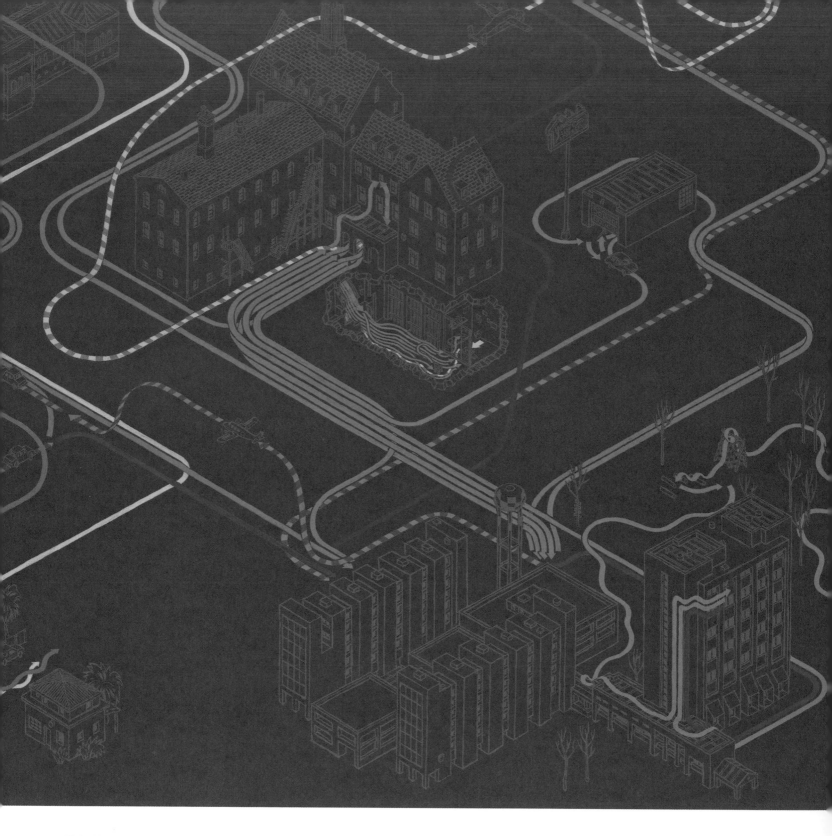

TWIN DUNGEONS (above)

ADAM: *The Silence of the Lambs* is built on parallels, containing not one but two subterranean prisons, each holding a different prisoner: Catherine Martin, Hannibal Lecter. By the movie's end, both are free.

her life in exchange for his help tracking down Buffalo Bill, an amalgamation of Ted Bundy and Ed Gein, a gangly loner who kidnaps young women in order to

make a dress out of their skins. Jonathan Demme stacks the deck, building our sympathy for Lecter by surrounding him with nitwits, none more maddening than the pompous Dr. Chilton, the puffed-up head of a genuine madhouse with stone walls and men who shriek and rattle the bars of their cells. By the time Lecter winds up strapped to a dolly, trussed up in a straitjacket, the lower half of his face concealed behind a mask, we're in his corner, cheering him on. Demme cheers him on, too. Note the brief glimpse that

he gives us, moments before Lecter murders the two guards serving him dinner, of an issue of *Bon Appétit*.

But Clarice Starling. We're introduced to her all sweaty, panting, navigating an obstacle course in the woods outside Quantico, scaling climbing nets while distant gunshots echo. Her name sounds fragile, and Jodie Foster looks young and fragile, always surrounded by taller men who coolly eye her up and down (the male gaze made manifest). She acts like she doesn't see it; instead, what

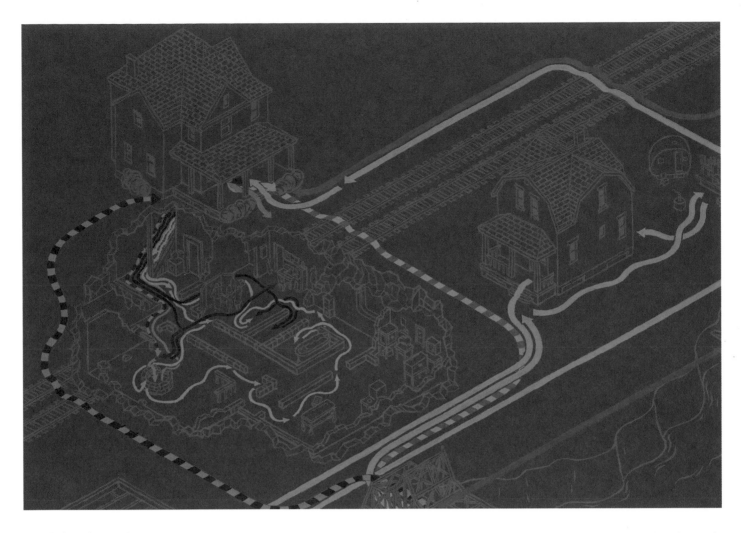

PRECIOUS (above)

ADAM: Trapped in Buffalo Bill's basement, Catherine Martin captures and threatens Bill's beloved toy poodle, Precious. But after being freed, she exits the house clutching the fluffy white dog to her chest, a haunting image that recalls Clarice Starling's own account of once trying to save a spring lamb from her relative's farm.

·

unsettles her is the past—her father's murder, and the screaming of slaughtered lambs on her relative's ranch. She's brimming over with remorse, the sense that she could have saved both lambs and Pa—which fascinates Lecter, to whom remorse is a foreign country.

What unfolds is a retelling, more or less, of beauty and the beast, set during winter, when the world is dead: imagery drained of color and sutured to Howard Shore's soundtrack, funereal brass and strings punctuated with exhalations. This Demme seasons with jarring crosscuts and surrealist details: two men playing chess with living beetles, blood slowly dripping from an elevator ceiling, multiple

death's-head hawkmoths (a clear nod toward Dalí, whose work the movie poster quotes), and—most memorable of all—Hannibal Lecter sitting up inside an ambulance, as if risen from the dead, ripping away a false face to grin beside an unsuspecting medic.

It comes down to taste. FBI special agent Jack Crawford, impeccably tailored, distant, baits Dr. Lecter with Clarice, prompting Chilton to observe, "Are you ever his taste!" Lecter mocks Starling when she shows up in front of his cell, saying that with her "good bag" and "cheap shoes" she looks "like a rube . . . with a little taste." He's trying not to let on how much he's intrigued by her, with her pluck and her talent for anagrams. As for her, she intuits straightaway that he's unlike other serial killers, men who surrender to deviant impulses, driven to hunt out of animal need. Reading Buffalo Bill's file, Starling tells Crawford the killer won't stop because "he's gotten a taste for it." But Lecter's taste is something different; the man is infinite patience and pure self-control. He eats people not out of any impulse, but because he *can*. He has an

argument with the world, and with people like Chilton and Senator Martin, rude inferiors who dare to regard him scornfully, bind and cage him, and assail him with Christian TV. Ultra-sophisticated, superior, superhuman, Lecter knows what's good in life, and so he hangs back, taking in everything and everyone with his dark eye. Biding his time.

He escapes, *naturellement*, during the film's climax, and then he calls Clarice, already missing her. We know he'd never harm her. They're equals, in agreement on one vital point: people are sheep. Their disagreement, instead, is what to do with that knowledge. Clarice wants to save them; Hannibal, to eat them (the big bad wolf). The movie for its part tries to remain above the fray. Demme cranes his camera up as Hannibal Lecter disappears into the crowd on a street in Bimini. But Demme likes the slippery gent, and so do we. We're happy to watch the doctor go free to stalk a new victim: Frederick Chilton. The former jailer stands no chance. It's easy to win when the director's on your side—and giving you peeks, now and then, at the script. •

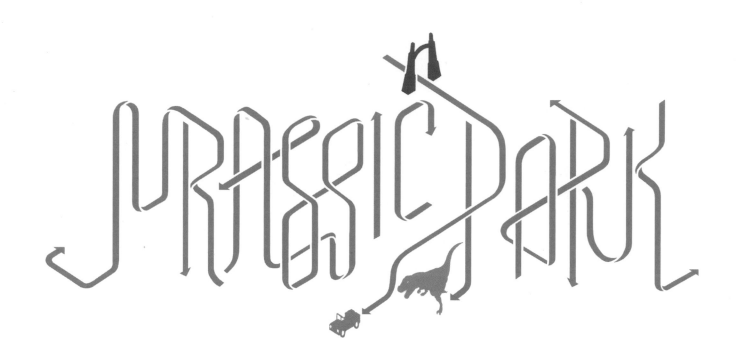

Two-thirds of the way through *Jurassic Park*, the grown-up little boy John Hammond sits alone in the dark eating melting ice cream. He tells paleobotanist Ellie Sattler that the first attraction he built when he came down from Scotland was a flea circus, "Petticoat Lane," which had a trapeze and a seesaw and carousel. People loved it, gathered to marvel at the fleas. But it was all fake. "With this place," says Hammond, meaning the park that's collapsing around his ears, "I wanted to show them something that wasn't an illusion—something real."

He succeeded, for a spell. When *Jurassic Park* came out, people marveled at the dinosaurs, so lifelike, and made it the highest-grossing movie of all time. Now, nearly twenty-five years later, it's hard to view the film so naively. It's clear the dinosaurs are illusions. The parts done with practical effects, with animatronics, have held up better than the parts done with CGI, but it's all clearly no more real than Hammond's motorized fleas.

But does that matter? Hammond's mistake is thinking that it takes something real to thrill us. He's not satisfied with art. "We're overdependent on automation," he tells Sattler. He wants a creature you can *touch*—not pixels or plastic, ersatz beasts that show their seams, but monsters that really eat the actors. "Next time," he promises, "it'll be flawless."

It's inviting here to read the film as a metaphor for filmmaking, with Hammond as Spielberg's stand-in. The opening scene depicts

DIRECTED BY **Steven Spielberg**
RELEASED IN **1993**

- ⬤ GRANT
- ⬤ ELLIE
- ◯ HAMMOND
- ⬤ MALCOLM
- ⬤ LEX
- ⬤ TIM
- ⬤ NEDRY
- ⬤ GENNARO
- ⬤ MULDOON
- ⬤ DODGSON

Paths of the Isla Nublar (2016)
Gouache on paper
10½ x 14 in (27 x 36 cm)

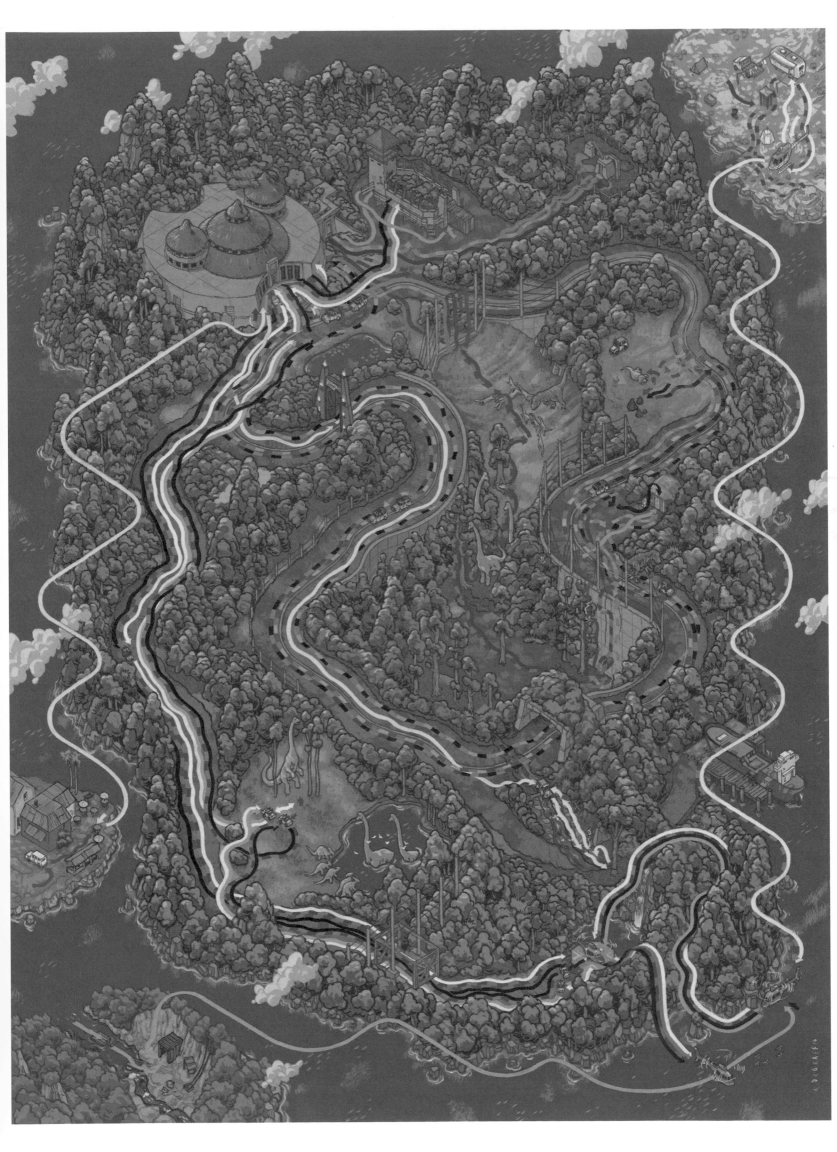

FIELD OF DREAMS (above)

ADAM: Unlike a lot of computer-generated imagery from the 1990s, the inhabitants of Jurassic Park still hold up pretty well. This meadow featured our first look at the dinosaurs, whose realism and detail were unprecedented. To bring his dinosaurs to life, Spielberg amplified the CGI effects by using animatronics and puppetry, too. Jurassic Park established solid ground rules that today's filmmakers are wise to obey: use practical effects whenever possible, computers when you have to.

an accident, as a worker falls prey to a vicious velociraptor. The park's financiers, suddenly skittish, demand that experts visit the island, Isla Nublar, and report on whether it's stable. If it isn't safe—if they're not absolutely certain they'll make billions—then the investors are pulling out. How many times did Spielberg hear such threats as he struggled to make a motion picture? Just like Hammond, he had to create a massive enterprise that would entertain young and old—to which extent he "spared no expense" in bringing dinosaurs back to life. When late in the movie the camera tracks through Jurassic Park's gift shop, lingering over the dolls and lunch pails, how much of the stuff is really merchandise for the film?

The crucial difference is that Hammond is messing with nature, trying to tame what can't be tamed. He and his scientists have taken the most ferocious animals ever (dinosaurs!) and made them the center of the safest thing imaginable (a park!). It's the height of hubris; as rock

star mathematician Ian Malcolm proclaims over his plate of Chilean sea bass, "The lack of humility before nature staggers me." Hammond thinks he can turn nature into whatever he wants it to be, contain its power.

He's wrong, of course, and the park falls apart, its center unable to hold because nature doesn't honor human intentions. The critters don't know they're supposed to stay locked up in their paddocks, performing like dolphins and seals at Sea World. As Sattler puts it, the dinosaurs don't know and don't care what year it is, and they "will defend themselves—violently, if necessary." Despite Hammond's staff's meticulous efforts—despite their electrified fences and video surveillance system—they can't plan for every contingency. We see how it goes awry as duplicitous Dennis Nedry, seduced by a rival firm, shuts down the system so he can abscond with viable embryos in a faux can of shaving cream. He, too, learns the hard way that nature is red in claw and tooth, and can spit blinding neurotoxins.

This is where Spielberg differs from Hammond; he has to solve a different problem. Nature doesn't give a hoot what Hammond wants, or what any human wants—as far as nature is concerned, we could all go extinct tomorrow. All life could. "Life finds a way," Ian Malcolm insists, but sometimes it doesn't. The reason why Hammond is able to make his park in the first place is because dinosaurs, long ago, went the way of the dodo. Nature is indifferent to our intentions; it's simply what it is.

But intentions are all that matter when it comes to art, which differs from nature in being *contrivance*, not accident. Hammond's plans implode because he doesn't—and can't—account for everything that could happen. That's the lesson Malcolm teaches (chaos theory) as he flirts with Dr. Sattler, dripping water on her hand. The world is too big; representations fall short, distort. The map is not the terrain. The world wriggles free from our control. Things just happen. But art is the one place where everything happens for a reason. It's pure contrivance, pure control. Spielberg, a master, lines everything up, crafts the perfect storm. Jurassic Park is not *Jurassic Park*.

For example, when we first meet Alan Grant, digging up dinosaur bones in the Badlands, he clearly doesn't want kids, whereas Sattler clearly does. Their relationship, healthy for now, is presumably headed for the rocks—and not the kind they like, the ones laden with fossils. On Isla Nublar, Sattler sics Timmy on her beau, encouraging the little kid to ride in whichever Jeep Grant chooses. But Sattler's scheme fails, and Hammond's grandkids wind up with the craven lawyer, Gennaro.

Still, Spielberg succeeds where Sattler couldn't. He has the cars stall right by the *T. rex* while the tropical storm is at its peak and Nedry is shutting down the system. The *T. rex* attacks and Gennaro runs off, only to get gobbled up while cowering on a toilet. It falls to Grant to take care of the kids, to help them survive the night and return to the visitor center—the movie's backbone. Along the way, Grant transforms from gleefully pretending to slash a boy's stomach with a velociraptor claw to defending two kids from that gruesome fate. They make it, of course, and as they escape in a helicopter, Ellie watches the kids fall asleep in her boyfriend's lap. He looks at her; she looks at him. The music swells. Art finds a way. •

CHAOS THEORY (opposite)

ADAM: For the movie to work, the park must fail, with dinosaurs running amok. But that makes sequels inherently comedic: Why would anyone visit the island again, or reopen the park?

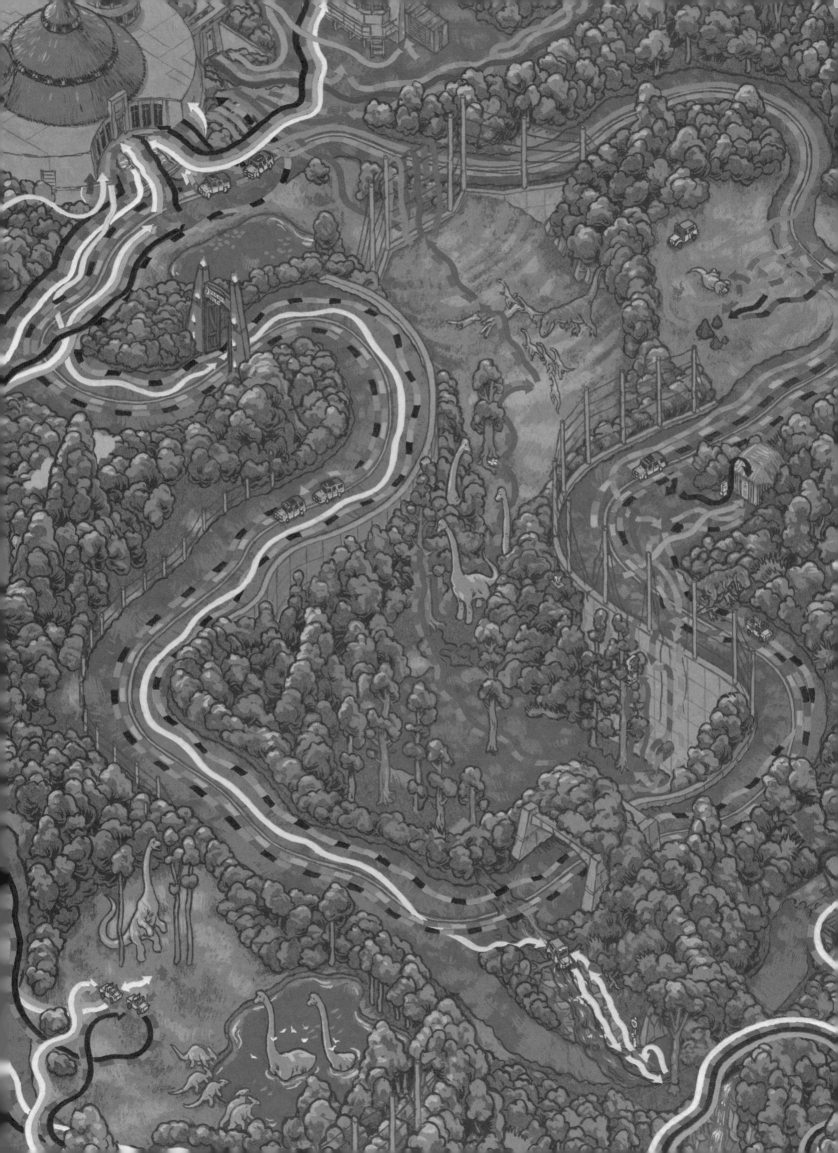

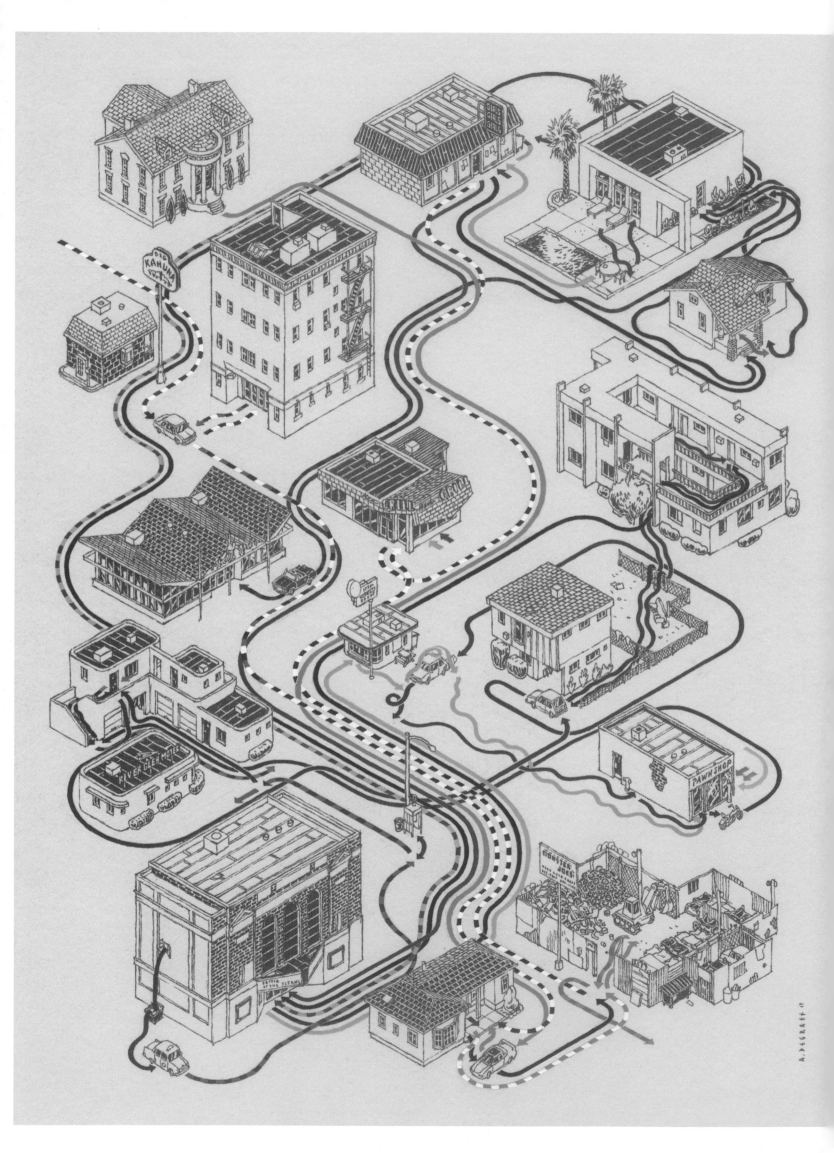

DIRECTED BY **Quentin Tarantino**

RELEASED IN **1994**

- ○ JULES WINNFIELD
- ● VINCENT VEGA
- ● MARSELLUS WALLACE
- ● MIA WALLACE
- ● BUTCH COOLIDGE
- ● FABIENNE
- ● ESMARELDA VILLALOBOS
- ● MAYNARD

- ● ZED
- ● THE GIMP
- ● MARVIN
- ● JIMMIE
- ● THE WOLF
- ● RAQUEL
- ● PUMPKIN
- ● HONEY BUNNY
- ● LANCE

Paths of Fiction (2017)
Gouache on paper
9 x 12 in (23 x 30 cm)

Pulp Fiction isn't about pulp fiction, even though it pretends to be, its opening screen presenting two definitions of *pulp*. The first—"a soft, moist shapeless mass of matter"—is a joke, a jab at the film's convoluted structure that, despite its initial appearance, is anything but soft or shapeless. The second describes "a magazine or book" with "lurid subject matter . . . printed on rough, unfinished paper"—and that's a joke, too. Unlike *Grindhouse*, which reveled for hours in imperfections—scratches and soundtrack pops and bad splices—*Pulp Fiction* isn't rough or gritty or cheap, but shiny, timeless, bright and clean. It's *glamorous*, like Hollywood films of the 1950s, by which point the pulps were in decline. As Tarantino himself said, *Pulp Fiction* is an epic, an $8 million film that looks like $25 million, shot on lustrous stock with hardly any grain—noir in broad daylight with all the lights on.

Pulp Fiction also isn't postmodern, although critics tripped over one another to call it that in 1994, when it burst onto the scene. Pomo has never been QT's thing. True, he steals willy-nilly from movies that he likes (and he likes a whole lot), stuffing his films with the pilfered goods. But it isn't reference—it's repossession. There is nothing outside his texts. Part of his genius is to make his allusions look not like allusions, but already his. He steals not only shamelessly but seamlessly, building his own artistic landscape, the Tarantino Cinematic Universe, closed off and hermetic and consistent.

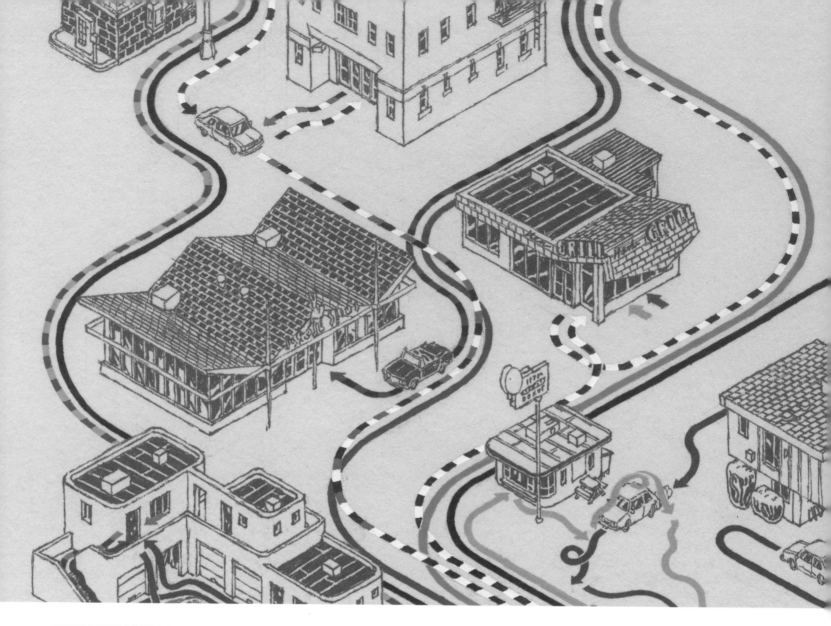

EATING THE PAST (above)

ADAM: The diners in *Pulp Fiction* function like time machines, Jack Rabbit Slim taking us back to an idealized 1950s, while the Hawthorne Grill seems stuck in the 1970s. The latter was a real restaurant, but was torn down after filming.

You could say it's like a clock—a golden wristwatch—precise and deliberate, nothing haphazard or accidental, nothing scrambled for scrambled's sake. Just like the characters he writes, QT savors his meals (feasts of red meat), never skipping ahead to the bloodshed. We open in medias res in a diner where Pumpkin and Honey Bunny are talking (as his creations are wont to do), discussing the ins and outs of different robbery targets before they settle on right where they're sitting. They share a kiss, then leap to their feet, guns out, warning patrons not to move—at which point Tarantino digresses, cutting to titles set to Dick Dale's surf-rock take on "Misirlou."

The film's first half repeats that structure as Tarantino sets his half dozen plots in motion. The station changes, literally, with "Miserlou" giving way to "Jungle Boogie." Two gangsters are driving: Jules and Vincent, dapper in black suits, looking as though they just auditioned for *Reservoir Dogs*. We're in medias res again, Vincent regaling Jules with details about his recent trip to Europe ("Royale with Cheese") as they head to retrieve a briefcase for their crime lord boss. Arriving early, they kill more time (debating the degree of intimacy of a foot massage) before barging in on a quartet of young punks enjoying breakfast. Brainy banter followed by bloody business ensues, but right as the bullets begin to fly Tarantino cuts again, interrupting himself once more, heading elsewhere, starting his sprawling story anew.

The first half is all setup, and the second is all resolution—which is what Tarantino does in all his films. Two decades later, it's plain to see he's obsessed

with suspense, crafting long scenes that slowly escalate as he explores different means for delaying the resolution. Consider the bit where Bruce Willis's Butch, while fleeing the pawn shop, decides to go back for Marsellus Wallace. He chooses a weapon, first lifting a hammer, then a baseball bat, then a chainsaw—until he sees it, hanging above him, holy and on high: a samurai sword. Tarantino always makes us wait. Before that, Butch went home for his gold watch, lifting it off the kangaroo figurine on the nightstand and slipping it onto his wrist, then moseying into the kitchen to heat up some toaster pastries. *Pulp Fiction*'s pleasure is the pleasure of the tease, of gratification long delayed.

Which is why *Pulp Fiction*, in the end, isn't like Butch's watch. Time marches on, in real life as well as in the movies. Tarantino impedes that progress, suspending moments, building his films out of past things he can't bear to see forgotten. It isn't kitsch, and it's more than

OAK IS NICE (above)

ADAM: Jimmie and Bonnie's house in the Valley is pretty domesticated, with gourmet coffee and a beautiful oak bedroom set. It's also extremely clean, thanks to Winston Wolfe.

nostalgia. Butch goes back for his father's gold watch because it has sentimental value: a family heirloom, it's been passed down from father to son over four generations, from his great-granddad to the present. It means everything to Butch, but its value has nothing to do with money. Butch could buy another wristwatch, maybe even a nicer one, but there's only one watch that is his birthright, only one watch his father hid up his ass in Hanoi. That watch is synonymous with his father, and with his family: there's nothing else like it, and it can never be replaced.

Tarantino loves old films, of that there's no doubt. But his love for those artworks is more than mere sentiment, and his movie is more than a watch. He wants to preserve older pieces of culture not because they're heirlooms or antiques, but because they are *good*. The man is a connoisseur, gleefully rummaging through pop culture, singling out songs and TV shows and movies worthy of being remembered and revered. He builds his

own films out of their parts, an expansive world made of solid gold—a fantasy realm where Colombian women drive old-fashioned taxi cabs, and briefcases glow when opened, mesmerizing their beholders. In that world, everyone's sexy and cool, confident and eccentric, unhurried and verbose. They're poetic and articulate—literary—never hackneyed or vulgar or rude. They lead such exciting lives, and every scene is good, every line is good. Everything's crafted, and everyone has exquisite taste. Jules recites what he claims is a Bible passage (Ezekiel 25:17), but really it's taken from Sonny Chiba—which is, in QT's estimation, truer scripture.

Of course the result was highly successful and, for a while, everyone copied it, or tried to—the mid- to late '90s were littered with wise-talking badass gangsters wearing suits. Those rip-offs and knock-offs were the true pulp, lurid hack work with purplish prose and drugs and graphic sex and violence. They didn't get it; they

lacked what Tarantino has, which is, in the words of Winston Wolfe, "respect for one's elders." Those feeble films have been forgotten, consigned to the dustbin, whereas *Pulp Fiction* has rightly taken its place among the classic works of art it venerated. A classicist of impeccable taste, Tarantino knows what's good, what's worth keeping around. •

Clueless

You couldn't put one past Sherlock Holmes. That peerless sleuth saw all, his pipe gripped tightly between his teeth, his beady eyes drinking in every detail that came his way. Stand before him and he could assemble your whole life story, recite your biography back to you, cradle to present, just from observing stray scuffs on your insoles, or the smudges and stains on your sleeves. Give him a magnifying glass, a microscope, and enough time, and Holmes—forensics' patron saint, omniscience incarnate—could not only unravel plots and conspiracies and solve dense mysteries of all kinds, but also reconstruct the entire world's history, working backward.

Unlike the teen at the center of *Clueless*, Cher (Alicia Silverstone), whose knowledge of history extends no further than 1972. And though her geometry instructor admires her "nice shapes," she mostly exasperates her teachers by not knowing who the Haitians are, or even how to pronounce the word "Haitians"; she also mistakes one of Shakespeare's sonnets for a "famous quote" from Cliffs Notes (though, to be fair, she does better with *Hamlet*, having seen the Mel Gibson version). More obviously, more obliviously, Cher claims to be a normal teenage girl when in fact she's filthy rich, an elite among elites who spends her ample spare time buying clothes and doing aerobics, or using software to design ultra-fashionable ensembles from her ever-expanding wardrobe. Where Holmes contented himself with one outfit, Cher is a whirlwind of jackets and

DIRECTED BY **Amy Heckerling**
RELEASED IN **1995**

- ○ CHER
- ● DIONNE
- ● TAI
- ● JOSH
- ● CHRISTIAN
- ● MURRAY
- ● TRAVIS
- ● ELTON
- ● AMBER

Paths of Cher (2017)
Gouache on paper
9 x 12 in (23 x 30 cm)

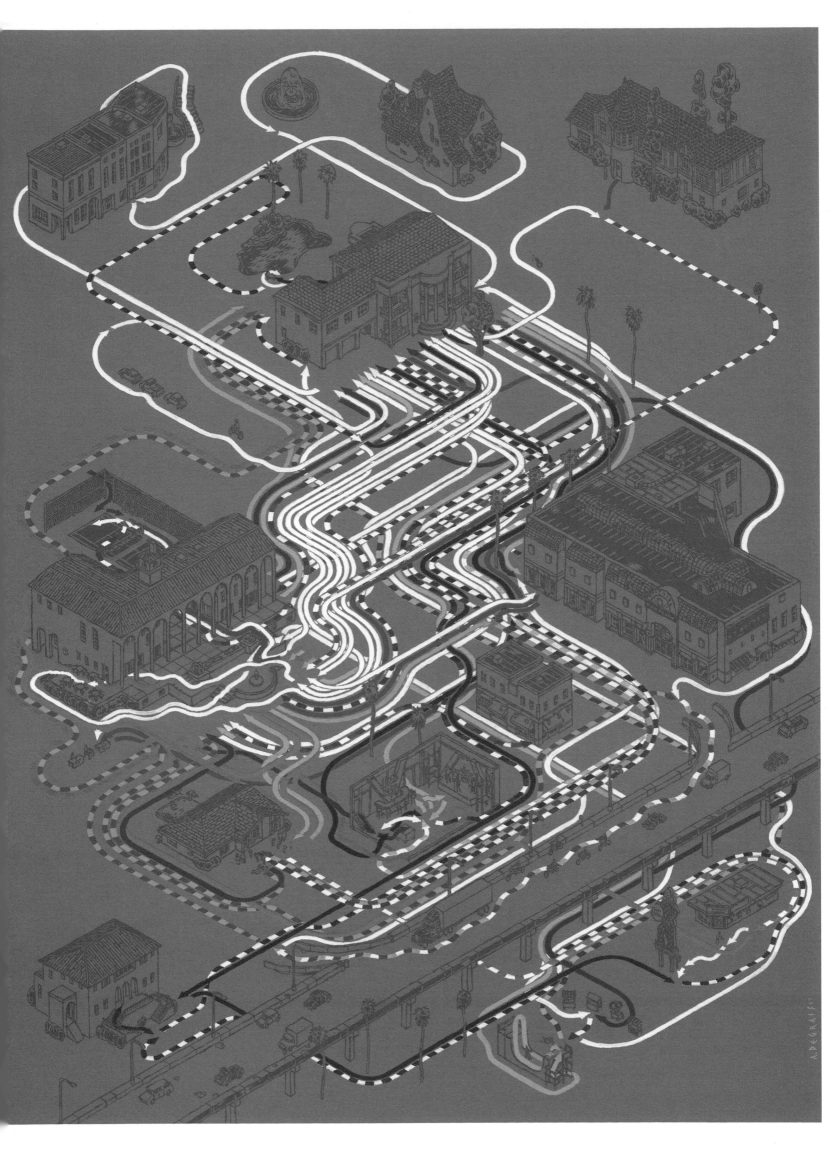

miniskirts and vests and knee socks and shoes, as well as matching accessories (though, like Holmes, she favors plaid).

But in other ways, Cher proves eagle-eyed, far more perceptive than her peers. She just sees what she wants to see—what pertains to her. She sits atop her high school's pecking order, having mastered its taxonomy of cliques, knowing precisely what to do in every conceivable situation. Like Holmes, she delights in displaying her knowledge. But whereas that man, passive-aggressive, amused himself by speaking down to his companions ("Elementary, my dear Watson!"), Cher takes us in as confidantes, sharing her tips for getting one's way, as well as her diatribes on (for instance) how poorly all the young dudes dress today. She also assumes that we, like her, speak the latest slang (much of which was invented for the film but went on to have a life of its own).

Articulate and sharp, Cher is admirably bold. Reasoning that a grade is "just an offer to begin negotiations," she fearlessly argues her way into an improved report card, rightly impressing her litigator father (Dan Hedaya, delightfully gruff). Apparently she does so every semester. But this time around, Cher decides to go further. Reasoning that her debate teacher, Mr. Hall (national treasure Wallace Shawn), gave her a C because he's middle aged and sexually frustrated, she schemes to make him "sublimely happy" via a "boink-fest," matching him up with frumpy fellow instructor Miss Geist. The

latter has runs in her stockings and lipstick on her teeth, but Cher and her best friend Dionne intervene and make Miss Geist over, revealing the cutie underneath. Holmes was content to explain the past—who did what to whom, where the bodies were buried, what mode of transit people took when visiting him. Cher uses her powers of perception to fashion the future, rewriting reality to accommodate her formidable will. Her matchmaking works: Hall and Geist share coffee, then start awkwardly smooching beside their cars. Meaning that everyone's grades go up, earning Cher a round of applause.

Delighted, she adopts as her next "good deed" the remaking of new student Tai (the late Brittany Murphy, brilliant), whom Cher finds "so adorably clueless." Cher and Dionne coach Tai on who's who in their school—who's a Betty and who's a Baldwin—scheming to set her up with Elton, a preppy snob who's named, like them, for a popular singer, ignoring the fact that it's the sweet stoner skateboarder Travis with whom Tai has real sparks. Here writer-director Amy Heckerling starts pulling the rug out from under Cher, who approaches dating like a general does war, sending herself love letters and flowers to arouse jealousy and designing lighting concepts to impress dates. ("Always have something baking," she tells us.) It's all about making sure things go exactly the way she wants.

But Cher fails to recognize that Elton cares not a whit for Tai, instead wanting her; nor does she realize that the dapper fellow she fancies, Christian—"the ring-a-ding kid" who loves shopping and dancing and art—is gay. And what's more, she's clueless about her annoying stepbrother Josh (Paul Rudd). That college lad is Cher's inverse and her foil: socially conscious and unfashionable, watching CNN and reading Nietzsche, studying environmental law while needling Cher for being "90 percent selfish." Only gradually does Cher realize that she loves Josh, and that he's also fallen for her—that he's been mooning after her ever since he saw her atop a staircase in a slinky white number by Calvin Klein.

A retelling of Jane Austen's *Emma* (which I assume Cher has never read), *Clueless* is fast paced, witty, funny, and

endlessly quotable: "She's a full-on Monet!" "I've got a .45 and a shovel. I doubt anybody would miss you." "As if!" It's also a meditation on cluelessness. We always know more than its characters do (both the teenagers and the adults), and everyone screws up at least once—even the singer from the Mighty Mighty Bosstones fails to crowd surf. But just as in *Fast Times at Ridgemont High*, Heckerling never paints her characters as objects of derision, even when they do foolish things like fall down stairs and upchuck in swimming pools. Instead, she strikes a balance between the cartoonish and the endearing: Cher donates her skis and caviar to disaster relief, and Travis (Jeff Spicoli's younger brother) delivers an impromptu speech on the secret of being tardy. (He thanks McDonald's.)

Clueless opens like a Noxzema commercial—girls sunbathing poolside, impishly feeding cute guys the cherries from their milkshakes—and concludes with a wedding, the merry union of Geist and Hall. That great detective Sherlock Holmes may have perceived all, but when there was no case to be solved he grew lethargic, cooping up in his flat on Baker Street, doing coke. He never married. Cher, who catches Geist's bouquet, may not know much about the past, but she could never be so clueless as dusty old Sherlock—not when there are so many plots left to hatch, so much future yet to be written. •

MAKING MONET PROUD (opposite)
DREW: The character paths get so tangled here, they wind up becoming a full-on *reverse* Monet: up close it's OK, but from far away, it's a big old mess.

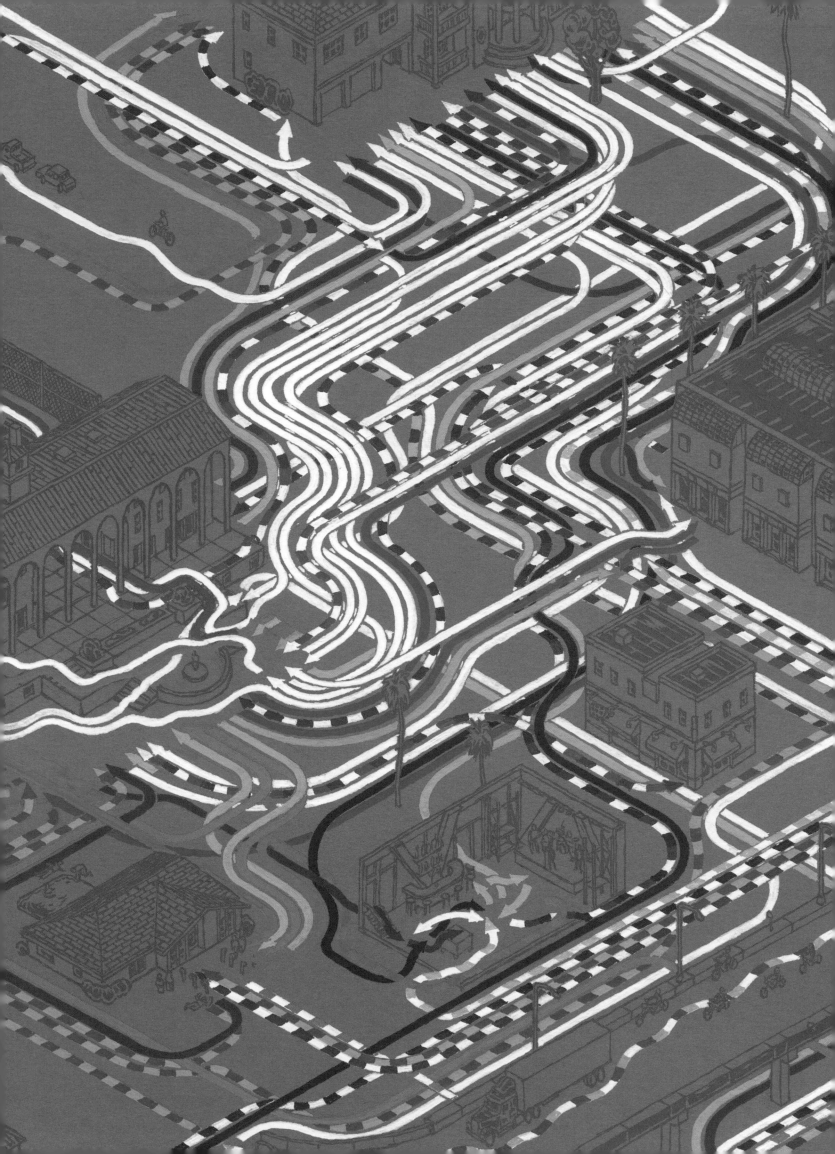

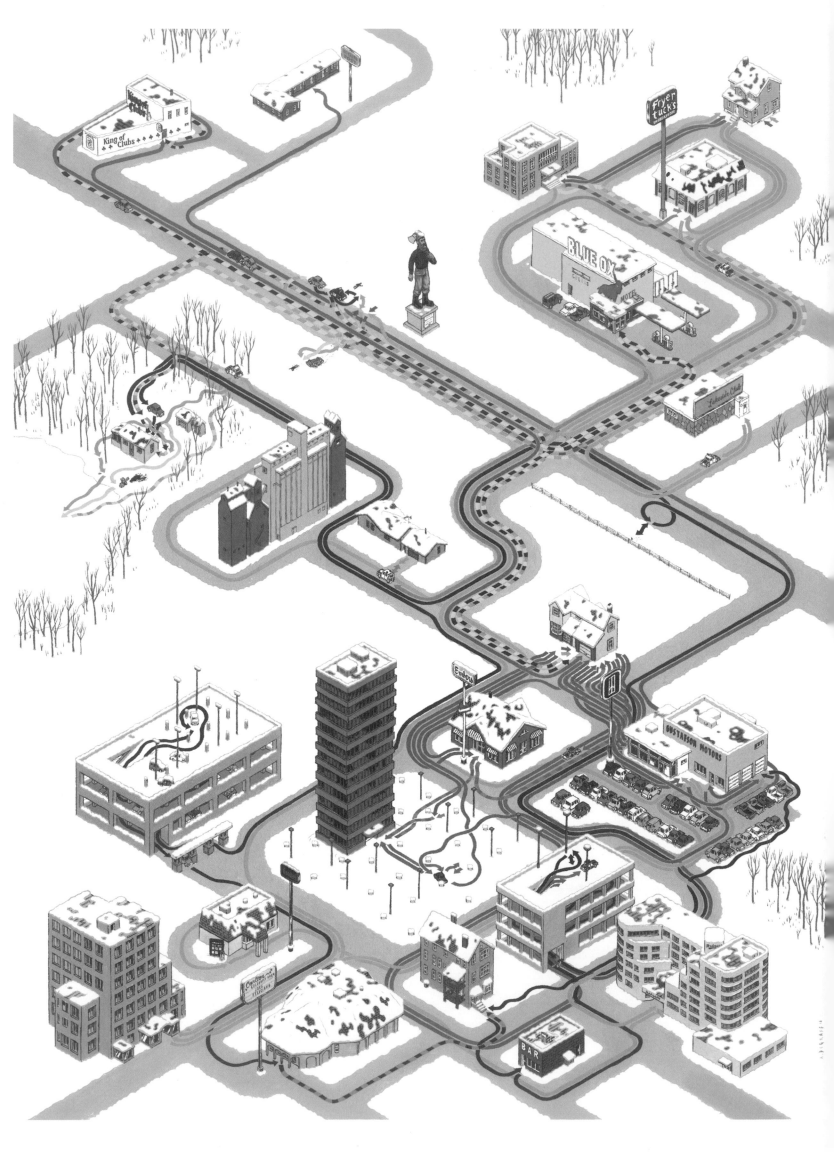

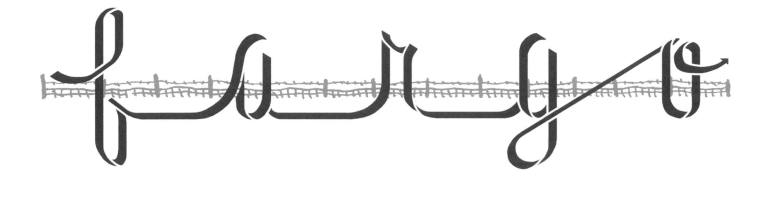

DIRECTED BY the Coen Brothers

RELEASED IN 1996

- ● MARGE GUNDERSON
- ● JERRY LUNDEGAARD
- ● JEAN LUNDEGAARD
- ● CARL SHOWALTER
- ○ GAEAR GRIMSRUD
- ● WADE GUSTAFSON
- ● SHEP PROUDFOOT
- ● STAN GROSSMAN
- ● NORM
- ● MIKE YANAGITA
- ● LOU
- ● OFFICER OLSON
- ● MR. MOHRA
- ● THE ESCORT

Paths of Fargo (2016)
Gouache on paper
16½ x 22 in (42 x 56 cm)

There aren't many trees in *Fargo*. The stray ones we see are relegated to the backgrounds of occasional shots, gray and ghostly and unmemorable. A straggly bunch of saplings, naked and frail and spaced out in planters, adorns the parking lot where the similarly feeble salesman Jerry Lundegaard, having once again been humiliated and thwarted in his ambitions, futilely vents his many frustrations on his sedan's iced-over windshield before he settles down and dutifully resumes scraping. By 1987, when the movie is set, nothing remained of the old-growth forests that once extended across Minnesota and North Dakota, mighty forests that Paul Bunyan cleared with the help of his loyal blue ox, Babe, two giants leaving in their wake a landscape like a relentless flat plane, extending, barren and snowy, in every cardinal direction. Only at the end of the film is the existential monotony relieved by a scene that takes place in the woods, a young patch of maples on the bank of Moose Lake, clinging tenuously to land. There, intrepid police chief Marge Gunderson advances on one Gaear Grimsrud, a tall silent killer who looks, some say, like the Marlboro Man, and who fails to notice her at first, being intent on feeding the corpse of his former associate, Carl Showalter, into a wood chipper that emits a fine bloody mist, transforming the snow before man and machine into a mess of gore the color of red velvet cake—a rare bright patch in a film that embodies the dullest, most overcast days of winter.

This is America, darn tootin'. Lundegaard, the executive sales manager at the Oldsmobile dealership owned by his surly father-in-law, is a feckless man who spends long lonely days trying to con people into paying for unwanted extras. He's an American archetype, a descendent of *Death of a Salesman*'s Willy Loman and a kindred soul to the flimflam men in *Glengarry Glen Ross*, sunken, hollow, gray and ghostly, as unmemorable as the trees. Lundegaard in up to his eyeballs in shady dealings, which is what leads him to hire the two goons, Gaear and Carl, to kidnap his wife. He drives out to meet them at a seedy bar in Fargo, the King of Clubs, advancing cautiously through a blizzard, towing a burnt-umber Cutlass Ciera as Carter Burwell's momentous score, based on a Norwegian folk tune, builds. The solemn tone is undercut in the following scene, which introduces Carl, an East Coast hipster who's "kinda funny lookin'" ("more than most people, even"). Gleefully profane, twitchy and impolite, woefully underdressed for the weather, Carl is already being driven slowly insane by the snowy landscape, by repetitive meals ("we stop at pancakes house"), and by awful TV reception. It's immediately clear he'll screw his companions the first chance he gets, just to prove that he can, and that he's just as inept as Jerry. He lashes out at the wide-eyed salesman,

berating him for having arrived late, which Jerry dismisses as "a mix-up."

Things only get more mixed up from there. What was supposed to be a no-rough-stuff type of deal goes rapidly south—southwest, actually. Typical for the Coen brothers (ironists till the end), the bulk of the film takes place not in Fargo, but in Minnesota—Minneapolis, and Brainerd, and the aforementioned Moose Lake—which is to say, it takes place not far from where the directors grew up, in the suburb of St. Louis Park. That's one reason the movie poster, a faux-cross-stitched image of a corpse in a snowy field, calls it "a homespun murder story."

The other is that the story concerns two different homes. The first one belongs to the Lundegaards, relatively affluent and fond of pig figurines. There, Jean busily cooks and knits until she's taken away in a scene that recalls both *The Shining* and *Psycho*, never to return. No path leads back to her unfinished chores, to the skein of wool she drops when taken. The second home belongs to the Gundersons, Marge and Norm, and their unborn child, due to arrive in two more months. Instead of pigs, their place of residence (less opulent than the Gundersons, but cozier) is adorned with images of ducks, most of them paintings made by Norm, an artist competing to have a mallard chosen for a stamp. Their home is their nest, a point

made explicit by a television program in which a bark beetle ferries a worm back to its lair to feed its young. Norm brings Marge lunch at her office, and as she sits down to her meal—"What do we got here, Arby's?"—she hands him a sack of bait; the Coens intercut a close-up shot of the earthworms, fat and wriggling. The couple's sturdy love anchors the film ("Aw, Norm, you got Arby's all over me"), as does Marge's decency. She's pragmatic and even-tempered and always polite, even when dealing with crooks, or a former classmate who tries to seduce her but turns out to be a serial liar. She's like a Midwestern Sherlock Holmes, quickly and expertly reading crime scenes while suffering from morning sickness and muttering folksy sayings like "It's a real shame." Her goodhearted logic guides us through the moral wasteland, a place where, just as in *Twin Peaks*, the regional dialect and good manners ("Ya, you betcha") barely conceal a morass of festering resentment.

It's a true story, the Coens insist, and though they're lying, we would do well to believe them. As in all their films, the proceedings in *Fargo* are exaggerated, but they're also true in the same way that legends and folk tales are true. *Fargo* ends fairly happily, thanks to Marge, who stares unflinchingly at everything and everyone she encounters, restoring order. As she

LUMBERJACKS (left)

ADAM: Jerry Lundegaard dreams of building a parking lot, paving over yet more of the deforested expanse of Minnesota. He aspires to be a modern Paul Bunyan, which is why he hires Gaear Grimsrud, who resembles the hulking lumberjack of lore. And who appropriately enough winds up killing someone with an ax, then feeding the victim's body into a wood chipper.

climbs into bed with Norm in the last scene, he reveals that his mallard was chosen to adorn the three-cent stamp, but not the twenty-nine. Marge consoles her glum husband, defending the three-cent stamp as useful, and their conversation echoes the one we just watched her have with the sullen murderer Gaear, hand-cuffed in the backseat of her patrol car. Studying him in the rearview mirror, she tries making sense of the horrible things he's done "for a little bit of money." "There's more to life than money," she says. Why chase the twenty-nine-cent stamp when postage will only go up? Meanwhile, the three-cent stamp endures.

That's true, Marge, but so do dreams of avarice. On the outskirts of Brainerd looms a wooden statue of Paul Bunyan, its ominous painted eyes leering down at all who enter. That fantastical lumberjack never really lived, never really walked the American Midwest. But just try telling that to the trees. •

AN OCEAN OF SNOW (below)

DREW: I approached *Fargo* as an ocean of snow, with little islands and causeways breaking up the monotony. But as I painted, I began thinking of that ocean as frosting on a rotten cake. What pokes through the saccharine monotony is brutal banality.

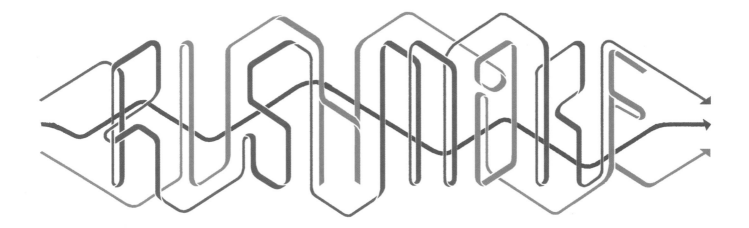

DIRECTED BY **Wes Anderson**

RELEASED IN **1998**

● MAX FISCHER

● HERMAN BLUME

● ROSEMARY CROSS

● BERT FISCHER

● DR. NELSON GUGGENHEIM

● DIRK CALLOWAY

● DR. PETER FLYNN

● MARGARET YANG

Rushmore's title has to be a pun, a reference not only to those monumental presidential heads adorning their mountain, but also to the bewildering behavior of Max Fischer, an extraordinary teen who knows only a single speed: ever busier. We meet him at the start of a new term at the prestigious prep school where, precious and precocious, he busies himself with extracurricular activities in lieu of passing his classes. Industrialist Herman Blume, having just delivered an address to the student body, asks Max the secret of his self-assuredness, to which Max replies, "You've just gotta find something you love to do and then do it for the rest of your life. For me, it's going to Rushmore." The elite academy is his means of entertaining his many ambitions—captaining the debate team, managing the lacrosse team, fencing, shooting, keeping bees, putting on elaborately designed plays. In other words, Max Fischer wishes he were a dandy, a man of leisure. He's like the younger brother of Eli Cash in *The Royal Tenenbaums*, who'd gladly trade away all his success as an author to have been born upper-class.

Fancy, fancy, being rich. Ashamed of his own humble roots, Max tells everyone he meets that his father is a neurosurgeon who cuts open people's brains, when in fact the man cuts hair—one of many ways in which Wes Anderson compares Max to Charlie Brown, another son of a barber. But Max is pragmatic, not despondent, and energetic instead of worrisome and glum; his bushy brow

Paths of Rushmore (2017)
Gouache on paper
14½ x 20 in (37 x 51 cm)

furrows only when he's on the brink of some crazy new scheme. The adults around him have no clue what to make of this fifteen-year-old in braces who acts like their equal, looking both confident and ridiculous in his charismatic presumption. He captivates Blume, a Vietnam vet who was once "in the shit" and is now astonished to find himself middle-aged, bored, drinking too much, and deeply depressed. He's *The Graduate*'s Benjamin Braddock all grown up and all sold out, having gone into plastics (or steel) and still seeking escape at the bottom of a swimming pool. Blume asks Max to work for him—he can see the kid has backbone, which money can't buy. Indeed, Max Fischer is Blume's inverse, having ambition but no success, whereas Blume is all success without ambition.

But Max declines. He has eyes only for Rushmore—until he catches sight of the school's new first-grade teacher, Miss Cross, a young widow whose husband was once a student there. Smitten, Max finds a new lease on life: to impress her, and thereby convince her that she should take both his attention and his affections seriously. Cross, unsettled but also bemused, humors Max. Like Blume she's vulnerable, pale and lovely, her eyes always puffy, as though she's recently been crying. Unable to move past her husband's death, she moves into his parents' home, lying awake in his childhood bed, staring up at the model planes his young hands hung from the ceiling.

Blume falls for Cross, too, running Max smack dab into the truth that, although he pretends to be an adult, he isn't one, yet. Max also gets expelled from Rushmore and is forced to attend a public high school, where he acts as though nothing has changed, marching through the halls in his Rushmore threads like he owns the place, putting on elaborate new plays, creating new clubs. He also turns nasty, vying with Blume in a series of escalating attacks that transform everyone's lives into a living hell as fall gives way to winter. In the darkest part of the year, which is also the lowest point in the film (dramatically), Max tries once more to seduce Miss Cross, an attempt that fails when she sees through the fake blood anointing the teenager's forehead.

And so Max Fischer, like Alvy Singer in *Annie Hall*, turns to the theater. Which makes total sense—after all, a play ("a little one-act about Watergate") won him a scholarship to Rushmore. Now he mounts his greatest production, *Heaven and Hell*, an ambitious Vietnam action-drama. The fake blood that Miss Cross saw through in real life works wonders onstage, bringing the audience to its feet and reuniting and reconciling the many people whom Max has wronged. The film reveals itself as a comedy, a tale of rebirth, the social order freshly restored, pairing off its lonely characters: Cross with Blume, Max with Margaret Yang, Max's father with Max's math teacher. They happily dance as the movie slows, the heavy curtains swinging closed amid catharsis.

Rushmore took audiences aback when it came out, with its distinctly twee aesthetic, a carefully posed look drawn from the works of Martin Scorsese, Roman Polanski, Stanley Kubrick, Jerry Lewis, and Hal Ashby. It was obvious Max was some kind of stand-in for Anderson, another eccentric prodigy. The film, bookended by velvet curtains and accompanied by a bounty of pretty songs, gives the impression of being one of Max Fischer's plays; it's easy to imagine that Anderson directed it while wearing Max's splendid green corduroy suit and red beret. What both Fischer and Anderson like about directing is how it rewards their endless fussing, bending to their wills and going exactly the way they want. Life is messy and sprawling and always hurrying by, unable to be paused or contained or comprehended. Art is a means for slowing down time, ensuring that things wind up in the right spots, neat and tidy, all made perfect. Art is the one place where we never have to rush. •

AT LEAST NOBODY GOT HURT

DREW: Every character in this movie, major or minor, has a great moment, so it broke my heart to cut anyone out. That said, I drew the line with Luke Wilson's Dr. Peter Flynn, because his exchange with Max in the restaurant about OR scrubs is my favorite joke in the film.

LORD OF THE RINGS

DIRECTED BY **Peter Jackson**

RELEASED IN **2001–2003**

- FRODO
- SAM
- GANDALF
- ARAGORN
- GOLLUM
- MERRY
- PIPPIN
- BILBO
- LEGOLAS
- GIMLI
- BOROMIR
- WORMTONGUE
- ELROND
- ARWEN
- TREEBEARD
- URUK-HAI
- WITCH-KING OF ANGMAR
- THÉODEN
- ÉOWYN
- ÉOMIR
- FARAMIR
- DENETHOR

Next spread: *Paths of the Ring* (2014)
Detail, this page
Gouache on paper
52½ x 30 in (133 x 76 cm)

All John Ronald Reuel Tolkien wanted to do, way back when he started, was to write a bedtime story for his children, in which a chubby jolly hobbit named Bilbo Baggins, who liked to spend his days eating his meals and smoking his pipe, was forced by the elderly wizard Gandalf to leave his snug home in the ground and set out on a perilous adventure with some dwarves. Along the way, Bilbo wound up lost and trapped in a cave with a curious creature, a miserable being who fed on fishes and unwary travelers, who made a sound in the back of his throat, "*gollum, gollum.*" Desperate, frantic to escape, Bilbo agreed to a riddle contest with the monster who, when defeated, not only showed Bilbo how to get out, but handed over his magic ring, which turned its wearer invisible. With that enchanted piece of jewelry, Bilbo helped the dwarves defeat the dragon Smaug and reclaim their ancestral mountain kingdom and its treasure. Now a hero, as well as a very wealthy hobbit, Bilbo returned to his comfy home and retired. The end.

Except the story didn't end. Something about Middle-earth gnawed at Tolkien, who started writing a sequel, "The New Hobbit," in which a relative of Bilbo's sets out on his own quest. Like his uncle he went astray, running into not Gollum but a man with a magical ring of his own. Here Tolkien paused. Who was this man? And what did his ring do? Thus *The Hobbit Part 2* became something else entirely, "a tale that grew in the telling," an epic

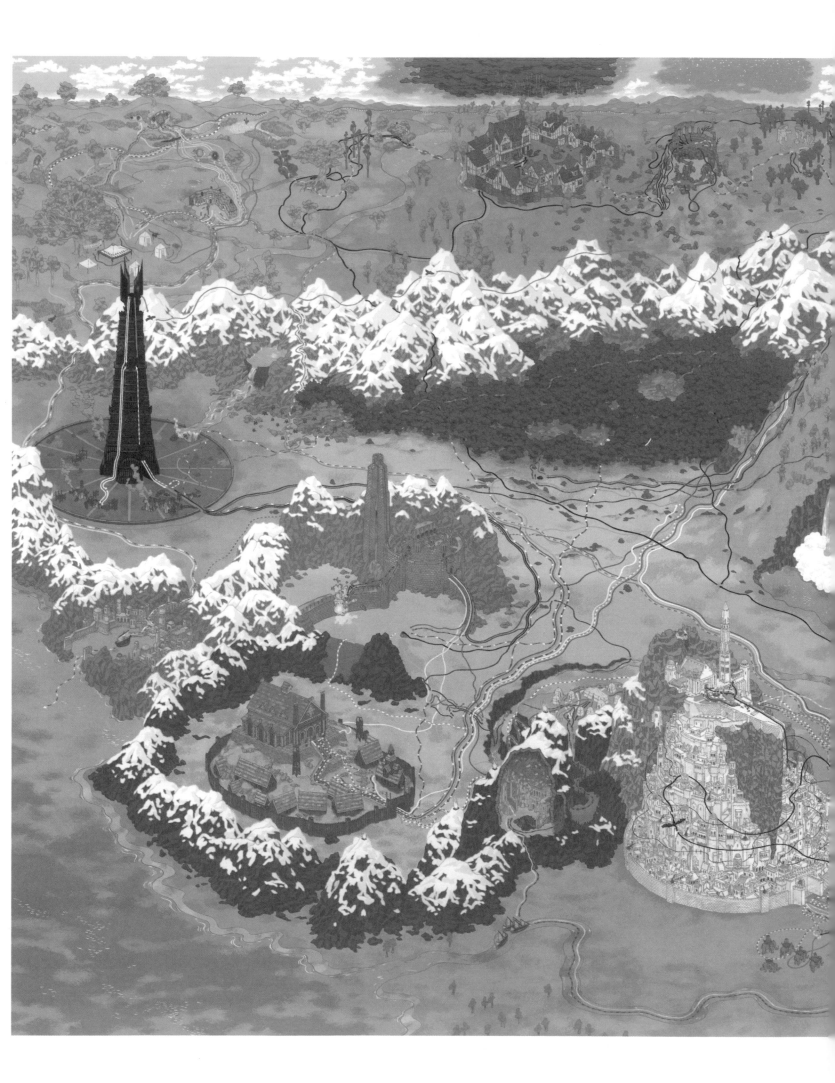

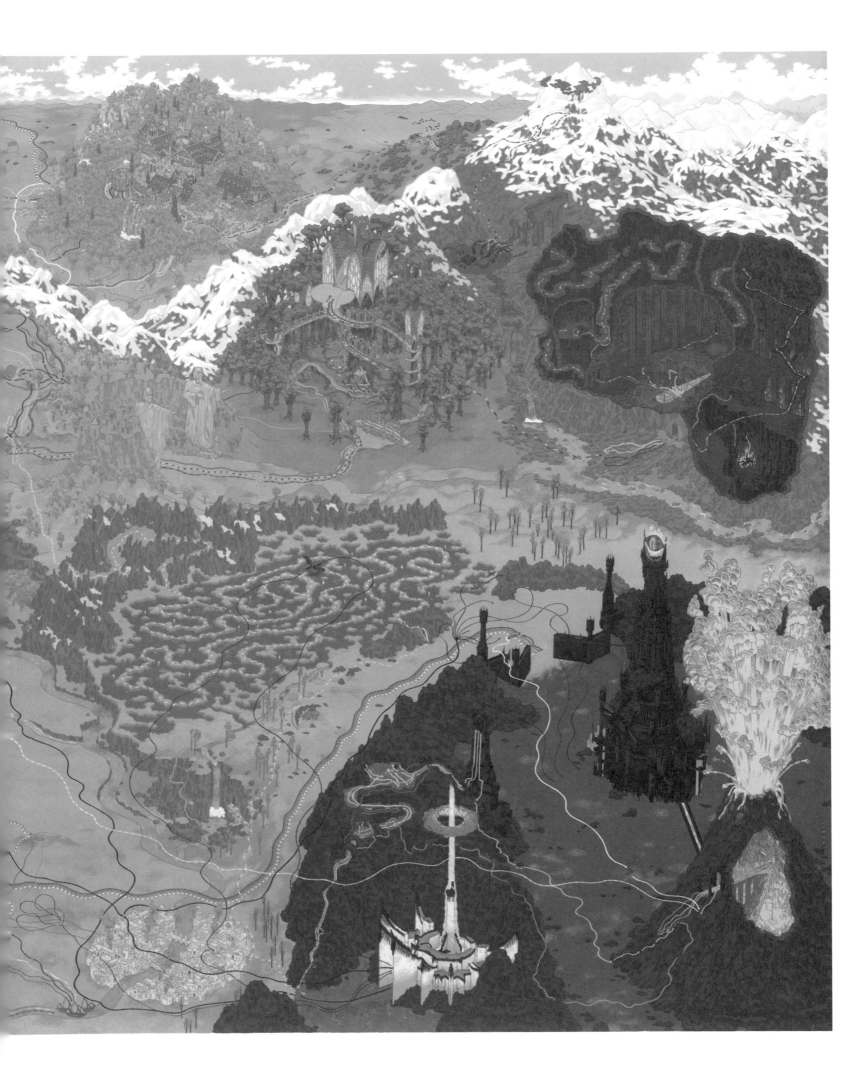

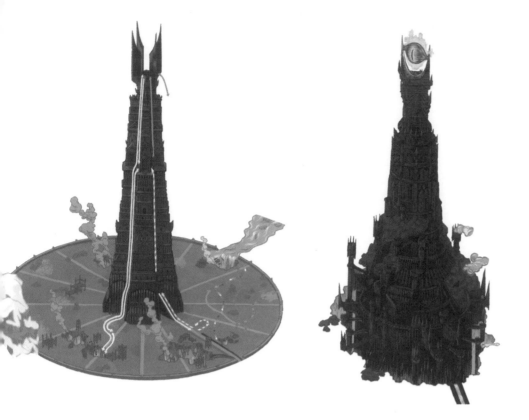

THE TWO TOWERS (above)

ADAM: Saurman sits atop his tower, gazing into his Palantir, while Sauron's tower is topped with a burning eye. Both towers are panopticons—places from which one can see all. But in the end, there can be only one panopticon.

account of the forces of good and the forces of evil. Bilbo's magic ring, Tolkien decided, wasn't just any old magic ring, but the *One Ring*, an ultimate weapon crafted ages ago by the necromancer Sauron as part of his scheme to enslave all of Middle-earth. Bilbo's nephew Frodo volunteered with others to carry the Ring to the site of its making and cast it into the fires there, the only power that could destroy it.

But first a problem had to be solved. The Ring, being wicked, corrupted anyone who bore it. Why then had Gollum freely surrendered it to Bilbo? Tolkien revised *The Hobbit*: Bilbo had in fact *stolen* the Ring from Gollum, then lied to Gandalf. Already the trinket was working its malice. This established a pattern: first a falsehood, then a revision. That structure repeats throughout the tale. Wherever Gandalf goes, he encounters the belief that all is well in Middle-earth. His task is to overcome that impression, convincing people that their complacency is a ruse, a deception crafted by Sauron's agents—propaganda. In truth, their situation is

urgent; they stand on the precipice of war.

As soon as he finished *The Lord of the Rings*, Tolkien began work on an even greater epic, *The Silmarillion*, an account of creation, as well as other wars (this time over jewels); it was to serve as a lavish backdrop to the story he'd just told. There's something about Middle-earth that makes it hard to quit, to tell things simply and to the point. Peter Jackson discovered that when he started adapting Tolkien to the screen. He made three films, which upon release met with acclaim. But something compelled him to fiddle further, releasing extended DVD versions, which added upwards of two hours to the saga. He then took his leave of Middle-earth, inviting Guillermo del Toro (Frodo to his Bilbo) to try his hand at making *The Hobbit*. But letting go of his creation proved a challenge, and ten years later Jackson was back behind the camera, adapting *The Hobbit* himself. That project went from two films to three, then saw DVDs with longer versions—a tale that kept growing in the telling.

First a falsehood, then a revision. One is tempted to circle back, to make a change. The Ring is crafty. Bilbo tells Gandalf that he's bequeathing it to Frodo, that he's placed it in an envelope on the mantel. Only—what's this? It's in his pocket. Odd, but why not? Why shouldn't he keep it? It's like a magic trick, except he's not the magician. We all know who's secretly pulling the strings. Even a mighty

wizard like Gandalf, and Galadriel the elf queen, know not to trifle with the thing; even they must work to resist its temptation.

Sauron forged the One Ring to rule his other Rings and, thereby, all mortals. His greatest creation, it is a test, the source of Middle-earth's deepest perils and subtlest lies. It wins not by threats, but by seduction. It tells us what we want to hear. We purchase our tickets and enter the theater, taking our seats as the lights go down. And in that darkness, the One Ring binds us. It is the author of its fate. Bilbo found it because it *wanted* to be found. Even before that, it slipped free from Isildur's finger and made its way to two hobbits, one of whom strangled the other for it, becoming Gollum. Even before that, it made its way to a middle-aged man, an Oxford fellow at Pembroke College, busy grading student exams. He turned one over to find a blank page; a sentence popped into his head: "In a hole in the ground there lived a hobbit." He scribbled it down, went where it led. The Ring was already in his pocket, its voice in his ear. •

A REAL OTHER PLACE (opposite top)

ADAM: Maps have been central to *The Lord of the Rings* since its inception. Tolkien sketched his own versions, including them at the front of each volume. It is essential to the fantasy's success that we believe the story is about a real, other place, a land that can be charted just like our own.

A MORE INTEGRATED LANDSCAPE (opposite bottom)

DREW: This is the largest map in the book, 52 inches long, and producing it took me a thousand hours of painting. And yes, it differs from Tolkien's own map of Middle-earth—but I had my reasons! Nothing happens in 80% of Tolkien's map, where north-south mountain ranges divide the locations into isolated boxes. And Peter Jackson's films make Middle-earth its own place, giving it a vast, sweeping feel. So I broke down Tolkien's lonely boxes, merging them into a more integrated landscape, viewed from a lower angle, looking northwest. It's much more exciting this way, even if I had to relocate the Grey Havens.

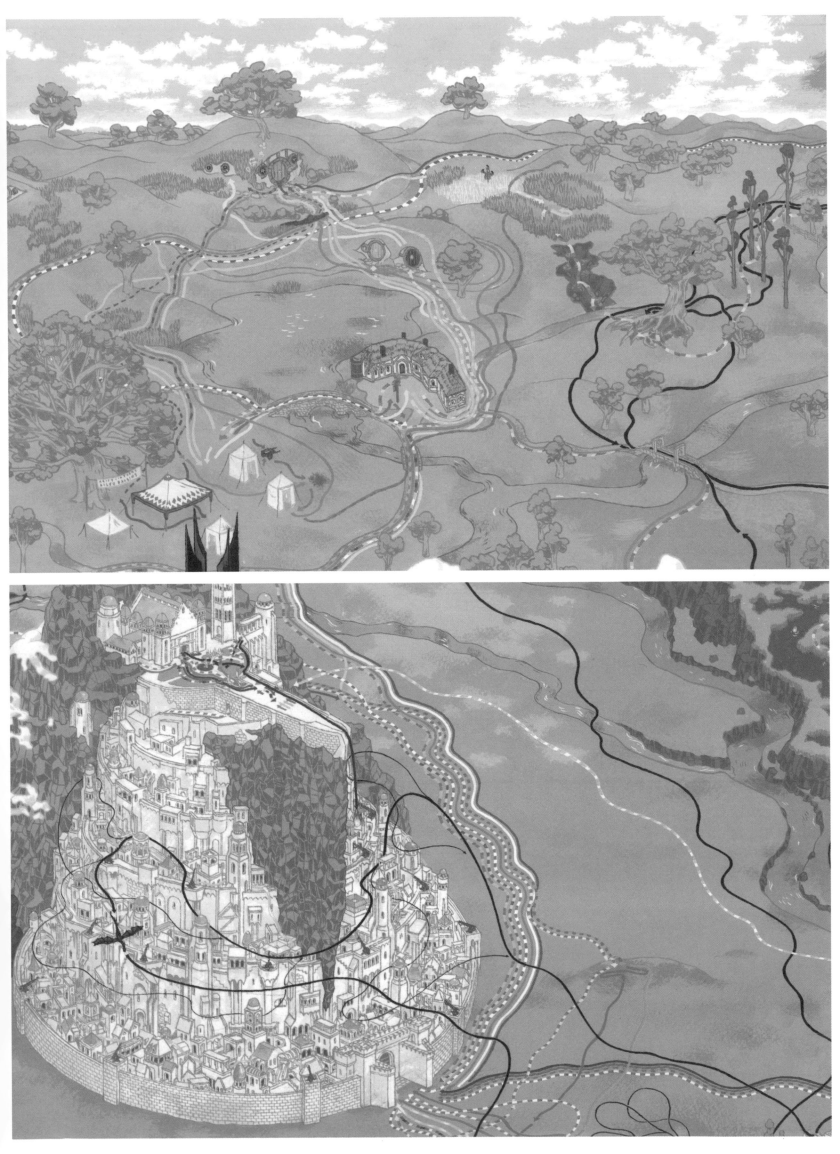

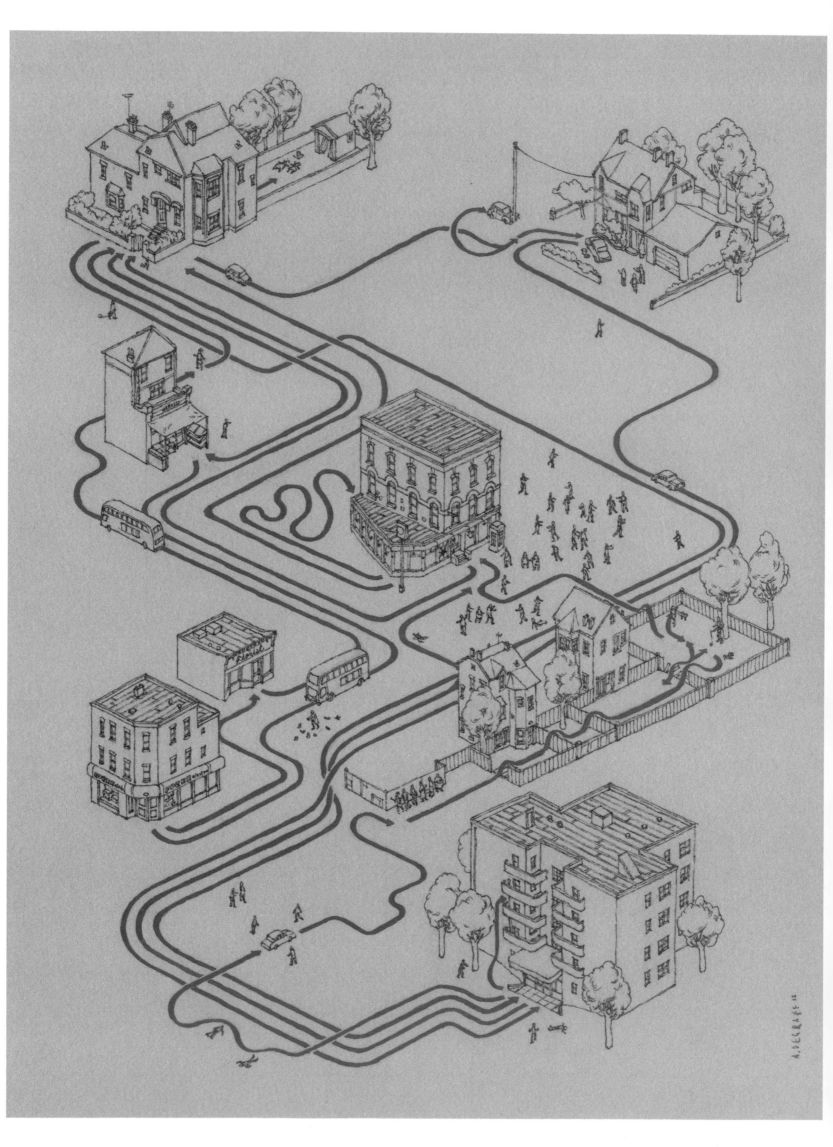

DIRECTED BY **Edgar Wright**

RELEASED IN **2004**

● **SHAUN**

Zombies are an epitome of artlessness, purely instinctive and unthinking, just shambling around, eating and moaning. They have no speech, no imagination. What makes them frightening is how they bleakly parody us. Vampires are similarly undead, but they're also exceedingly genteel, and usually rich. Frankenstein's monster could read and thereby better himself (at least in Shelley's original novel). But zombies are humans devoid of culture, the very thing that makes us *us*. They're humans reduced to basic nature, a fate worse than death. They lunge about, hungry for brains. Like the Scarecrow in *The Wizard of Oz*, they want wits—except, unlike the Scarecrow, they don't even know what it is that they want. Although they're conscious, they're not *self*-conscious; they can't see themselves or represent themselves. They're "poor in world" (as Heidegger said about animals— *weltarm*), unable to remake nature as they see fit and thereby domesticate themselves. A human being can change his or her mind. A zombie has no mind to change. Its brain is just basic motor functions, a glob of gray matter that's doing nothing but keeping it going, stumbling along.

In *Shaun of the Dead* (which is an epitome of art), Edgar Wright and Simon Pegg take their cue from George Romero; they also take great delight in putting the zombies through their paces, using them to satirize the service industry, as well as bar patrons and concertgoers. Modern living doth make zombies of us all. What

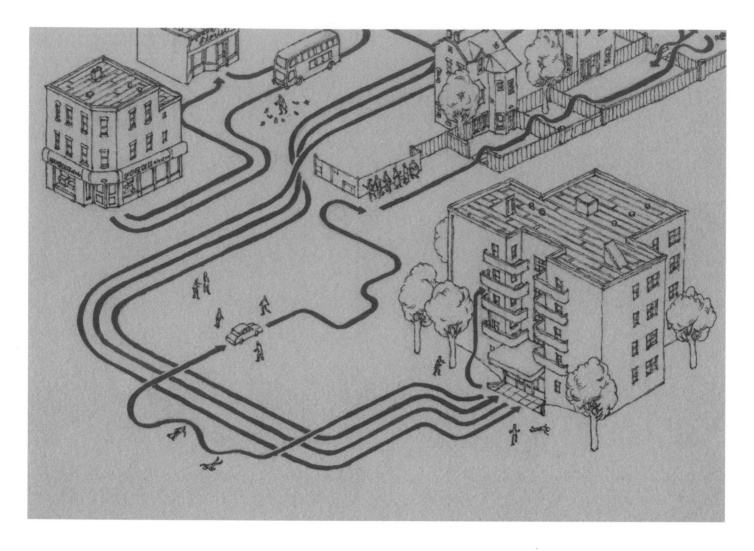

ROMEO OF THE DEAD (above)

ADAM: Shaun's scaling the trellis outside Liz's flat makes him a modern-day Romeo. He has less luck with fences.

else to do but follow routine? We go to work, we travel home, we head out to see shows, we meet up with friends at our local bar. We live life going through the motions.

Shaun of the Dead is really two horror films in one. The first sees its hero dead from the start, inured to life and just waiting to die. He spends the first half hour trudging along, unable to see what his girlfriend, Liz, is starting to realize. Twentysomethings on the cusp of turning thirty, they're staring down a string of identical days spent working, shopping, drinking, dating, and playing video games. Liz is beginning to see the light, becoming afraid that time's a-wasting. She gives Shaun the boot, knowing she must make a change if she wants to avoid living death, pissing her life away each night at the Winchester tavern, downing pints

until she's elderly and left "wondering what the hell happened."

Fortunately for Shaun, the zombie apocalypse intervenes. It creeps up slowly, as people faint on the bus and at bus stops and while urgent news broadcasts in the background, warning of people gone all bitey, go ignored. To be fair, Shaun has a great deal on his mind, what with Liz having ditched him and his flatmate Pete insisting that they ditch Ed—Shaun's best friend from primary school, now a deadbeat hanger-on whose only job is selling pot on the side. "All he ever does is hold you back!" Pete bellows, but Shaun still favors slumming around with Ed, living a life of static inaction, until the zombies start barging in. Unable to stay home, the two friends concoct a plan that's unique in horror cinema, which usually sees its heroes break with routine—the horror formula being the everyday interrupted. But after thinking it through, Shaun proposes to do what he planned to spend the day doing: visiting Mum, then taking Liz to (where else?) the Winchester. What has changed is the rest of the world, making

Shaun's lack of imagination downright inspired— it's "a slice of fried gold."

Since this is a comedy-horror film, putting that plan into action goes a little screwy. Along the way, Shaun's stepdad Phillip succumbs to a zombie bite (despite having run the wound under a cold tap), and fences collapse, and Shaun gets repeatedly harassed by Liz's own flatmate David, who's long been in love with Liz. But Shaun and the others, mindful, prevail. A crucial scene sees David's girlfriend, Dianne, an actress, teach a lesson on how to convincingly pass as zombies. The face is vacant, she observes, "with a hint of sadness. Like a drunk who's lost a bet." Humans, artistic, can imitate zombies, while zombies can't imitate anything— they can only be themselves.

Reaching the Winchester doesn't magically solve all their problems. Shaun's mom has been hiding that she got bitten, not wanting to trouble her Pickle on this funny sort of day. And there's a Mexican standoff with bottles and a corkscrew, broken only when zombies break in and carry off David and Dianne. Their gang of

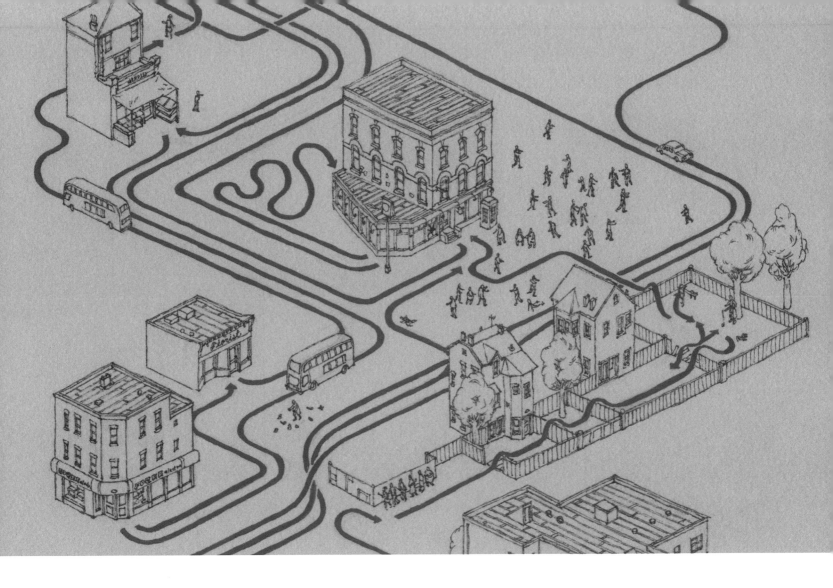

six whittled down to three, and the Winchester's Winchester out of ammo, Liz, Shaun, and Ed retreat to the basement, where Shaun is finally forced to say goodbye to his friend.

For a while, at least. The coda, set six months after "Z Day," sees Shaun and Liz now living together, with a zombified Ed chained up in their garden shed. That's a happy ending for him: lacking any higher ambition, he still gets to hang out with his mate, as an animal sidekick—a truer version of Clyde, the orangutan he so expertly imitates. He can't smell any worse than his farts, and maybe Shaun takes him down to the pub from time to time. As for Liz and Shaun, they've settled back into the old routine but with one vital difference: Shaun of the dead has come back to life, made a little more self-aware. •

THE WINCHESTER (above)

ADAM: The Winchester repeating rifle, invented in 1848, was nicknamed "The Gun That Won the West." Its bloody success led heir Sarah Winchester to dedicate her fortune to building the Winchester Mystery House, a labyrinthine manor in San Jose, California, whose bewildering design was intended to protect her from the firearm's ghostly victims. Which might make it the ideal refuge should zombies ever attack, though the Winchester Pub does serve cold beer on tap.

IT'S NOT HIP-HOP, IT'S ELECTRO (below)

ADAM: When Shaun and Ed play DJ on the eve of the zombie apocalypse, their antics only enrage their flatmate, Pete, who complains of a splitting headache. The following day, Shaun and Ed take a more direct approach, flinging their records at the heads of encroaching zombies.

STAR TREK

A massive starship, bristling with spikes and looking not unlike a robotic squid, glides out of a lightning storm in space and attacks the *Kelvin*, thereby setting in motion not just the movie's plot, but an entire other universe. From this point on, all will be different. Kirk's dad sacrifices himself, meaning his son grows up rebelling against Starfleet, intent on sabotaging his future. And later the Vulcans are nearly wiped out when their planet implodes, crumpling inward around a black hole, collapsing like a moldy muffin sucked into a vacuum.

But what's most different this time around is the approach to making *Star Trek*. Much has been made of the nonstop action, all the running and the shouting, as well as the lens flares. The characters punch their way out of problems, firing phasers instead of sitting down and talking. Down with philosophizing! Up with amping everything up! Even the transporters are more thrilling, swirling white ribbons of light that wrap up people like mummies. And the warp drive is something that Starfleet officers punch, just as in *Star Wars*. J. J. Abrams made no secret of which sci-fi franchise was his favorite, which worked out for him—he got the gig on *The Force Awakens*.

Star Trek has always flirted with alternate dimensions. The Original Series introduced the Mirror Universe, whose humans and Vulcans had formed a despotic alliance that subjugated other planets—an evil take on the Federation. Its version of Spock,

DIRECTED BY **J. J. Abrams**

RELEASED IN **2009**

- ● JAMES T. KIRK
- ● SPOCK
- ● SPOCK PRIME
- ● CAPTAIN NERO
- ● CHRISTOPHER PIKE
- ● BONES MCCOY
- ● NYOTA UHURA
- ● SCOTTY
- ● HIKARU SULU
- ● PAVEL CHEKOV
- ● CHIEF ENGINEER OLSON

Paths of the Trek (2013)
Gouache on paper
18 x 24 in (46 x 61 cm)

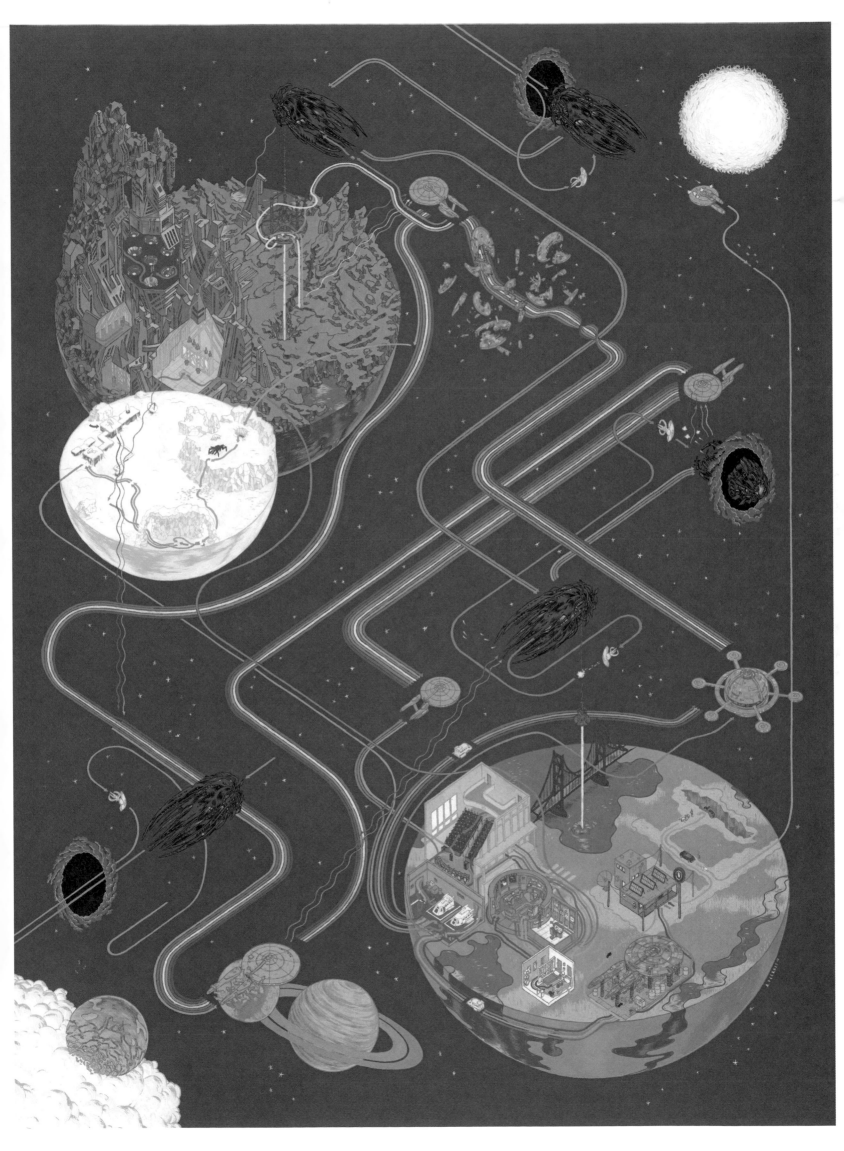

goateed and sadistic, became the poster child for dark versions of the self. Thirty years later, *Deep Space Nine* returned to that other world to find that its humans, in trying to act a little bit better, wound up only becoming enslaved.

These are dystopian fictions, whose pleasure comes from taking away the very things we love. *The Next Generation* episode "Yesterday's Enterprise" resurrects Tasha Yar, the security chief who died in the first season of the show. (The actress playing her wanted out.) But in exchange the episode pits the Federation against the Klingons, fighting a war they can't hope to win. Guinan, played by Whoopi Goldberg, senses that something is amiss—she's the viewer surrogate, whose conversations with Yar convince the young woman to go back in time, thereby stopping the war from ever starting.

A later episode, "Parallels," sees Worf caught shifting between different possible realities, including one where Picard was murdered by the Borg, and one where Worf is (unexpectedly) married to Counselor Deanna Troi. Toward the end of that show, space fractures and hundreds of

thousands of *Enterprise*s appear. One of the ships refuses to go home because in its timeline "the Borg are everywhere!" It's a frightening scene that has stuck with me ever since. Such shows are *Star Trek*'s take on *The Wizard of Oz*: we get swept up in a tornado (or a space-time anomaly) and then dropped into a world gone topsy-turvy to see how everything could be different. But then, in the end, we get to go home.

What differentiates Abrams's *Star Trek* is the sense that its universe—"the Kelvin Timeline," or the "J. J. Abrams-verse"—constitutes the new normal. Nero breaks *Star Trek* proper by traveling back in time and killing Kirk's father and nearly wiping out the Vulcans. From there it's all familiar but different. Scotty, stuck on an icy planet, keeps a caged tribble as a pet; Nero borrows a page from Khan by implanting Pike with a brainwashing slug. Pike winds up in a wheelchair, minus the facial scars this time. And we finally get to see Kirk beat the Kobayashi Maru, the unwinnable test—a story we only got to hear in *Star Trek II*. (He neglected to mention his eating an apple.)

The alternate Abramsverse has its pleasures. I quite like the updated '60s fashions, how the filmmakers managed to make the miniskirts and mod haircuts look both retro and futuristic. The red matter blob is like a lava lamp you'd find in an Apple store. And the *Enterprise* viewscreen and graphic displays have gotten the upgrades they sorely needed, especially after Tony Stark had so much fun swiping transparent screens in the *Iron Man* films.

Oddly, though, there's never any talk of undoing Nero's damage—of setting things right and escaping the Abramsverse, getting back to the *Star Trek* we know. And this despite the presence of Spock (the elderly one), who knows things are different. Instead, he resigns himself to the changes—this time, he's the audience proxy. He knows that Paramount intends this reboot to stick. There is no going back. With a heavy sigh he takes leave of the bridge, steps into the turbolift, and heads to the ship's bar, Ten Forward. He sits at a corner table; Guinan comes over to join him. Over a quiet drink, they share their feeling that something is amiss. •

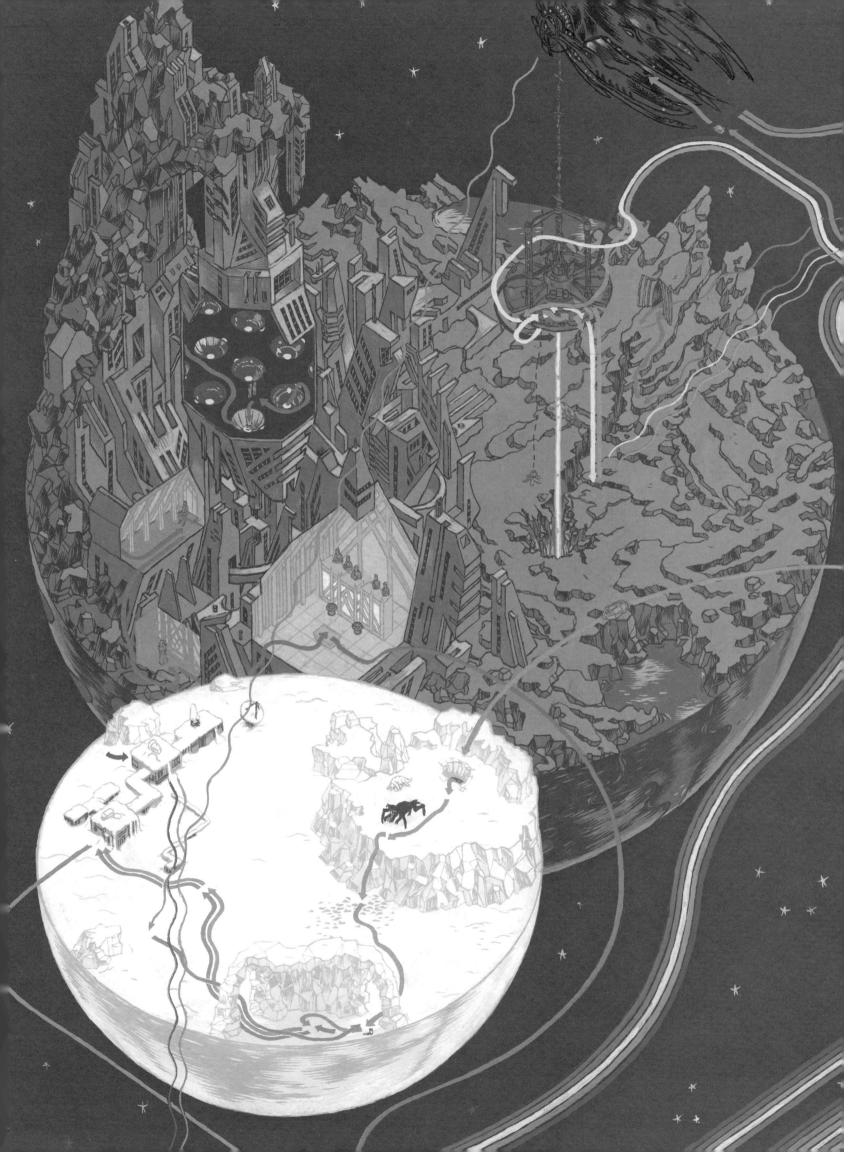

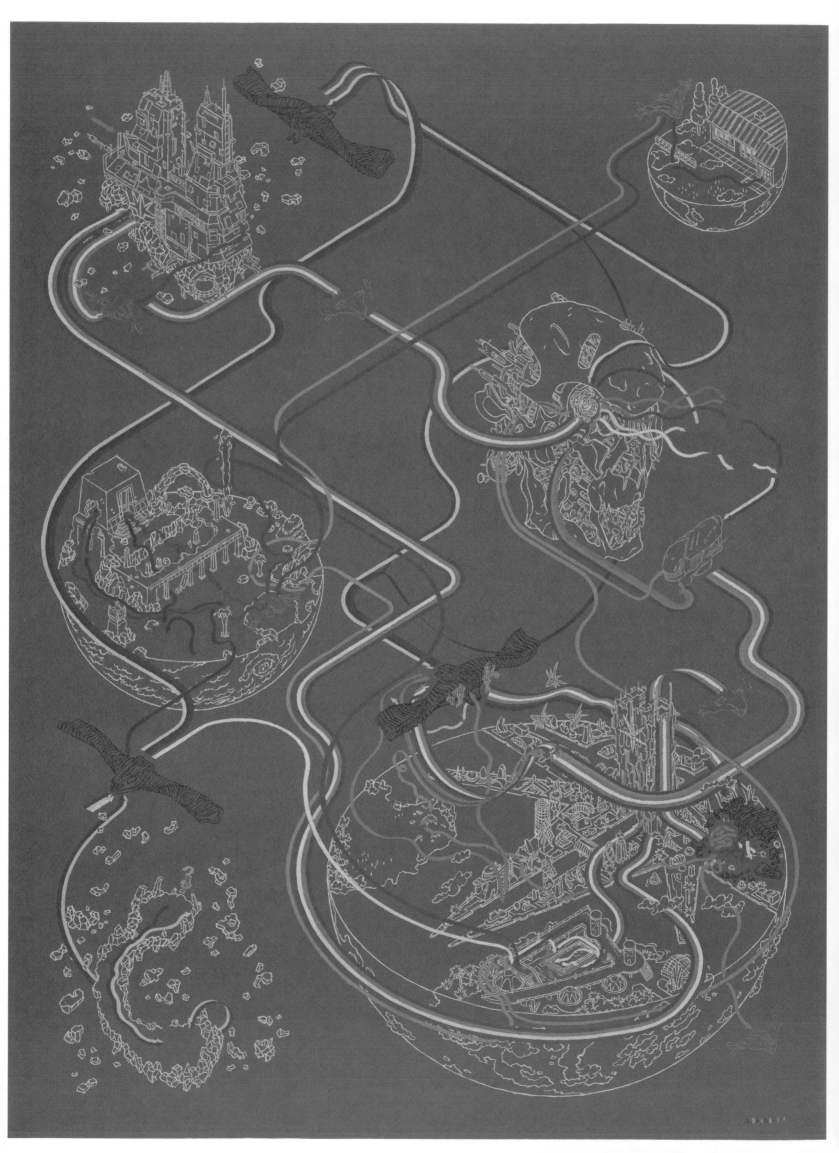

GUARDIANS OF THE GALAXY

DIRECTED BY **James Gunn**

RELEASED IN **2014**

- ● PETER QUILL
- ● GAMORA
- ● DRAX
- ● ROCKET
- ● GROOT
- ● RONAN
- ● YONDU UDONTA
- ● NEBULA
- ● KORATH
- ● THANOS

Paths of the Guardians (2017)
Gouache on paper
14½ x 20 in (37 x 51 cm)

Our red-blooded hero Peter Quill (who'd prefer to be known as Star-Lord) is immediately familiar, having been built out of popular parts. At times he's Captain Kirk, a cunning strategist and player; at other times he's Indiana Jones by way of Captain Solo.

This is fitting; he has a fondness for the past, is focused on how things used to be. On the abandoned planet Morag he shines a beam that illuminates by projecting history, like a sci-fi Google Street View that shows the planet in days of yore, rebuilding ruins and restoring inhabitants now absent. He slips on his headphones and clicks on his Walkman, then dances joyously, bold and brash, unafraid of the fauna that slithers and snarls all around him—he's like a little boy of twelve, kicking toothy beasts like footballs while grabbing another lizardy thing to use as a mic. Wrapped up inside a cocoon of popular tunes from the '60s and '70s, he's safe—he's back in the hallway outside his mother's hospital room, in the moments before he's called in to witness her death, which means she is still alive. The ultimate momma's boy, Quill can't come to terms with his grief, can't even acknowledge his mother's demise, or how he refused her frail and failing hand as she flatlined, running outside to howl in denial at the night sky. Quill never had to go back inside, never had to face the fact of her absence: abducted by aliens, he grew up in a galaxy far, far away, a foreign place that he renders familiar through snarky allusions to Earth that no one else understands.

Except for us. Peter Quill is James Gunn's clever means for embracing *Guardians'* expansive ancestry, including that one dread trilogy hanging above it all, whose name is too powerful to utter . . . or even whisper. Quill can't confront his mother's death, and he also can't reference (directly) the trio of movies without which he would not be—Star-Lord's lodestar, which shines through in numerous places. Consider Knowhere, a mining colony where people extract precious matter from the head of an ancient god. And which god would that be? The bar inside combines the rowdy Mos Eisley cantina with that holochess game board aboard the *Millennium Falcon* with Jabba's palace. No surprise it's also the home of the Collector, a consummate geek, whose pad is a prison-slash-zoo overstuffed with Easter eggs, including (we find out after the credits) Howard the Duck. That wise-ass fowl claims the final line while sipping a boozy drink, a sly allusion to the last time Marvel teamed up with Mr. Lucas.

The busy plot sees different sides scrambling for an orb, an antique metal sphere encasing a purple gem that can do magical things and whose power is more than mere mortals can withstand. The contestants are sharply drawn and engaging, each pursuing a separate agenda. The chief baddy, Ronan, is a zealot who wants to avenge his father's death, and that of his father's father, and so on and so forth; he flits about in a massive starship called the *Dark Aster*. (*Death Star* was taken.) He's hunted by Drax, who wants to avenge his wife and daughter, and who is betrayed by Gamora, the last of her green-skinned people and now enslaved to the mad titan who murdered her folks.

Drax and Gamora team up with Star-Lord, who managed to get his mitts on the orb first. They're joined by a surly raccoon named Rocket and his lumbering companion, a treelike alien named Groot who says only "I am Groot" till the one time that he doesn't. (Rocket can tell what Groot really means, the same way Han Solo could understand Chewie.) A band of losers ("people who've lost things," Quill clarifies), they prove a lot tougher than they look; like Indiana Jones, they can weather a lot of beatings. And though they bicker and fight at first, and Rocket

advocates running away, they throw in their lot with the ruling order, taking up arms with the Nova Corps to defend the galaxy from Ronan, who doesn't consider himself bound by governments or treaties. He's a fundamentalist who worships a different god—the wrong god, as it turns out—a false god. On Knowhere, he glances about unimpressed, stealing the orb before imperiously departing. Pop culture's majesty is lost on him—he has a stick up his butt, you might say—which is why he appears so perplexed at the climax, when Star-Lord distracts him with a dance-off. The central conflict comes down to religion vs. the geeks, Ronan's archaic fanaticism vs. secular popular culture—the latter including the movie we're watching. The Guardians of the Galaxy are the guardians of *Guardians of the Galaxy*—so no real surprise who wins the day. Ronan is blasted to smithereens (a purple haze).

That leaves Quill—pardoned and living with a new family—with the courage to open the present his dying mother handed him, which turns out to be more popular culture: another mix tape. He pops it in and presses Play, and we get the sense he's finally grasped that she is gone. He is ready to move on. But his true mother is still all around him, omnipresent and lighting the way, like the glowing wisps Groot makes when it gets too dark. The birth of the geek, the franchise that continues to this day to nourish nerds both near and afar—*Star Wars* is Star-Lord's mother's milk. •

THE *DARK ASTER* (right)

DREW: Legendary comics artist Jack Kirby developed much of Marvel's "cosmic" aesthetic, which includes characters like Galactus, Silver Surfer, and Ronan the Accuser. Ronan's spaceship, the *Dark Aster*, pays fitting homage to Kirby's work, being huge and impractical but also beautifully whimsical, its mystical nature standing in direct contrast to the Nova Corps's reliance on science and reason.

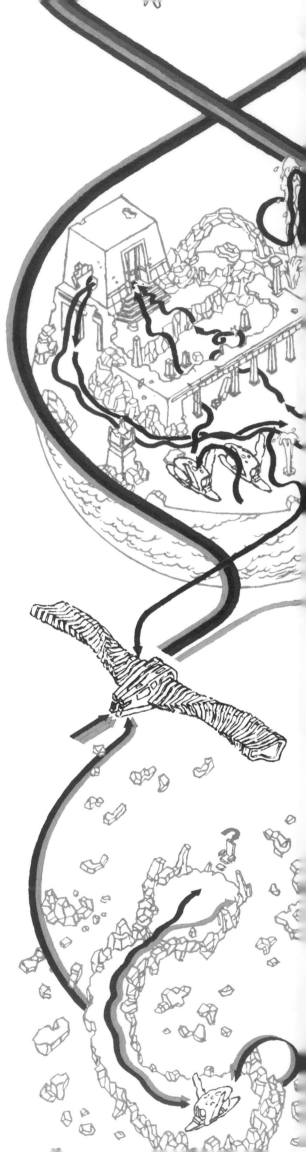

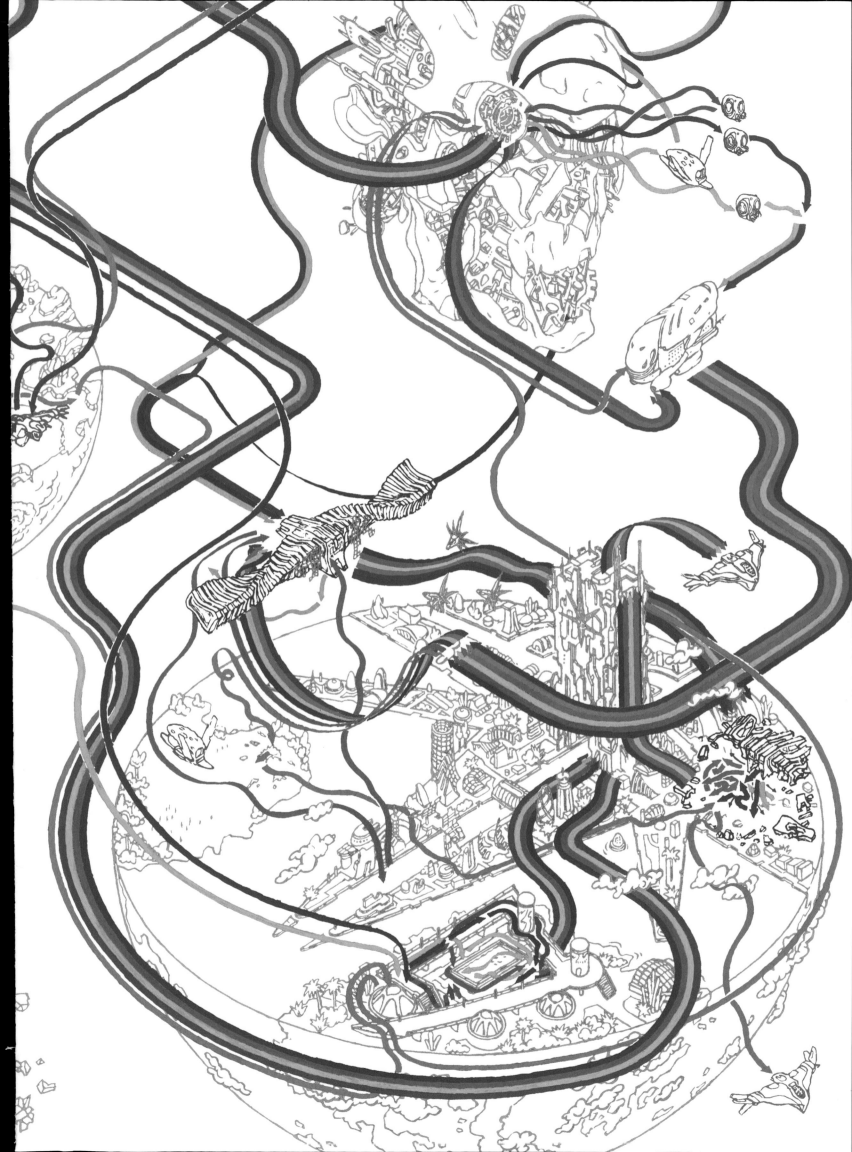

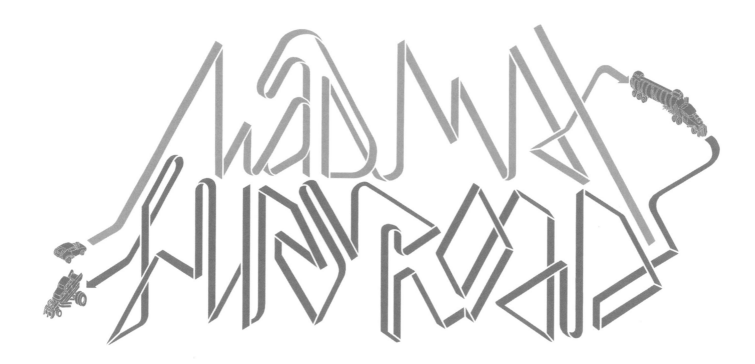

A sweaty franchise, *Mad Max* sweats most over matters of reproduction. Way back in the first film, made in 1979, society is still intact but going out of kilter: gangs of hoodlums rule the highways, and on the sign at the Hall of Justice, the letter *U* is coming loose. (Something is crooked). Cops spy on couples and have one-night stands with nightclub singers; the one honest man on the Main Force Patrol is Max Rockatansky, who lives by the sea, where he stares at the waves while eating honey and peanut butter. What keeps him noble and sane is his family: Jessie, his saxophonist wife, and their cherubic toddler, Sprog. But when Jessie and Sprog are run down by a vicious biker gang, Max snaps, renouncing his bronze badge and stealing a car ("the last of the V8 Interceptors") to embark on a rip-roaring rampage of revenge. He gets his sadistic satisfaction, but at the cost of becoming a criminal, condemned to endlessly roam the highways. An outcast.

Apparently society falls with him, taking things like ice-cream cones and lazy days spent by the river (as well as rivers). The sequel revises the setting, scorching the earth, now a place of great scarcity after a war between superpowers. The third film retcons matters again, introducing a nuclear war and irradiated water. Max lowers his shaggy head and focuses on survival, eking out a grim existence until he meets children—first a feral boy with a boomerang, then a whole tribe of lost youths. Max hardens his heart and tries to ignore them—we know when he looks at them he sees Sprog—

DIRECTED BY **George Miller**
RELEASED IN **2015**

- ● MAX ROCKATANSKY
- ○ FURIOSA'S COMPANY
- ● NUX
- ● IMMORTAN JOE'S ARMADA
- ● THE VUVALINI
- ● THE GAS TOWN BOYS
- ● BULLET FARMER AND GANG

Paths of Redemption (2017)
Gouache on paper
14¼ x 19 in (36 x 48 cm)

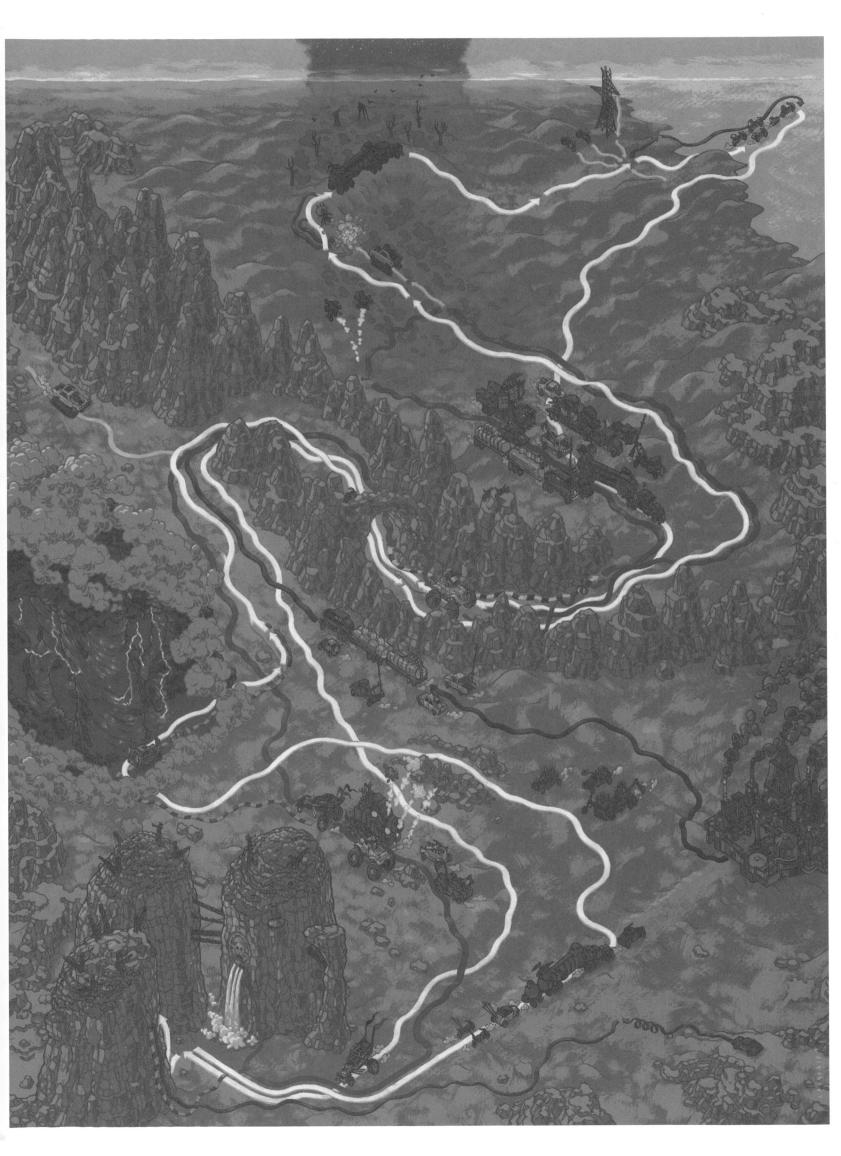

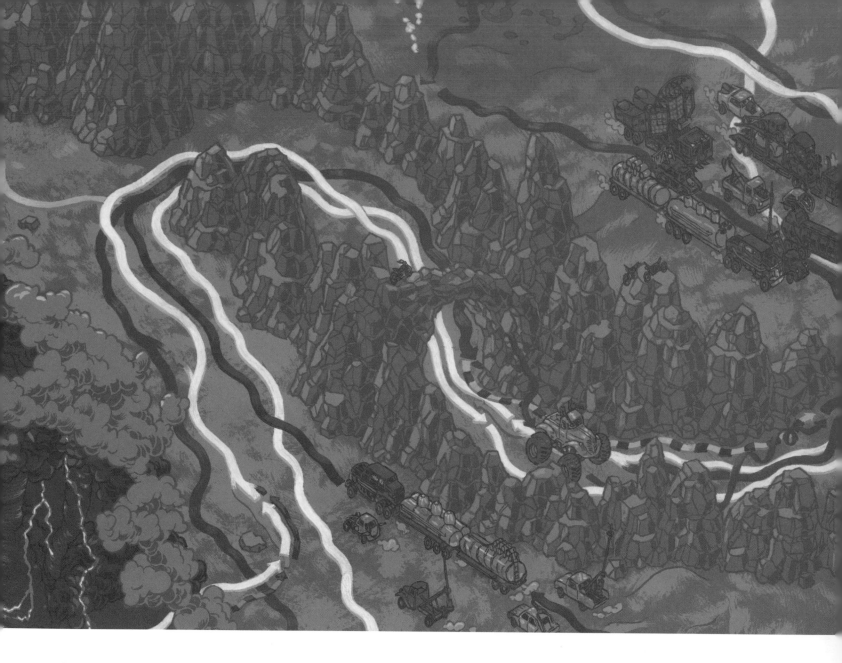

THE BIKERS' CANYON (above)

ADAM: Whatever river carved this canyon has disappeared by the time Immortal Joe perishes there, but that makes it a suitable resting place for the tyrant, whose power derived from depriving people of water.

but both times he softens and winds up leading the children to safety, in the process procuring some glimmer of redemption. With his own family slaughtered, Max reproduces by helping other people survive, folks who go on to rebuild parts of civilization. In return, they turn Max into legend. The Feral Kid grows up to lead the Great Northern Tribe, to whom he recounts the tale of his childhood and the Road Warrior who saved him. And Savannah Nix, whose Tribe That Left resettles amid Sydney's ruins, implores her descendants to 'member her tell of the man who found them, "him that

came the salvage."

But as Savannah Nix also said, "the years travel fast" and "time keeps counting"—not unlike his creation, George Miller is haunted by nightmarish imagery, compelled to put it up onscreen. And so, three decades beyond *Beyond Thunderdome*, Miller has Mad Max ride again, into a world of blood and heat, a blighted wasteland of massive sandstorms containing thunderstorms and tornadoes, where no one is averse to dining on two-headed mutant lizards and passing bugs.

This time around, Max runs afoul of Immortan Joe, a graying tyrant riddled with tumors and kept alive by means of a skull-shaped oxygen mask—Darth Vader by way of Skeletor. Fond of rituals and theatrics, Joe keeps the masses in thrall through occasional gifts of water and proclaims himself a redeemer able to lift his followers out of their world's ashes—literally. From his perch on high, he selects

those worthy of joining his Eloi in their aerie, bodies chosen for what they can offer to his cause: blood, milk, wombs. He's trying to breed control of the future—ensuring that his progeny reigns supreme, an endless dynasty of warlords—to which end he's founded a cult of personality. His foot soldier War Boys believe that if they're seen dying in his service, they'll ride eternal, "shiny and chrome," through the gates of Valhalla, their credo being, "I live, I die, I live again!" In other words, life after death. But Immortan Joe's favorite bride, the Splendid Angharad, sees through her husband's chicanery and knows there's only death after death. That's why she calls the bullets made by Joe's ally, the Bullet Farmer, "anti-seeds": "plant one and watch something die."

Splendid escapes with her four fellow brides, smuggled out of their vault of a home by Joe's rebellious lieutenant,

ADAM: Immortan Joe's Citadel is an update on the luxurious upper world of *Metropolis*, which means it's also an update on the realm inhabited by the Eloi in H. G. Wells's classic novel *The Time Machine*.

Imperator Furiosa. The six women head east in a war rig, in search of an Edenic realm ruled by matriarchs that Furiosa half-remembers from her youth. Joe, unwilling to lose his "prized breeders," leads a posse in pursuit, including a truck decked out with a massive speaker system and taiko drummers and a guitarist whose instrument doubles as a flamethrower. Joe is monstrous, yes—a wild-eyed, white-haired despot—but there's still strength in his aging limbs, and he knows how to throw a party.

This is the mix that Max, again a nameless stranger come to town, gets caught up in. Joe's War Boys capture him and crash his Interceptor, a blow that renders Max incomplete—recall how Furiosa's missing left forearm is painted on the driver's side door of her cab. Deprived of his car, Max becomes mere fuel, a source of "high octane crazy blood" for the War Boy Nux, who wants nothing

more than to lay down his life for Joe before wasting away from cancer. Max—reduced like the brides to a body part and a possession—gets strapped to a car and brought along as one more resource for the chase.

As in *The Hobbit*, the structure is "there and back again." The question is, what happens after that? What form should society take? Who gets to reproduce? Long story short, Joe's bid at immortality fails—he winds up just like Max, forced to confront the corpse of his wife and their son, who go underneath a tire. The parallel couldn't be more deliberate: Immortan Joe is played by Hugh Keays-Byrne, who was Toecutter in *Mad Max*, the very man who ran down Jessie and Sprog with his chopper. Now the scavenged boot is on the other foot. In another telling piece of imagery, Max collects Furiosa's guns, dropping them all into a bag—a womb filled with anti-seeds. Later

that bag gets emptied and refilled with heirloom seeds, "the real thing," a means of remaking the blasted wasteland into a green space where everybody (not just the people at the top) can have their fill. In other words, life after life. With Max's assistance (as well as his blood), the brides ride triumphant back to the Citadel, where Furiosa supplants Joe and turns on the spigots. Max slips away, presumably headed back into the desert, but the closing title card suggests he won't soon be forgotten. This time, will history start anew? Perhaps. One more legend has taken seed. •

ACKNOWLEDGMENTS

DREW: So many people have contributed to these paintings and this book, it's hard to know where to start. I suppose I'll begin at the beginning: Thanks to Mom and Dad and my family, both nuclear and extended, for everything.

Thank you to Jensen Karp and Katie Cromwell at Gallery1988 for showing this work and helping to propagate it throughout the e-world and the real world. Your contribution to the world of pop culture art and artistic commentary cannot be understated, and your many emulators are a testament to your success.

Thanks to all the incredible websites whose painstaking research made up some of the nuts and bolts of this book, including the IMCDb (the Internet Movie Car Database) and the many film location sites I used to compile photo reference. There are far too many to name, and far too many contributors. I can only say that many times I felt that your research was made just for me—and this project.

To all the people who bought paintings and prints over the years: this book would not exist without you. Your support in hard-earned dollars and emotional affirmation convinced me that my obsessions had merit and inspired me to keep going.

Thanks to Clara Sankey at Ten Speed and writer extraordinaire Martin Seay for helping to initialize this project and mold the tone and concept of what this book would become. And to Martin again for introducing me to the cinematic, cultural, wordsmithing alchemist Adam Jameson.

Adam, it would take a better writer than myself to elucidate a proper thanks for your words, your knowledge, your wit, and your panache. I can only say it's an honor to share pages with you.

Thanks to Quirk Books publisher Jason Rekulak for championing this book. Your unflagging positivity and creativity is very much at the core of this project. Thanks to designer and *Cinemaps* wrangler Andie Reid for assembling and disassembling these maps for easy consumption and for making a beautiful book.

Finally, this book is dedicated to my wife, Michelle. Your support, love, and laughter have made this project fun, even as it stole thousands of hours from our life together. There is no thank-you big enough to reflect all of your artistic consultations and your role as my sounding board—let alone your grace, kindness, patience, and sacrifice. Thank you.

ADAM: I'd like to thank, as always, my mother, father, sister, and brother-in-law, as well as Christopher Grimes, Philip Durkin, Mazin Saleem, Tim Feeney, Sally O'Brien, James Curley, Aloysius T. Furball, and especially Jeremy M. Davies, Justin Roman, and Melissa McEwen.